Praise for
FIRST THEY KILLED MY FATHER

"This book left me gasping for air. Loung Ung plunges her readers into a Kafkaesque world—her childhood robbed by Pol Pot's Khmer Rouge—and forces them to experience the mass murder, starvation, and disease that claimed half her beloved family. In the end, the horror of the Cambodian genocide is matched only by the author's indomitable spirit."

—IRIS CHANG, author of *The Rape of Nanking*

"This is a story of the triumph of a child's indomitable spirit over the tyranny of the Khmer Rouge; over a culture where children are trained to become killing machines. Loung's subsequent campaign against land mines is a result of witnessing firsthand how her famished neighbors, after dodging soldiers' bullets, risked their lives to traverse unmapped minefields in search of food. Despite the heartache, I could not put the book down until I reached the end. Meeting Loung in person merely reaffirmed my admiration for her."

—QUEEN NOOR

"Despite the tragedy all around her, this scrappy kid struggles for life and beats the odds. I thought young Ung's story would make me sad. But this spunky child warrior carried me with her in her courageous quest for life. Reading these pages has strengthened me in my own struggle to disarm the powers of violence in this world."

—SISTER HELEN PREJEAN, CSJ,
author of *Dead Man Walking*

"In this gripping narrative Loung Ung describes the unfathomable evil that engulfed Cambodia during her childhood, the courage that enabled her family to survive, and the determination that has made her an eloquent voice for peace and justice in Cambodia. It is a tour de force that strengthens our resolve to prevent and punish crimes against humanity."

—U. S. Senator PATRICK LEAHY, congressional leader
on human rights and a global ban on land mines

"Loung has written an eloquent and powerful narrative as a young witness to the Khmer Rouge atrocities. This is an important story that will have a dramatic impact on today's readers and inform generations to come."

—DITH PRAN, whose wartime life was portrayed
in the award-winning film *The Killing Fields*

first
they killed my father

first
they killed my father

a daughter of cambodia remembers

LOUNG UNG

HARPER **PERENNIAL**

HARPER ● PERENNIAL

A hardcover edition of this book was published in 2000 by HarperCollins Publishers.

HarperCollins books may be purchased for educational, business, or sales promotional use. For information please write: Special Markets Department, HarperCollins Publishers Inc., 10 East 53rd Street, New York, NY 10022.

First Perennial edition published 2001.

Designed by Laura Lindgren and Celia Fuller

The Library of Congress has catalogued the hardcover edition as follows:
Ung, Loung.
 First they killed my father : a daughter of Cambodia remembers / Loung Ung.—
1st ed.
 p. cm.
 ISBN 0-06-019332-8
 1. Cambodia—Politics and government—1975–1979. 2. Political atrocities—Cambodia. 3. Ung, Loung. I. Title.
 DS554.8.U54 2000 99-34707
 959.604'2—dc21

ISBN 0-06-093138-8 (pbk.) ISBN 978-0-06-093138-4

 05 ❖/RRD 20 19 18 17

**In memory of the two million people who perished
under the Khmer Rouge regime.**

*This book is dedicated to my father, Ung; Seng Im, who always believed
in me; my mother, Ung; Ay Choung, who always loved me.*

*To my sisters Keav, Chou, and Geak because sisters are forever; my
brother Kim, who taught me about courage; my brother Khouy, for con-
tributing more than one hundred pages of our family history and details
of our lives under the Khmer Rouge, many of which I incorporated into
this book; to my brother Meng and sister-in-law Eang Muy Tan, who
raised me (quite well) in America.*

contents

author's note

From 1975 to 1979—through execution, starvation, disease, and forced labor—the Khmer Rouge systematically killed an estimated two million Cambodians, almost a fourth of the country's population.

This is a story of survival: my own and my family's. Though these events constitute my experience, my story mirrors that of millions of Cambodians. If you had been living in Cambodia during this period, this would be your story too.

family chart 1975

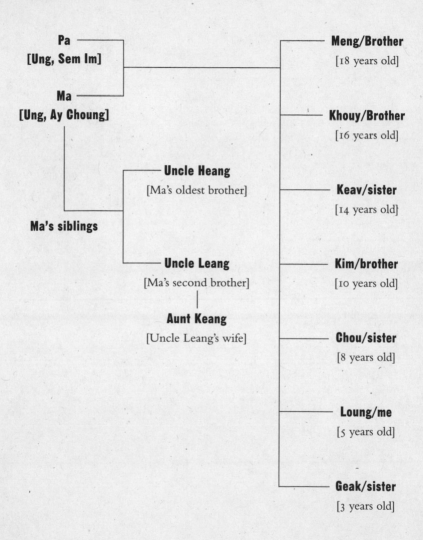

Pa
[Ung, Sem Im]

Ma
[Ung, Ay Choung]

Ma's siblings

Uncle Heang
[Ma's oldest brother]

Uncle Leang
[Ma's second brother]

Aunt Keang
[Uncle Leang's wife]

Meng/Brother
[18 years old]

Khouy/Brother
[16 years old]

Keav/sister
[14 years old]

Kim/brother
[10 years old]

Chou/sister
[8 years old]

Loung/me
[5 years old]

Geak/sister
[3 years old]

THAILAND

LAOS

RATANAKIRI

SIEM REAP N *PREAH VIHEAR* *STUNG TRENG* NE

C A M B O D I A

•Siem Reap

BATTAMBANG *Tonle Sap*

NW *KAMPONG THUM* *KRACHEH* *MONDUL KIRI*

C

PURSAT

•Ro Leap *KAMPONG CHHNANG*

KAMPONG CHAM

KOMPONG SPEU *PREY VENG* E

Krang Truop• ★

KAOH KONG W Phnom Penh VIETNAM

SVAY RIENG

SW

KAMPOT

Gulf of Thailand

South China Sea

——	Zone Boundary
- - - -	Provincial Boundary

0 ———— 50 miles

first
they killed my father

phnom penh

Phnom Penh city wakes early to take advantage of the cool morning breeze before the sun breaks through the haze and invades the country with sweltering heat. Already at 6 A.M. people in Phnom Penh are rushing and bumping into each other on dusty, narrow side streets. Waiters and waitresses in black-and-white uniforms swing open shop doors as the aroma of noodle soup greets waiting customers. Street vendors push food carts piled with steamed dumplings, smoked beef teriyaki sticks, and roasted peanuts along the sidewalks and begin to set up for another day of business. Children in colorful T-shirts and shorts kick soccer balls on sidewalks with their bare feet, ignoring the grunts and screams of the food cart owners. The wide boulevards sing with the buzz of motorcycle engines, squeaky bicycles, and, for those wealthy enough to afford them, small cars. By midday, as temperatures climb to over a hundred degrees, the streets grow quiet again. People rush home to seek relief from the heat, have lunch, take cold showers, and nap before returning to work at 2 P.M.

My family lives on a third-floor apartment in the middle of Phnom Penh, so I am used to the traffic and the noise. We don't have traffic lights on our streets; instead, policemen stand on raised metal boxes, in

the middle of the intersections directing traffic. Yet the city always seems to be one big traffic jam. My favorite way to get around with Ma is the cyclo because the driver can maneuver it in the heaviest traffic. A cyclo resembles a big wheelchair attached to the front of a bicycle. You just take a seat and pay the driver to wheel you around wherever you want to go. Even though we own two cars and a truck, when Ma takes me to the market we often go in a cyclo because we get to our destination faster. Sitting on her lap I bounce and laugh as the driver pedals through the congested city streets.

This morning, I am stuck at a noodle shop a block from our apartment in this big chair. I'd much rather be playing hopscotch with my friends. Big chairs always make me want to jump on them. I hate the way my feet just hang in the air and dangle. Today, Ma has already warned me twice not to climb and stand on the chair. I settle for simply swinging my legs back and forth beneath the table.

Ma and Pa enjoy taking us to a noodle shop in the morning before Pa goes off to work. As usual, the place is filled with people having breakfast. The clang and clatter of spoons against the bottom of bowls, the slurping of hot tea and soup, the smell of garlic, cilantro, ginger, and beef broth in the air make my stomach rumble with hunger. Across from us, a man uses chopsticks to shovel noodles into his mouth. Next to him, a girl dips a piece of chicken into a small saucer of hoisin sauce while her mother cleans her teeth with a toothpick. Noodle soup is a traditional breakfast for Cambodians and Chinese. We usually have this, or for a special treat, French bread with iced coffee.

"Sit still," Ma says as she reaches down to stop my leg midswing, but I end up kicking her hand. Ma gives me a stern look and a swift slap on my leg.

"Don't you ever sit still? You are five years old. You are the most troublesome child. Why can't you be like your sisters? How will you ever grow up to be a proper young lady?" Ma sighs. Of course I have heard all this before.

It must be hard for her to have a daughter who does not act like a girl, to be so beautiful and have a daughter like me. Among her women friends, Ma is admired for her height, slender build, and porcelain white skin. I often overhear them talking about her beautiful face when they

think she cannot hear. Because I'm a child, they feel free to say what-
ever they want in front of me, believing I cannot understand. So while
they're ignoring me, they comment on her perfectly arched eyebrows;
almond-shaped eyes; tall, straight Western nose; and oval face. At 5'6",
Ma is an amazon among Cambodian women. Ma says she's so tall
because she's all Chinese. She says that some day my Chinese side will
also make me tall. I hope so, because now when I stand I'm only as tall
as Ma's hips.

"Princess Monineath of Cambodia, now she is famous for being
proper," Ma continues. "It is said that she walks so quietly that no one
ever hears her approaching. She smiles without ever showing her teeth.
She talks to men without looking directly in their eyes. What a gracious
lady she is." Ma looks at me and shakes her head.

"Hmm . . ." is my reply, taking a loud swig of Coca-Cola from the
small bottle.

Ma says I stomp around like a cow dying of thirst. She's tried many
times to teach me the proper way for a young lady to walk. First, you
connect your heel to the ground, then roll the ball of your feet on the
earth while your toes curl up painfully. Finally you end up with your
toes gently pushing you off the ground. All this is supposed to be done
gracefully, naturally, and quietly. It all sounds too complicated and
painful to me. Besides, I am happy stomping around.

"The kind of trouble she gets into, while just the other day she—"
Ma continues to Pa but is interrupted when our waitress arrives with
our soup.

"Phnom Penh special noodles with chicken for you and a glass of
hot water," says the waitress as she puts the steaming bowl of translucent
potato noodles swimming in clear broth before Ma. "Two spicy
Shanghai noodles with beef tripe and tendons." Before she leaves, the
waitress also puts down a plate filled with fresh bean sprouts, lime slices,
chopped scallions, whole red chili peppers, and mint leaves.

As I add scallions, bean sprouts, and mint leaves to my soup, Ma
dips my spoon and chopsticks into the hot water, wiping them dry
with her napkin before handing them back to me. "These restaurants
are not too clean, but the hot water kills the germs." She does the same
to her and Pa's tableware. While Ma tastes her clear broth chicken

noodle soup, I drop two whole red chili peppers in my bowl as Pa looks on approvingly. I crush the peppers against the side of the bowl with my spoon and finally my soup is ready to taste the way I like it. Slowly, I slurp the broth and instantaneously my tongue burns and my nose drips.

A long time ago, Pa told me that people living in hot countries should eat spicy foods because it makes them drink more water. The more water we drink, the more we sweat, and sweating cleanses our bodies of impurities. I don't understand this, but I like the smile he gives me; so I again reach my chopsticks toward the pepper dish, knocking over the salt shaker, which rolls like a fallen log onto the floor.

"Stop what you're doing," Ma hisses.

"It was an accident," Pa tells her and smiles at me.

Ma frowns at Pa and says, "Don't you encourage her. Have you forgotten the chicken fight episode? She said that was an accident also and now look at her face."

I can't believe Ma is still angry about that. It was such a long time ago, when we visited my uncle's and aunt's farm in the countryside and I played with their neighbor's daughter. She and I had a chicken we would carry around to have fights with the other kids' chickens. Ma wouldn't have found out about it if it weren't for the big scratch that still scars my face.

"The fact that she gets herself in and out of these situations gives me hope. I see them as clear signs of her cleverness." Pa always defends me—to everybody. He often says that people just don't understand how cleverness works in a child and that all these troublesome things I do are actually signs of strength and intelligence. Whether or not Pa is right, I believe him. I believe everything Pa tells me.

If Ma is known for her beauty, Pa is loved for his generous heart. At 5'5", he weighs about 150 pounds and has a large, stocky shape that contrasts with Ma's long, slender frame. Pa reminds me of a teddy bear, soft and big and easy to hug. Pa is part Cambodian and part Chinese and has black curly hair, a wide nose, full lips, and a round face. His eyes are warm and brown like the earth, shaped like a full moon. What I love most about Pa is the way he smiles not only with his mouth but also with his eyes.

I love the stories about how my parents met and married. While Pa was a monk, he happened to walk across a stream where Ma was gathering water with her jug. Pa took one look at Ma and was immediately smitten. Ma saw that he was kind, strong, and handsome, and she eventually fell in love with him. Pa quit the monastery so he could ask her to marry him, and she said yes. However, because Pa is dark-skinned and was very poor, Ma's parents refused to let them marry. But they were in love and determined, so they ran away and eloped.

They were financially stable until Pa turned to gambling. At first, he was good at it and won many times. Then one day he went too far and bet everything on a game—his house and all his money. He lost that game and almost lost his family when Ma threatened to walk out on him if he did not stop gambling. After that, Pa never played card games again. Now we are all forbidden to play cards or even to bring a deck of cards home. If caught, even I will receive grave punishment from him. Other than his gambling, Pa is everything a good father could be: kind, gentle, and loving. He works hard, as a military police captain so I don't get to see him as much as I want. Ma tells me that his success never came from stepping on everyone along the way. Pa never forgot what it was like to be poor, and as a result, he takes time to help many others in need. People truly respect and like him.

"Loung is too smart and clever for people to understand," Pa says and winks at me. I beam at him. While I don't know about the cleverness part, I do know that I am curious about the world—from worms and bugs to chicken fights and the bras Ma hangs in her room.

"There you go again, encouraging her to behave this way." Ma looks at me, but I ignore her and continue to slurp my soup. "The other day she walked up to a street vendor selling grilled frog legs and proceeded to ask him all these questions. 'Mister, did you catch the frogs from the ponds in the country or do you raise them? What do you feed frogs? How do you skin a frog? Do you find worms in its stomach? What do you do with the bodies when you sell only the legs?' Loung asked so many questions that the vendor had to move his cart away from her. It is just not proper for a girl to talk so much."

Squirming around in a big chair, Ma tells me, is also not proper behavior.

"I'm full, can I go?" I ask, swinging my legs even harder.

"All right, you can go play," Ma says with a sigh. I jump out of the chair and head off to my friend's house down the street.

Though my stomach is full, I still crave salty snack food. With the money Pa gave me in my pocket, I approach a food cart selling roasted crickets. There are food carts on every corner, selling everything from ripe mangoes to sugarcane, from Western cakes to French crêpes. The street foods are readily available and always cheap. These stands are very popular in Cambodia. It is a common sight in Phnom Penh to see people on side streets sitting in rows on squat stools eating their food. Cambodians eat constantly, and everything is there to be savored if you have money in your pocket, as I do this morning.

Wrapped in a green lotus leaf, the brown, glazed crickets smell of smoked wood and honey. They taste like salty burnt nuts. Strolling slowly along the sidewalk, I watch men crowd around the stands with the pretty young girls at them. I realize that a woman's physical beauty is important, that it never hurts business to have attractive girls selling your products. A beautiful young woman turns otherwise smart men into gawking boys. I've seen my own brothers buy snacks they'd never usually eat from a pretty girl while avoiding delicious food sold by homely girls.

At five I also know I am a pretty child, for I have heard adults say to Ma many times how ugly I am. "Isn't she ugly?" her friends would say to her. "What black, shiny hair, look at her brown, smooth skin! That heart-shaped face makes one want to reach out and pinch those dimpled apple cheeks. Look at those full lips and her smile! Ugly!"

"Don't tell me I am ugly!" I would scream at them, and they would laugh.

That was before Ma explained to me that in Cambodia people don't outright compliment a child. They don't want to call attention to the child. It is believed that evil spirits easily get jealous when they hear a child being complimented, and they may come and take away the child to the other world.

the ung family

We have a big family, nine in all: Pa, Ma, three boys, and four girls. Fortunately, we have a big apartment that houses everyone comfortably. Our apartment is built like a train, narrow in the front with rooms extending out to the back. We have many more rooms than the other houses I've visited. The most important room in our house is the living room, where we often watch television together. It is very spacious and has an unusually high ceiling to leave room for the loft that my three brothers share as their bedroom. A small hallway leading to the kitchen splits Ma and Pa's bedroom from the room my three sisters and I share. The smell of fried garlic and cooked rice fills our kitchen when the family takes their usual places around a mahogany table where we each have our own high-backed teak chair. From the kitchen ceiling the electric fan spins continuously, carrying these familiar aromas all around our house—even into our bathroom. We are very modern—our bathroom is equipped with amenities such as a flushing toilet, an iron bathtub, and running water.

I know we are middle-class because of our apartment and the possessions we have. Many of my friends live in crowded homes with only two or three rooms for a family of ten. Most well-to-do families live in

apartments or houses above the ground floor. In Phnom Penh, it seems that the more money you have, the more stairs you have to climb to your home. Ma says the ground level is undesirable because dirt gets into the house and nosy people are always peeking in, so of course only poor people live on the ground level. The truly impoverished live in makeshift tents in areas where I have never been allowed to wander.

Sometimes on the way to the market with Ma, I catch brief glimpses of these poor areas. I watch with fascination as children with oily black hair, wearing old, dirty clothes run up to our cyclo in their bare feet. Many look about the same size as me as they rush over with naked younger siblings bouncing on their backs. Even from afar, I see red dirt covers their faces, nestling in the creases of their necks and under their fingernails. Holding up small wooden carvings of the Buddha, oxen, wagons, and miniature bamboo flutes with one hand, they balance oversized woven straw baskets on their heads or straddled on their hips and plead with us to buy their wares. Some have nothing to sell and approach us murmuring with extended hands. Every time, before I can make out what they say, the cyclo's rusty bell clangs noisily, forcing the children to scurry out of our way.

There are many markets in Phnom Penh, some big and others small, but their products are always similar. There is the Central Market, the Russian Market, the Olympic Market, and many others. Where people go to shop depends on which market is the closest to their house. Pa told me the Olympic Market was once a beautiful building. Now its lackluster façade is gray from mold and pollution, and its walls cracked from neglect. The ground that was once lush and green, filled with bushes and flowers, is now dead and buried under outdoor tents and food carts, where thousands of shoppers traverse everyday.

Under the bright green and blue plastic tents vendors sell everything from fabrics with stripes, paisley, and flowers to books in Chinese, Khmer, English, and French. Cracked green coconuts, tiny bananas, orange mangoes, and pink dragon fruit are on sale as are delicacies such as silver squid—their beady eyes watching their neighbors—and teams of brown tiger shrimp crawling in white plastic buckets. Indoors, where the temperature is usually ten degrees cooler, well-groomed girls in starched shirts and pleated skirts perch on tall stools behind glass stalls

displaying gold and silver jewelry. Their ears, necks, fingers, and hands are heavy with yellow twenty-four-carat gold jewels as they beckon you over to their counters. A couple of feet across from the women, behind yellow, featherless chickens hanging from hooks, men in bloody aprons raise their cleavers and cut into slabs of beef with the precision of many years' practice. Farther away from the meat vendors, fashionable youths with thin Elvis Presley sideburns in bell-bottom pants and corduroy jackets play loud Cambodian pop music from their eight-track tape players. The songs and the shouting vendors bounce off of each other, all vying for your attention.

Lately, Ma has stopped taking me to the market with her. But I still wake up early to watch as she sets her hair in hot rollers and applies her makeup. I plead with her to take me, as she slips into her blue silk shirt and maroon sarong. I beg her to buy me cookies while she puts on her gold necklace, ruby earrings, and bracelets. After dabbing perfume around her neck, Ma yells to our maid to look after me and leaves for the market.

Because we do not have a refrigerator, Ma shops every morning. Ma likes it this way because everything we eat each day is at its freshest. The pork, beef, and chicken she brings back is put in a trunk-sized cooler filled with blocks of ice bought from the ice shop down the street. When she returns hot and fatigued from a day of shopping, the first thing she does, following Chinese culture, is to take off her sandals and leave them at the door. She then stands in her bare feet on the ceramic tile floor and breathes a sigh of relief as the coolness of the tile flows through the soles of her feet.

At night, I like to sit out on our balcony with Pa and watch the world below us pass by. From our balcony, most of Phnom Penh looms only two or three stories high, with few buildings standing as tall as eight. The buildings are narrow, closely built, as the city's perimeter is longer than it is wide, stretching two miles along the Tonle Sap River. The city owes its ultramodern look to the French colonial buildings that are juxtaposed with the dingy, soot-covered ground-level houses.

In the dark, the world is quiet and unhurried as streetlights flicker on and off. Restaurants close their doors and food carts disappear into side streets. Some cyclo drivers climb into their cyclo to sleep while

others continue to peddle around, looking for fares. Sometimes when I feel brave, I walk over to the edge of the railing and look down at the lights below. When I'm very brave, I climb onto the railing, holding on to the banister very tightly. With my whole body supported by the railing I dare myself to look at my toes as they hang at the edge of the world. As I look down at the cars and bicycles below, a tingling sensation rushes to my toes, making them feel as if a thousand little pins are gently pricking them. Sometimes, I just hang there against the railing, letting go of the banister altogether, stretching my arms up high above my head. My arms loose and flapping in the wind, I pretend that I am a dragon flying high above the city. The balcony is a special place because it's where Pa and I often have important conversations.

When I was small, much younger than I am now, Pa told me that in a certain Chinese dialect my name, Loung, translates into "dragon." He said that dragons are the animals of the gods, if not gods themselves. Dragons are very powerful and wise and can often see into the future. He also explained that, like in the movies, occasionally one or two bad dragons can come to earth and wreak havoc on the people, though most act as our protectors.

"When Kim was born I was out walking," Pa said a few nights ago. "All of a sudden, I looked up and saw these beautiful puffy white clouds moving toward me. It was as if they were following me. Then the clouds began to take the shape of a big, fierce-looking dragon. The dragon was twenty or thirty feet long, had four little legs, and wings that spread half its body length. Two curly horns grew out of its head and shot off in opposite directions. Its whiskers were five feet long and swayed gently back and forth as if doing a ribbon dance. Suddenly it swooped down next to me and stared at me with its eyes, which were as big as tires. 'You will have a son, a strong and healthy son who will grow up to do many wonderful things.' And that is how I heard of the news about Kim." Pa told me the dragon visited him many times, and each time it gave him messages about our births. So here I am, my hair dancing about like whiskers behind me, and my hands flapping like wings, flying above the world until Pa summons me away.

Ma says I ask too many questions. When I ask what Pa does at work, she tells me he is a military policeman. He has four stripes on his

uniform, which means he makes good money. Ma then said that someone once tried to kill him by putting a bomb in our trashcan when I was one or two years old. I have no memory of this and ask, "Why would someone want to kill him?" I asked her.

"When the planes started dropping bombs in the countryside, many people moved to Phnom Penh. Once here, they could not find work and they blamed the government. These people didn't know Pa, but they thought all officers were corrupt and bad. So they targeted all the high-ranking officers."

"What are bombs? Who's dropping them?"

"You'll have to ask Pa that," she replied.

Later that evening, out on the balcony, I asked Pa about the bombs dropping in the countryside. He told me that Cambodia is fighting a civil war, and that most Cambodians do not live in cities but in rural villages, farming their small plot of land. And bombs are metal balls dropped from airplanes. When they explode, the bombs make craters in the earth the size of small ponds. The bombs kill farming families, destroy their land, and drive them out of their homes. Now homeless and hungry, these people come to the city seeking shelter and help. Finding neither, they are angry and take it out on all officers in the government. His words made my head spin and my heart beat rapidly.

"Why are they dropping the bombs?" I asked him.

"Cambodia is fighting a war that I do not understand and that is enough of your questions," he said and became quiet.

The explosion from the bomb in our trashcan knocked down the walls of our kitchen, but luckily no one was hurt. The police never found out who put the bomb there. My heart is sick at the thought that someone actually tried to hurt Pa. If only these new people in the city could understand that Pa is a very nice man, someone who's always willing to help others, they would not want to hurt him.

Pa was born in 1931 in Tro Nuon, a small, rural village in the Kampong Cham province. By village standards, his family was well-to-do and Pa was given everything he needed. When he was twelve years old, his father died and his mother remarried. Pa's stepfather was often drunk and would physically abuse him. At eighteen, Pa left home and went to live in a Buddhist temple to get away from his violent home,

further his study, and eventually became a monk. He told me that during his life as a monk, wherever he walked he had to carry a broom and dustpan to sweep the path in front of him so as not to kill any living things by stepping on them. After leaving the monastic order to marry Ma, Pa joined the police force. He was so good he was promoted to the Cambodian Royal Secret Service under Prince Norodom Sihanouk. As an agent, Pa worked undercover and posed as a civilian to gather information for the government. He was very secretive about his work. Thinking he could fare better in the private sector, he eventually quit the force to go into business with friends. After Prince Sihanouk's government fell in 1970, he was conscripted into the new government of Lon Nol. Though promoted to a major by the Lon Nol government, Pa said he did not want to join but had to, or he would risk being persecuted, branded a traitor, and perhaps even killed.

"Why? Is it like this in other places?" I asked him.

"No," he says, stroking my hair. "You ask a lot of questions." Then the corner of his mouth turns upside down and his eyes leave my face. When he speaks again, his voice is weary and distant.

"In many countries, it's not that way," he says. "In a country called America it is not that way."

"Where is America?"

"It's a place far, far away from here, across many oceans."

"And in America, Pa, you would not be forced to join the army?"

"No, there two political parties run the country. One side is called the Democrats and the other the Republicans. During their fights, whichever side wins, the other side has to look for different jobs. For example, if the Democrats win, the Republicans lose their jobs and often have to go elsewhere to find new jobs. It is not this way in Cambodia now. If the Republicans lost their fights in Cambodia, they would all have to become Democrats or risk punishment."

Our conversation is interrupted when my oldest brother joins us on the balcony. Meng is eighteen and adores us younger children. Like Pa, he is very soft-spoken, gentle, and giving. Meng is a responsible, reliable type who was the valedictorian of his class. Pa just bought him a car, and it seems he uses it to drive his books around instead of girls. But Meng does have a girlfriend, and they are to be married when he

returns from France with his degree. He was to leave for France on April 14 to go college, but because the thirteenth was New Year's, Pa let him stay for the celebration.

While Meng is the brother we look up to, Khouy is the brother we fear. Khouy is sixteen and more interested in girls and karate than books. His motorcycle is more than a transportation vehicle; it is a girl magnet. He fancies himself extremely cool and suave, but I know that he is mean. In Cambodia, if the father is busy with work and the mother is busy with babies and shopping, the responsibility of disciplining and punishing the younger siblings often falls on the oldest child. In our family, because none of us fear Meng, this role falls to Khouy, who is not easily dissuaded by our charms or excuses. Even though he's never carried out his threat to hit us, we all fear him and always do what he says.

My oldest sister, Keav, is already beautiful at fourteen. Ma says she will have many men seeking her hand in marriage and can pick anyone she wants. However, Ma also says that Keav has the misfortune to like to gossip and argue too much. This trait is not considered ladylike. As Ma sets to work shaping Keav into a great lady, Pa has more serious worries. He wants to keep her safe. He knows that people are so discontent they are taking their anger out on the government officers' families. Many of his colleagues' daughters have been harassed on the streets or even kidnapped. Pa is so afraid something will happen to her that he has two military policemen follow her everywhere she goes.

Kim, whose name in Chinese means "gold," is my ten-year-old brother. Ma nicknamed him "the little monkey" because he is small, agile, and quick on his feet. He watches a lot of Chinese martial arts movies and annoys us with his imitations of the movies' monkey style. I used to think he was weird, but having met other girls with brothers his age, I realize that older brothers are all the same. Their whole purpose for being is to pick on you and provoke you.

Chou, my older sister by three years, is the complete opposite of me. Her name means "gem" in Chinese. At eight, she is quiet, shy, and obedient. Ma is always comparing us and asking why I cannot behave nicely like her. Unlike the rest of us, Chou takes after Pa and has unusually dark skin. My older brothers kid her about how she really

isn't one of us. They tease her about how Pa found her abandoned near our trashcan and adopted her out of pity.

I am next in line and at five, I am already as big as Chou. Most of my siblings regard me as being spoiled and a troublemaker, but Pa says I am really a diamond in the rough. Being a Buddhist, Pa believes in visions, energy fields, seeing people's aura, and things other people might view as superstitious. An aura is a color that your body exudes and tells the observer what kind of person you are; blue means happy, pink is loving, and black is mean. He says though most cannot see it, all people walk around in a bubble that emits a very clear color. Pa tells me that when I was born he saw a bright red aura surrounding me, which means I will be a passionate person. To that, Ma told him all babies are born red.

Geak is my younger sister who is three years old. In Chinese Geak means "jade," the most precious and loved of all gems to Asians. She is beautiful and everything she does is adorable, including the way she drools. The elders are always pinching her chubby cheeks, making them pink, which they say is a sign of great health. I think it is a sign of great pain. Despite this, she is a happy baby. I was the cranky one.

As Meng and Pa talk, I lean against the railing and look at the movie theater across the street from our apartment building. I go to a lot of movies and because of who Pa is, the theater owner lets us kids in for free. When Pa goes with us, he always insists we pay for our tickets. From our balcony I can see a big billboard over the theater portraying this week's movie. The billboard shows a large picture of a pretty young woman with wild, messy hair and tears streaming down her cheeks. Her hair, at a closer inspection, is actually many little writhing snakes. The background depicts villagers throwing stones at her as she runs away while trying to cover her head with a traditional Khmer scarf called a "kroma."

The street below me is quiet now, except for the sound of straw brooms sweeping the day's litter into small piles on side streets. Moments later, an old man and a young boy come by with a large wooden cart. While the man accepts a few sheets of riel from the storefront owner, the boy shovels the garbage onto the cart. After they are done, the old man and the boy pull the cart to the next pile of garbage.

Inside our apartment, Kim, Chou, Geak, and Ma sit watching television in the living room while Khouy and Keav do their homework. Being

a middle-class family means that we have a lot more money and posses-
sions than many others do. When my friends come over to play, they all
like our cuckoo clock. And while many people on our street do not have
a telephone, and though I am not allowed to use one, we have two.

In our living room, we have a very tall glass cabinet where Ma keeps
a lot of plates and little ornaments, but especially all the delicious, pretty
candies. When Ma is in the room, I often stand in front of the cabinet,
my palms pressing flat against the glass, drooling at the candies. I look at
her with pleading eyes, hoping she will feel bad and give me some.
Sometimes this works, but other times she chases me away with a swat
to the bottom, complains about my dirty handprints on her glass, and
says that I can't have the candies because they are for guests.

Aside from our money and possessions, middle-class families, from
what I can see, have a lot more leisure time. While Pa goes off to work
and we children to school every morning, Ma does not have too much
to do. We have a maid who comes to our house every day to do the
laundry, cooking, and cleaning. Unlike other children I don't have to do
any chores because our maid does them for us. However, I do work
hard because Pa makes us go to school all the time. Each morning as
Chou, Kim, and I walk to school together, we see many children not
much older than I am in the streets selling their mangoes, plastic flowers
made from colorful straws, and naked pink plastic Barbie dolls. Loyal to
my fellow kids, I always buy from the children and not the adults.

I begin my school day in a French class; in the afternoon, it's Chi-
nese; and in the evening, I am busy with my Khmer class. I do this six
days a week, and on Sunday, I have to do my homework. Pa tells us
every day that our number one priority is to go to school and learn to
speak many languages. He speaks fluent French and says that's how he's
able to succeed in his career. I love listening to Pa speak French to his
colleagues and that's why I like learning the language, even if the
teacher is mean and I don't like her. Every morning, she makes us stand
single file facing her. Holding our hands straight out, she inspects our
nails to see if they are clean, and if not, hits our hands with her pointing
stick. Sometimes she won't let me go to the bathroom until I ask per-
mission in French. "Madam, puis j'aller au toilet?" The other day she
threw a piece of chalk at me because I was falling asleep. The chalk hit

me on my nose and everyone laughed at me. I just wish she would teach us the language and not be so mean.

I don't enjoy going to school all the time so I occasionally skip school and stay at the playground all day, but I don't tell Pa. One thing I do like about school is the uniform I get to wear this year. My uniform consists of a white shirt with puffy, short sleeves and a short, blue pleated skirt. I think it is very pretty, though sometimes I worry that my skirt is too short. A few days ago, while I was playing hopscotch with my friends, a boy came over and tried to lift up my skirt. I was so angry that I pushed him really hard, harder than I thought I could. He fell, and I ran away, my knees weak. I think the boy is afraid of me now.

Most Sundays after we've finished all our homework, Pa rewards us by taking us swimming at the club. I love to swim, but I am not allowed in the deep end. The pool at the club is very big, so even in the shallow end there is plenty of room to play and splash water in Chou's face. After Ma helps me put on my bathing suit, which is a very short pink dress with the legs sewn in, she and Pa go to the second floor and have their lunch. With Keav keeping an eye on us, Pa and Ma wave from their table behind the glass window. This is the first time I saw a Barang.

"Chou, he is so big and white!" I stop splashing water long enough to whisper to her.

"He's a Barang. It means he's a white man." Chou says with a smirk, trying to show off her age.

I stare at the Barang as he walks onto the diving board. He is more than a foot taller than Pa, with very hairy long arms and legs. He has a long, angular face and a tall, thin nose like a hawk. His white skin is covered with small black, brown, and even red dots. He wears only underwear and a tan rubber cap on his head, which makes him look bald. He dives off the diving board, enter the water effortlessly, and creates very little splashing.

As we watch the Barang float on his back in the water, Keav chides Chou for giving me the wrong information. Dipping her freshly painted red toenails in and out of the water, she tells us "Barang" means he's French. Because the French have been in Cambodia so long, we call all white people "Barang," but they can be from many other countries, including America.

takeover

It is afternoon and I am playing hopscotch with my friends on the street in front of our apartment. Usually on a Thursday I would be in school, but for some reason Pa has kept us all home today. I stop playing when I hear the thunder of engines in the distance. Everyone suddenly stops what they are doing to watch the trucks roar into our city. Minutes later, the mud-covered old trucks heave and bounce as they pass slowly in front of our house. Green, gray, black, these cargo trucks sway back and forth on bald tires, spitting out dirt and engine smoke as they roll on. In the back of the trucks, men wearing faded black long pants and long-sleeve black shirts, with red sashes cinched tightly around their waists and red scarves tied around their foreheads, stand body to body. They raise their fists to the sky and cheer. Most look young and all are thin and dark-skinned, like the peasant workers at our uncle's farm, with greasy long hair flowing past their shoulders. Long, greasy hair is unacceptable for girls in Cambodia and is a sign that one does not take care of her appearance. Men with long hair are looked down upon and regarded with suspicion. It is believed that men who wear their hair long must have something to hide.

Despite their appearance, the crowd greets their arrival with clapping and cheering. And although all the men are filthy, the expression on their faces is of sheer elation. With long rifles in their arms or strapped across their backs, they smile, laugh, and wave back to the crowds the way the king does when he passes by.

"What's going on? Who are these people?" my friend asks me.

"I don't know. I'm going to find Pa. He will know."

I run up to my apartment to find Pa sitting on our balcony observing the excitement below. Climbing onto his lap I ask him, "Pa, who are those men and why is everybody cheering them?"

"They are soldiers and people are cheering because the war is over," he replies quietly.

"What do they want?"

"They want us," Pa says.

"For what?"

"They're not nice people. Look at their shoes—they wear sandals made from car tires." At five, I am oblivious to the events of war, yet I know Pa to be brilliant, and therefore he must be right. That he can tell what these soldiers are like merely by looking at their shoes tells me even more about his all-powerful knowledge.

"Pa, why the shoes? Why are they bad?"

"It shows that these people are destroyers of things."

I do not quite understand what Pa means. I only hope that someday I can be half as smart as he is.

"I don't understand."

"That's all right. Why don't you go and play; don't go far and stay out of people's way."

Feeling safer after my talk with Pa, I climb off his lap and make my way back downstairs. I always listen to Pa, but this time my curiosity takes over when I see that many more people have gathered in the street. People everywhere are cheering the arrival of these strange men. The barbers have stopped cutting hair and are standing outside with scissors still in their hands. Restaurant owners and patrons have come out of the restaurants to watch and cheer. Along the side streets, groups of boys and girls, some on foot, some on motorcycles yell and honk their horns as others run up to the trucks, slapping and touching the

soldiers' hands. On our block, children jump up and down and wave their arms in the air to greet these strange men. Excited, I cheer and wave at the soldiers even though I don't know why.

Only after the trucks have passed through my street and the people quiet down do I go home. When I get there, I am confused to find my whole family packing.

"What's going on? Where's everybody going?"

"Where have you been? We have to leave the house soon, so hurry, go and eat your lunch!" Ma is running in every direction as she continues to pack up our house. She scurries from the bedroom to the living room, taking pictures of our family and the Buddha off the walls and piles them into her arms.

"I'm not hungry."

"Don't argue with me, just go and eat something. It's going to be a long trip."

I sense that Ma's patience is thin today and decide not to press my luck. I sneak into the kitchen prepared not to eat anything. I can always sneak my food out and hide it somewhere until it is found later by one of our helpers. The only thing I am afraid of is my brother Khouy. Sometimes, he waits for me in the kitchen to make me eat proper food—or else. Heading to the kitchen, I poke my head into my bedroom and spy Keav shoving clothes into a brown plastic bag. On the bed, Geak sits quietly playing with a handheld mirror while Chou throws our brushes, combs, and hairpins into her school bag.

As quiet as I can be, I tiptoe into the kitchen and sure enough, there he is. He is feeding himself with his right hand while his left gently touches a slim bamboo stick lying on the kitchen table. Next to the bamboo stick is a bowl of rice and some salted eggs. Most evenings, the younger kids in the house will gather in the kitchen to study Chinese, and a tutor uses the bamboo stick to point out characters on the blackboard. In the hands of my brother, it is used to educate us about something else entirely. I was taught to fear what my brother will do with it if I do not do as I am told.

I give Khouy my most charming smile, but this time it does not work. He sternly tells me to wash up and eat. In moments like these I fantasize about how much I hate him. I cannot wait until I am as strong

and as big as he is. Then I will take him on and teach him many lessons. But for now, since I am the smaller one, I have to listen to him. I whine and sigh with every bite of food. Every time he looks elsewhere I stick out my tongue and make faces at him.

After a few minutes, Ma rushes into the kitchen and begins to toss aluminum bowls, plates, spoons, forks, and knives into a big pot. The silverware clangs noisily, making me jittery. Then picking up a cloth bag, she throws bags of sugar, salt, dried fish, uncooked rice, and canned foods into it. In the bathroom, Kim throws soap, shampoo, towels, and other assorted items into a pillowcase.

"Aren't you finished yet?" she asks me, out of breath.

"No."

"Well, you better go wash your hands and get into the truck anyway."

Glad to escape from Khouy, who sits glaring at me, I hurriedly jump off my chair and head for the bathroom.

"Ma, where are we going in such a hurry?" I yell out to her from the bathroom as Kim leaves with his bag.

"You'd better hurry and change your shirt, the one you are wearing is dirty. Then go downstairs and get into the truck," Ma tells me as she turns away without answering. I believe it is because of my age that no one ever pays any attention to me. It is always so frustrating to have your questions unanswered time and time again. Fearing more threats from Khouy, I walk to my bedroom.

The bedroom looks as if a monsoon has passed through it: clothes, barrettes, shoes, socks, belts, and scarves are strewn everywhere—on the bed that Chou and I share as well as on Keav's bed. Quickly, I change out of my brown jumper and into a yellow short-sleeve shirt and blue shorts I pick up off the floor. Once finished, I walk downstairs to where our car is. Our Mazda is black, sleek, and much more comfortable than riding in the back of our truck. Riding in the Mazda sets us apart from the rest of the population. Along with our other material possessions, our Mazda tells everybody we are from the middle class. Despite what Ma tells me, I decided to head toward our car. I begin to climb into the Mazda when I hear Kim call out to me.

"Don't get in there. Pa said we're leaving the Mazda behind."

"Why? I like it more than the truck."

Again, Kim is gone before answering my question. Pa bought the truck to use for deliveries for the import/export business he had briefly gone into with friends. The business never got going, so the truck has been sitting in our back alley for many months. The old pickup truck creaks and squeaks as Khouy throws a cloth bag onto its floor. In front, Pa ties a large white cloth to the antenna while Meng ties another piece to the side mirrors. Without any words, Khouy picks me up and loads me onto the back of the truck filled with bags of clothes and pots and pans and food. The rest of my siblings climb on board and we drive off.

The streets of Phnom Penh are noisier than ever. Meng, Keav, Kim, Chou, and I sit in the back of the truck while Pa drives with Ma and Geak in the cab. Khouy follows us slowly on his motorcycle. From up on our truck, we hear the booming roars of cars, trucks, and motorcycles, the jarring rings of the cyclos' bells, the clanking of pots and pans banging against each other, and the cries of people all around us. We are not the only family leaving the city. People pour out of their homes and into the streets, moving very slowly out of Phnom Penh. Like us, some are lucky and ride away in some kind of vehicle; however, many leave on foot, their sandals flapping against the soles of their feet with every step.

Our truck inches on in the streets, allowing us a safe view of the scene. Everywhere, people scream their good-byes to those who choose to stay behind; tears pour from their eyes. Little children cry for their mothers, snot dripping from their noses into their open mouths. Farmers harshly whip their cows and oxen to pull the wagons faster. Women and men carry their belongings in cloth bags on their backs and their heads. They walk with short, brisk steps, yelling for their kids to stay together, to hold each other's hands, to not get left behind. I squeeze my body closer to Keav as the world moves in hurried confusion from the city.

The soldiers are everywhere. There are so many of them around, yelling into their bullhorns, no longer smiling as I saw them before. Now they shout loud, angry words at us while cradling rifles in their arms. They holler for the people to close their shops, to gather all guns and weapons, to surrender the weapons to them. They scream at families

to move faster, to get out of the way, to not talk back. I bury my face into Keav's chest, my arms tight around her waist, stifling a cry. Chou sits silently on the other side of Keav, her eyes shut. Beside us, Kim and Meng sit stone-faced, watching the commotion below.

"Keav, why are the soldiers so mean to us?" I ask, clinging even more tightly to her.

"Shhh. They are called Khmer Rouge. They are the Communists."

"What is a Communist?"

"Well, it means. . . . It's hard to explain. Ask Pa later," she whispers.

Keav tells me the soldiers claim to love Cambodia and its people very much. I wonder then why they are this mean if they love us so much. I cheered for them earlier today, but now I am afraid of them.

"Take as little as you can! You will not need your city belongings! You will be able to return in three days! No one can stay here! The city must be clean and empty! The U. S. will bomb the city! The U. S. will bomb the city! Leave and stay in the country for a few days! Leave now!" The soldiers blast these messages repeatedly. I clap my hands over my ears and I hide my face against Keav's chest, feeling her arms tighten around my small body. The soldiers wave their guns above their heads and fire shots into the air to make sure we all understand their threats are real. After each round of rifle fire, people push and shove one another in a panicked frenzy trying to evacuate the city. I am riddled with fear, but I am lucky my family has a truck in which we can all ride safely away from the panicked crowds.

evacuation

After many hours, we are finally out of the city and on the road, though still moving very slowly.

"Where are we going?" I ask Kim repeatedly, after it seems like we have been traveling forever.

"I don't know, we just passed the Po Chentong airport, which means we are on Highway Four. Stop asking me all the time."

I burrow under my scarf to hide from the sun and resign myself to sulking.

My body sags and I begin to grow tired. My eyelids struggle to stay open against the glaring sunlight and the dust from the road. The wind whips my hair all about, tickling my face, but I do not smile. I wince as the hot, dry air enters my nostrils. Keav wraps the end of my scarf tightly over my nose and mouth to keep the dust out, and she tells me not to look over the side of the truck.

In Cambodia we have only two seasons, dry and rain. Cambodia's tropical climate is dictated by the monsoons, which bring heavy rain from May to October. Keav says during the rainy season, the country is a green paradise. She says there's so much water that the trees grow very tall and the leaves swell with moisture. They take on a dark, metallic

green color, looking as if they will burst like a water balloon. Before the monsoons hit in May, we have to endure April, our hottest month, with temperatures often reaching 110 degrees—so hot that even the children stay indoors to avoid the sun. It's this hot now.

As we move farther and farther away from the city, the high-rise apartments disappear and thatched-roof huts take their place. The buildings in the city are tall and close together, but the huts are low-lying and widely dispersed in the middle of the rice fields. As our truck moves slowly in the crowd of people, the wide, paved boulevard gives way to windy, dusty roads that are no more than wagon trails. Tall elephant grass and prickly, brown brush have replaced Phnom Penh's blooming flowers and tall trees. A queasy feeling grips me as I watch the villages pass by. As far as the eye can see, there are people marching in the road while huts stand empty and rice fields are left unattended.

I fall asleep and dream that I am still at home, still playing hopscotch with my friends. When I wake we are parked near an empty hut to rest for the night. We are in a world very different from Phnom Penh, yet we have traveled only ten miles or so. The sun has gone down, relieving us of its burning rays. All around us, the field lights up with small fires illuminating the faces of women squatting by them to prepare meals. I can still make out thousands of people milling around or walking to unknown destinations. Others, like us, have stopped to rest for the night along the roadside.

My family scrambles to set up our encampment in the field near an abandoned hut. My brothers gather wood to build a fire, while Ma and Keav prepare our meal. Chou is brushing Geak's hair, being careful not to pull it. When everything is set up, we gather around the fire and eat a dinner of rice and salted pork that Ma cooked earlier in the day. There are no tables or chairs for us to sit on. While we kids make do with squatting, my parents sit on a little straw mat that Ma has packed.

"I have to go to the toilet," I tell Ma urgently after dinner.

"You have to go in the woods."

"But where?"

"Anywhere you can find. Wait, I'll get you some toilet paper." Ma

goes away and comes back with a bunch of paper sheets in her hand. My eyes widen in disbelief, "Ma! It's money. I can't use money!"

"Use it, it is of no use to us anymore," she replies, pushing the crisp sheets into my hand. I don't understand this. I know that we must be in really big trouble. I know this is no time to argue, so I grab the money and head off to the woods.

After I finish, Chou and I decide to explore the area. As we walk, we hear leaves rustling in the bushes nearby. Our bodies tense, we clasp each other's hands, holding our breath, but then a small feline silhouette saunters lazily out of the bushes, looking for food. The owners must have forgotten it in their hurry to leave.

"Chou, I wonder what happened to our cats."

"Don't worry about them."

We had five cats in Phnom Penh. Even though we say they were our cats, we had no real claim to them. We didn't even have names for them. They came to our house when they were hungry and left when they were bored.

"Well, somebody is probably having them for dinner by now," Kim teases us when we ask him. We all laugh and scold him for saying such a thing. Cambodians do not generally eat cats and dogs. There are specialty stores where they sell dog meat but at a very expensive price. It is a delicacy. The elders say that eating dog meat increases body heat, thus increasing energy, but you shouldn't eat too much of it or your body will burn up and combust.

That night, Ma tucks me in on the back of the truck. While Chou, Geak and I sleep with her on the truck, the older kids sleep on the ground with Pa. It is a warm and breezy night, the kind that requires no blankets. I love sleeping outside with the stars. My imagination is captured by the bright shining light, but I don't understand the vastness of the sky. Every time I try to wrap my mind around the concept of the universe, my mind spins as if caught in a whirlpool of information I will never be able to understand.

"Chou, the sky is so big!"

"Shhh. I am trying to sleep."

"Look at the stars. They are so beautiful and they are winking at us. I wish I was up there with them and the angels."

"That's nice, now go to sleep."

"You know the stars are candles in the sky. Every evening, the angels come out and light them for us, so if we lose our way, we can still see."

Pa has told me in the past that I am blessed with a gifted imagination and he likes the stories I tell.

When I awaken in the morning, my siblings are already up. They were awakened by gunshots fired into the distant sky by the Khmer Rouge, but I was so tired I slept through it. My siblings all have gray pouches under their eyes; their hair is knotted and sticking out in many directions. Slowly, I sit up and stretch out my sore shoulders and back. Sleeping in the truck is not as much fun as I thought it would be. Before long, a group of Khmer Rouge soldiers come by and yell at us to keep moving.

After a small breakfast of rice and salted eggs, we get back in our truck and take off again. We drive for many hours and everywhere we go we see people walking in all directions. The sun is high and hot on our backs. It burns through my black hair as little beads of water collect around my hairline and on the curve of my upper lip. After a while, we all get on each other's nerves and start to fight.

"It's not much farther, kids. We're almost there," Pa tells us when we stop to have our lunch. "Soon we will be where it is safe."

As Ma and Keav prepare our meal, Pa and Meng disappear to gather firewood. When they return, Pa tells Khouy that it is a good thing that we got out of the city as quickly as we did. He says the people he just talked to told him that the soldiers made everyone leave the city. They emptied schools, restaurants, and hospitals. The soldiers even forced the sick to leave. They were not allowed to go home first to their families so many people are separated.

"Many old and sick people did not make it today," Khouy offers grimly. "I saw them on the side of the streets still in their bloody hospital robes. Some were walking and others were pushed in carts or hospital beds by their relatives."

Now I understand why Keav kept wrapping the scarf around my head, telling me to keep my head down, to not peer above the truck's sides.

"The soldiers walked around the neighborhood, knocking on all the doors, telling people to leave. Those who refused were shot dead right on their doorsteps." Pa shakes his head.

"Why are they doing this, Pa?" Kim asks.

"Because they are destroyers of things."

Chou and Kim look at each other and I sit there feeling lost and afraid.

"I don't understand. What does all this mean?" I ask them. They look at me but say nothing. Yesterday I was playing hopscotch with my friends. Today we are running from soldiers with guns.

After a quick lunch of rice with salted fish, we climb in the truck and move again. I watch as a stream of people seems to follow our trail. Fighting drowsiness caused by the smothering heat, my thoughts race from one subject to another. I question why we had to leave, where we are going, and when will we return home. I do not understand what is happening and long to go back home. The sudden sputtering and choking of our truck halt my daydreaming. It kicks and whines, and finally stops. I climb off hoping it will move again.

"The truck's out of petrol and there's no petrol station around here," Pa says. "Looks like we have to walk the rest of the way. Everybody grab only some clothes and all the food you can carry. We have a long way to go yet." Pa then orders us what to take and what to leave behind.

"You!" someone yells. We all stop what we are doing and stand paralyzed.

"You!" A Khmer Rouge soldier comes over to us. "Give me your watches."

"Certainly." With shoulders bent to show submission, Pa takes the watches off of Meng and Khouy's wrists. Pa does not look the soldier in the eyes as he hands the watches over.

"All right, now move," the soldier orders and then walks away. When he is out of earshot, Pa whispers that from now on we are to give the soldiers anything they want or they will shoot us.

We walk from the break of day until the dark of the evening. When night comes, we rest by the roadside near a temple. We unpack the dried fish and rice and eat in silence. Gone is the air of mystery and excitement; now I am simply afraid.

seven-day walk

The first sight I see when I open up my eyes the next morning is the glum upside-down face of Chou against the background of cloudy skies as she tugs at my hair. "Wake up. We have to move again," she tells me.

Slowly I sit up and rub the seeds out of my sleepy eyes. All around me, a sea of people wake: babies cry, old people groan, pots and pans clang against the sides of wagons whose wheels grind the dirt beneath them. There are many more people than the numbers I know to count them with. My eyes follow Khouy and Meng as they walk into the temple with big silver pots to fetch water. Keav says there is always a well near a temple. Moments later, Khouy and Meng return visibly shaken with their empty pots.

"We went into the temple but found no monks there, only a Khmer Rouge soldier," they tell Pa. "They yelled for us to stay away from the temple well. We stopped and came back but other people went in anyway—" Khouy's words are interrupted by the sound of gunshots coming from inside the temple. Hurriedly, we pack our belongings and leave the area. Later on we hear the Khmer Rouge soldiers had killed two people inside the temple and wounded many more.

Today, our third day on the road, I walk with a little more bounce in my step. In Phnom Penh, the soldiers had said we could return home after three days. The soldiers told us we had to leave because the United States was going to bomb our city. But I have not seen any planes in the sky and have heard no bombs dropped. It is strange to me that they made us leave just so we can turn back and go home after three days. I smile at the silly picture of us marching like black ants coming to a stop at the end of the day only to head back home. I do not understand, but I guess three days is how long it takes for them to clean the city.

"Pa, will we go home soon? The soldiers said we can return home after three days." I tug at Pa's pants. It is afternoon and we are not even slowing down yet.

"Maybe, but meanwhile, we have to walk."

"But Pa, this is the third day. Are we going to turn around and walk back home now?"

"No, we have to keep walking," Pa says sadly. Reluctantly, I do what Pa tells me. Everybody has to carry something, so I pick the smallest item in the pile, the rice pot. As I walk, the pot becomes heavier and heavier in my hands as the sun climbs higher and higher in the sky. The metal handle digs and burns the palms of my hands. Sometimes I carry it with two hands in front of me, other times I switch the pot from my right to my left arm, but it seems no matter how I carry it the pot painfully bangs into some part of my leg. It is evening now and I am losing hope that we can go home tonight. Tired and hungry, I drag my feet, taking smaller and smaller steps until I am far behind everyone else.

"Pa, I'm very hungry and my feet hurt," I yell to him.

"You can't eat now. We have very little food left and we need to ration it because we have a long way to go."

"I don't know why we have to save it!" I stand still in the road, letting go of the rice pot to wipe dirt and tears from my cheeks. "Our three days will soon be over. We can return home. Let's just go home. I want to go home." The words somehow come out between halting sobs. My forty-pound body refuses to walk any more. The red dust from the road and the sweat on my body has mixed to create a layer of mud on my skin making it dry and itchy. Pa walks over to Keav and takes a ball of sticky rice out of the pot she is carrying. He comes over to me and hands me the food. My

eyes look down at the ground in shame, but I take the food from him anyway. Silently, he strokes my hair while I eat my rice between choking sobs. Bending down, Pa looks me in my eyes and says softly, "They lie, the soldiers lie. We cannot go home tonight." His words make me sob harder.

"But they said three days."

"I know. I'm sorry you believed them, but they lied."

"I don't understand why they lied," my voice quivers as I say it.

"I don't know either, but they lied to us." My hopes crushed, I wipe my forearm across my nose, dragging snot all over my cheek. Pa gently cleans my face with his hand, then takes the rice pot from me and says I only have to carry myself for the rest of the trip.

With Geak on her hip, Ma walks over to me and wraps my scarf around my head to protect me from the sun. I wish that I were a little baby like Geak. She doesn't have to walk at all. Ma carries her in her arms all the way. I am miserable, but at least I have shoes. Some of the people walk barefoot in the scorching heat, carrying their life's belongings on their backs or heads. I feel sorry for them knowing they are worse off than I am. And no matter how far we go, there are always more people along the way. When night falls, once again we make the road our home and sleep, along with the hundreds of thousands of other families fleeing Phnom Penh.

Our fourth day on the road starts the same as the all the other days. "Are we there yet?" I keep asking Kim. When I receive no attention, I proceed to sniff and cry.

"Nobody cares about me!" I moan and keep walking anyway.

By noontime we have reached the Khmer Rouge's military checkpoint in the town of Kom Baul. The checkpoint consists of no more than a few small makeshift tents with trucks parked beside them. There are many soldiers at this base, and it is easy to recognize them because they wear identical loose-fitting black pajama pants and shirts. All carry identical guns slung across their backs. They move quickly from place to place with fingers on the triggers of their weapons, pacing back and forth in front of the crowd, yelling instructions into a bullhorn.

"This is Kom Baul base! You are not allowed to pass until we have cleared you! Stand with your family in a line! Our comrade soldiers will come and ask a few simple questions! You are to answer them truthfully

and not lie to the Angkar! If you lie to the Angkar, we will find out! The Angkar is all-knowing and has eyes and ears everywhere." This is the first time I hear the word "Angkar," which means "the organization." Pa says the Angkar is the new government of Cambodia. He tells us that in the past, Prince Sihanouk ruled Cambodia as a monarch. Then in 1970, unhappy with the Prince's government, General Lon Nol, deposed him in a military coup. The Lon Nol democratic government has been fighting a civil war with the Communist Khmer Rouge ever since. Now the Khmer Rouge has won the war and its government is called "the Angkar."

"To your right, you see a table where your comrade brothers sit waiting to help you. Anyone who has worked for the deposed government, ex-soldiers or politicians, step up to the table to register for work. The Angkar needs you right away." Anxiety spreads through my body at the sight of the Khmer Rouge soldiers. I feel like I have to vomit.

Pa quickly gathers our family and stands us in line with other peasant families. "Remember, we are a family of peasants. Give them whatever they want and don't argue. Don't say anything, let me do all the talking, don't go anywhere, and don't make any moves unless I tell you to do so," Pa instructs us firmly.

Standing in line wedged among many people, my nostrils are assaulted by the stale smell of bodies that have not been washed for many days. To filter the smell, I pull the scarf tightly over my nose and mouth. In front of us, the line splits in two as a large group of ex-soldiers, government workers, and former politicians walk over to the table to register for work. My heart pounds quickly against my chest, but I say nothing and lean against Pa's legs. He reaches down and puts his hand on top of my head. It stays there as if protecting me from the sun and the soldiers. After a few minutes, my head feels cooler and my heartbeat slows.

Ahead of us in the line, Khmer Rouge soldiers yell something to the crowd, but I cannot hear what they say. Then one Khmer Rouge soldier roughly jerks a bag off of one man's shoulder and dumps its contents on the ground. From this pile, a Khmer Rouge soldier picks up an old Lon Nol army uniform. The Khmer Rouge soldier sneers at the man and pushes him to another Khmer Rouge soldier standing beside him. The soldier then moves on to the next family. Eyes downcast, shoulders

slumped, arms hanging loosely on both sides of him, the man with the Lon Nol uniform in his bag does not fight as another Khmer Rouge soldier points and pushes him away with the butt of his rifle.

After many hours, it is finally our time to be questioned. I can tell we've been standing here a long time because the sun now warms my lower back instead of the top of my head. As a Khmer Rouge soldier approaches us, my stomach twists into tight knots. I lean closer to Pa and reach up for his hand. Pa's hand is much too big for mine, so I am only able to wrap my fingers around his index finger.

"What do you do?" the soldier curtly asks Pa.

"I work as a packer in the shipping port."

"What do you do?" The soldier points his finger at Ma. Her eyes focus on the ground, and she shifts Geak's weight on her hips. "I sell old clothes in the market," she says in a barely audible voice.

The soldier rummages through all our bags one by one. Then he bends down and lifts the lid of the rice pot next to Pa's feet. Gripping Pa's finger even tighter, my heart races as the soldier checks the pot. His face is close to mine; I concentrate on my dirty toes. I dare not look into his eyes, for I have been told that when you look into their eyes, you can see the devil himself.

"All right, you are cleared. You may go."

"Thank you, comrade," Pa says meekly, his head bobbing up and down to the soldier. The soldier is already looking past Pa and merely waves his hand for us to hurry on. Passing the checkpoint safely, we walk a few hours more until the sun goes to sleep behind the mountains and the world becomes a place of shadows and shapes once again. In the mass of people, Pa finds us a spot of unoccupied grass near the side of the road. Ma puts Geak down next to me and tells me to keep an eye on her. Sitting next to her, I am struck by how pale she looks. Breathing quietly, she fights to keep her eyelids open, but in the end she loses and falls to sleep. Her growling stomach talks as mine grumbles in return. Knowing there will be nothing to eat for a while, I lie down on a small bundle of clothes next to her and rest my head on another. Quickly, I too fall asleep.

When I wake, I am sitting upright on the straw mat and Keav is pushing food into my mouth. "Eat this," she says. "Rice balls with wild

mushrooms. Khouy and Meng picked the mushrooms in the woods." With my eyes still closed, the rice ball works itself slowly down my dry throat and quiets my hunger. After I finish my small portion, I lie back down and leave the world of the Khmer Rouge soldiers behind.

In the middle of the night I dream I am at a New Year's parade. The Cambodian Lunar New Year this year falls on the thirteenth of April. Traditionally, for three days and nights, we celebrate the New Year with parades, food, and music. In my dream, fireworks crackle and boom noisily, rejoicing in the New Year celebration. There are many varieties of food on the table: red cookies, red candies, red roasted pigs, and red noodles. Everything is red. I'm even wearing a new red dress that Ma has made for this special occasion. In the Chinese culture it is not proper for girls to wear this color because it attracts too much attention. Only girls who want attention wear red and they are generally viewed as "bad" and "improper," more than likely from a bad family. But New Year's is a special occasion and during the celebration everyone is allowed to wear red. Chou is next to me clapping her hands at something. Geak is giggling and trying to catch up with me as I run and spin around and around. We all have on the same dress. We look so pretty with red ribbons in our ponytails, red rouge on our cheeks, and red lipstick on our lips. My sisters and I hold hands, laughing as fireworks boom in the background.

I wake up the next morning to the voices of my brothers and father whispering to each other about what went on in the night.

"Pa," Meng says in a frightened voice, "a man told me the noise last night was the Khmer Rouge soldiers opening fire on all the people who registered for work. They killed every one of them." Their words push at my temples, making my head throb with fear.

"Don't say anything. If the soldiers hear us we will be in danger."

Hearing this makes me afraid and I walk over to Pa. "We've been walking and walking for five days now. When can we go home?"

"Don't talk anymore," he whispers and hands me over to Keav. Keav takes my hand and leads me to the woods so I can go to the bathroom. We have only taken a few steps when Khouy stops us.

"Turn and walk back! Don't go any farther!" He yells.

"She has to go."

"There's a dead body in the tall grass only a few feet from where you are. That's why this spot was left empty last night."

I grip Keav's hand tighter and suddenly notice the smell that hits my nostrils. It is not the smell of rotten grass or my own body odor but a smell so putrid that my stomach coils. A smell similar to that of rotten chicken innards left out in the hot sun for too many days. Everything surrounding me becomes blurry and I do not hear Keav telling me to move my legs. I hear only the buzzing of flies feasting on the human corpse. I feel Keav's hand pull at me, and my feet automatically move in her direction. With my hand in hers, we catch up with the rest of the family and begin our sixth day of marching.

On our walk, the soldiers are everywhere, prodding us along. They point and give us directions with their guns and bullhorns. In the scorching April heat, many older people become ill from heatstroke and dehydration, but they dare not rest. When someone falls ill, the family throws out his belongings, puts the sick person on someone's back or a wagon if the family is lucky enough to have one, and march on. We walk all through the morning and afternoon, stopping for food and to rest only when the sun goes down.

All around us, other families also have stopped to rest for the night. Some stagger into the field, picking up firewood to cook their meals. Others eat what they cooked earlier and fall asleep as soon as they lie down. We walk around the curled up bodies to find an empty area of our own. Exhausted, Ma and Keav struggle to set up our resting spot and start a fire. From one of the plastic bags we carry our remaining belongings in, Keav takes out a bedsheet and spreads it on the ground. Ma unrolls the straw mat and lines it up next to the bed-sheets. While I sit with Geak on small bundles, rubbing my burned and aching ankles, Chou and Kim move our other bags onto the bed-sheet. Holding her hand, I attempt to lead Geak to sit on the sheets, but she pulls out of my hand and toddles over to Pa. He picks her up and holds her to his chest. Her face, brown and blistered from the sun, rests at the nape of his neck as his body swivels left and right. Before long, she is asleep.

Our food supply is reduced to only a few pounds of rice so Meng, Khouy, and Kim have to forage for other food to supplement the rice.

They walk half a mile to the nearby town of Ang Snur and return an hour later. Their figures move toward us slowly; Kim carries an armful of dry wood and in Meng's hand is a small branch piercing two small fish and some wild vegetables. Khouy walks toward us with a small pot and an ecstatic grin on his face.

"Ma, look!" he calls to her, barely able to contain his glee. "Sugar!"

"Brown sugar!" Ma exclaims, taking the pot away from him. Though I am tired, those two words bring me running in the direction of the pot.

"Brown sugar!" I repeat quietly. I never knew how two little words could bring me so much happiness. "Ma, let me have a taste! There's almost a quarter of a pot of it!"

"Shh. Don't say it so loud," Keav warns me, "or people will come and beg us for some." I notice a few of our neighbors look in our direction.

"Here everyone, have a small taste. We have to save some," Ma says as we gather around her. My siblings stick their fingers into the sugar and lick what they are able to pull out.

"Me . . . me . . . me . . ." I beg Ma as she slowly lowers the pot to my level. I know it is my one chance to get as much sugar as I can, so I wait a few seconds to form enough spit in my mouth. Then I put my finger in my mouth and swish the spit around my finger to make sure I wet every millimeter of my finger. When I am satisfied that my finger is wet enough, I take it out of my mouth and slowly roll it around on top of the sugar. My finger rolls so slowly that I can feel the rough grains bonding to it. When I pull it out of the pot, I am happy to see what I have achieved. I have more sugar on my one finger than anyone else does! Carefully, I place my other hand under my treasure to catch any grains that might fall from my finger. Slowly, I walk my finger back to my spot on the mat and begin to eat each grain of the sugar.

After dinner, Ma takes us girls to a nearby pond, which is already crowded with people washing their clothes and naked children, tentatively putting their heads under the muddy water. The children all look too tired to bop up and down, laugh, or splash at one another. Ma instructs us to strip off our clothes. I remove my brown shirt, a shirt that was yellow when I hurriedly dressed six days ago. Naked, Chou, Geak, and I wait while Ma removes her clothes from under her

sarong and hands them over to Keav. With no soap, Keav takes the clothes to the edge of the river and scrubs them against the rocks to get them clean.

With Geak balanced on one of her hips, Ma takes my hand and walks Chou and I into the pond for our first wash in six days. Hand in hand, we stop when the water reaches my waist. The water feels cool and soft on my skin, slowly peeling away the layers of grime that has collected. The slippery grass in the water sways back and forth to the rhythm of our movements, gently brushing against my legs. Some of the blades slither around my ankles, sending chills up and down my spine. I jump and fall into the water, pulling Chou with me, who is still holding on tight to Ma's hand. When I resurface, they are all laughing at me. I am happy to have all of us laughing together again.

In the morning, Ma wakes everyone and we get ready for our seventh day of walking. The road ahead of us shimmers in the heat, and the dust swells are everywhere, burning my eyes. In the distance, my eyes focus on a lone bicyclist. I cannot tell how tall he is, only that he is very thin. It is strange that he is traveling against the flow of traffic. All of a sudden, I am startled by Ma's scream. Between loud, halting sobs Ma manages to say, "It's your uncle Leang!"

With our hands in the air and bodies jumping up and down, we wave excitedly to our uncle. Uncle Leang waves one hand back and peddles his bike faster in our direction. He comes to a stop a few feet from us, and all at once we rush toward him. Blinking his eyes, he takes Ma into his arms with Pa standing quietly beside them. All the worries and fears of the past few days are now over, for at last he has found his sister. Uncle Leang hands Ma a package from his front bike rack, and while she opens the cans of tuna and other food he tells Pa that this morning other people from Phnom Penh arrived in his village. The new arrivals told him of the evacuation and how the Khmer Rouge forced everyone to leave all the cities, including Phnom Penh, Battambang, and Siem Reap. Hearing this, he got on his bike and has been looking for us all morning. He then shares with us the glorious news that Ma's oldest brother Heang is on his way to pick us up in a wagon. A smile of joy crosses over my face, knowing I will not have to walk anymore and that in a few days we can ride in their wagon home.

Standing next to Uncle Leang, I have to tilt my head back as far as I can to see his face because he is so tall. Even then all I can see is the shape of his thin lips and wide, black nostrils that flare once every few seconds as he talks to Ma. At almost six feet tall, second Uncle Kim Leang hovers above all of us. His long thin arms and legs make him look like the stick figures I used to draw on my schoolbooks. Uncle Leang lives in a village called Krang Truop. Both Uncle Leang and Uncle Heang have lived in the countryside since before the revolution and have never lived in a city. The Khmer Rouge considers them uncorrupted model citizens for their new society. Pa says we will go and live with our uncles in their village.

The wagon, pulled by two yellow skinny cows moving very slowly, arrives later that evening. While Pa and Ma talk to my uncle, I quickly claim a seat in the wagon with Chou and Geak. Our trail takes us on a gravel road along Route 26 westward until we reach the Khmer Rouge–occupied village of Bat Deng. No matter where we go or in which direction we turn, there are people marching ahead and behind us. In the midst of the crowd, our wagon passes the Khmer Rouge village without stopping. We veer westward, leaving our roadside companions far behind. Somewhere between Bat Deng and Krang Truop, I fall asleep.

krang truop

On the morning of April 25, eight days after leaving our wonderful home in Phnom Penh, we arrive at our destination. Krang Truop is a small and dusty village surrounded by rice fields as far as the eye can see. All around the rice paddies, little red-dirt roads wind like snakes slithering through water. In the fields, gray buffalos and brown cows graze lazily on the grass. Many have bells tied on strings around their necks, which chime when the animals slowly move their heads. When they run, they remind me of the sound of the ice cream cart in Phnom Penh. Here, instead of concrete city buildings and houses, people live in huts made out of straw that squat on four stilts above elephant grass in the middle of rice paddies.

"The kids are even messier than I am!" I exclaim, as one runs across our path, oblivious to my own ragtag appearance. "Ma's always complaining about me—just look at them." The children are red and dusty all over, crimson earth clinging to their clothing, skin, and hair.

Chou frowns at me and shakes her head. Though she is only three years older than I am, Chou often acts as if she knows many more things than I do. I have the larger build and can beat her up easily, though I rarely do it. Because she is shy, quiet, obedient, and doesn't say

much, all our older siblings assume what she chooses to say is of some importance and usually take her side in our fights. Because I am loud and talkative, my words are thought trite and silly. Chou looks at me now with her brows wrinkling close together, as if trying to figure out my thoughts. I stick my tongue out at her. I don't care. I am thrilled to be here and able to return home in a few days.

After a joyous reunion with my aunts and many cousins, Pa disappears with Uncle Leang to meet with the village chief and request permission to live here. Uncle Leang and Uncle Heang say that since the Khmer Rouge have won the war, the soldiers removed the old village chief and replaced him with a Khmer Rouge cadre. Now the villagers have to seek permission for the simplest of human desires—to have family members live with them or to leave the village to visit another area.

They return shortly and report that our request is granted. My interest in the town quickly dies when Pa tells us we will all live with Uncle Leang and his family in their house. Uncle Leang and his wife have six children, so with the nine of us it makes seventeen under one thatched roof. Their house would not be called a house by city people's standards. It looks more like one of those simple huts poor people live in. The roof and walls are made of straw and the hut has only a dirt floor. There are no bedrooms or bathrooms, just one big open room. There is no indoor kitchen, so all the cooking is done outside under a straw roof awning. Later that night Kim took me aside, scolding me for being snobbish about our new house. Even as a ten-year-old boy he understood how brave our uncle was to beg the new Khmer Rouge village chief to permit us to stay.

"The village is so poor," I say to Pa as the family gathers on the floor of Uncle Leang's hut. Sitting on straw mats or wooden stools and chairs, we listen to Pa's instructions.

"So are we." The sternness in Pa's voice makes my face burn with shame. "From now on we are as poor as all these people here. We have to live far away from the city where people might recognize me and know who I am. If anybody outside the family asks where we are from, tell them we are country people just like your uncles."

"Why don't we want them to know who we are, Pa? Why can't we go home to our own house? The soldiers promised that we could go home after three days."

"The Khmer Rouge lied. They have won the war, and we cannot go back. You must stop thinking we can go back. You have to forget Phnom Penh." Pa has never spoken so bluntly to me before, and slowly the reality of what he says sinks in. My body trembles with fear and disbelief. I am never going home. I will never see Phnom Penh again, drive in our car, ride a cyclo with Ma to the markets, buy food from the carts. All of that is gone. He reaches out and takes me into his arms as my eyes water and my lips tremble.

As Pa continues to talk, I slide out of his arms and into Keav's. Pa tries to make my brothers understand the history of politics in Cambodia. Led by Prince Sihanouk, Cambodia, then a French colony, became an independent nation in 1953. Throughout the 1950s and 1960s, Cambodia prospered and was self-sufficient. However, many people were not happy with Prince Sihanouk's government. Many regarded the Sihanouk government as corrupt and self-serving, where the poor got poorer and the rich became richer. Various nationalistic factions sprang up to demand reforms. One of the groups, a secret Communist faction—the Khmer Rouge—launched an armed struggle against the Cambodian government.

The war in Vietnam spread to Cambodia when the United States bombed Cambodia's borders to try to destroy the North Vietnamese bases. The bombings destroyed many villages and killed many people, allowing the Khmer Rouge to gain support from the peasants and farmers. In 1970, Prince Sihanouk was overthrown by his top general, Lon Nol. The United States–backed Lon Nol government was corrupt and weak and was easily defeated by the Khmer Rouge.

Pa says many more things to my brothers, but I don't care much about politics. All I know is that I am supposed to act dumb and never speak of our lives in the city. I can never tell another soul that I miss home, that I want to go back to the way things were. I rest my head on Keav's shoulder and close my eyes while gritting my teeth. She softly strokes my hair and caresses my cheeks.

"Don't worry, your big sister will look after you," she whispers quietly into my hair. Next to her, Ma sits on the mat, holding Geak, who sleeps quietly in her arms. Chou is next to her, focusing on her red-and-white kroma, intently folding and refolding it.

Later in the night, lying on the wooden plank for beds, I keep Chou awake by tossing and turning.

"I hate this. I am so uncomfortable!" I gripe to Chou, who is sleeping next to me. In the city, we three youngest girls slept on mattresses in the same bed. On the farm, the boys get to sleep in hammocks while the girls sleep all lined up like sardines on a rough wooden platform made of bamboo trees. I'd much rather sleep in the hammocks.

"Be quiet and go to sleep."

"Chou, I have to go to the bathroom."

"Go then."

"I'm afraid. Come with me."

Chou answers by turning her back to me. Every time I have to go, I have to walk into the woods by myself to the outhouse. We have used up our paper money and now have nothing to use for toilet paper. Chou taught me to use leaves, but at night, when I cannot see, I am afraid there might be bugs on them.

Entering the woods at night is a haunting experience, especially for someone with a vivid imagination. In the darkness, I see spirits shaking the trees, letting me know they are waiting for me. They whisper chants and spells that the wind carries through the leaves, back to my ears. The spirits call me to come to them so they can take possession of my body. I am so filled with fear about going to the bathroom alone at night that I force myself to hold it until dawn when I make a mad run into the woods.

I soon realize how early everyone gets up when they are already busy about the farm before the sun rises and long before I awake the next morning. Life on the farm is boring and dull, but at least there is enough to eat. Unlike my life in Phnom Penh, I do not have any friends outside the family. It is hard to make friends because I am afraid to speak, afraid I will blurt out secrets about our family. Pa says the Angkar has abolished markets, schools, and universities, and has banned money, watches, clocks, eight-track players, and televisions.

Since we are now a family of peasants I will have to learn the time of day and night by the position of the sun and moon in the sky. If I run into other children and speak to them, I have to watch what I say

and what language I use. I cannot mention the food I wish I could eat, the movies I have seen, or the cyclo I have ridden in. If I speak about them, the children will know we are from the city. I am used to kids seeking my attention and friendship in the city. Here they look at me with suspicion and steer away from me when I approach them. No matter, I have many cousins to play with. On the days I don't spend watching other people watch us, I help my older cousins bring their cows to the field to graze. I gradually adjust to life on the farm and let go of my dream of returning home.

The first time my cousin Lee Cheun puts me on a cow, I am afraid I will fall off. The cows are much taller than I am. Lee Cheun is sixteen and taller than the cows. She hoists me effortlessly on top of one. Sitting on its back, my legs hang to the middle of its stomach. My hands hold tightly to the rope tied to the ring pierced through its nose while my legs hug its body. Every time the cow moves, its huge rib cage shifts between my legs, and my heels slide over the ribs like fingers over piano keys.

"Relax your body." Lee Cheun laughs. "Cows are lazy so they move slowly. You will fall if you sit so rigidly." Following her advice, I stop holding on so hard and sway my upper body with the movement of the cow. After a few minutes, my fear subsides.

"How much farther before we stop? It's hot and my bottom is hurting," I complain.

"We're going just over the hill where the grass is greener. You're the one who wants to come so stop grumbling." Lee Cheun points to a group of girls walking in a distant field. "Look, at least you don't have their jobs."

They are peasant girls, not much older than I am, wandering in the field. They carry bags strapped diagonally across their back and their eyes look at the ground. Occasionally, a girl bends to pick up a round greenish-black patty from the ground and puts it in her bag.

"What are they doing?"

"They are collecting dry cow dung."

"Disgusting!"

"Usually the peasants come by with their wagons and scoop up the fresh manure to use as topsoil. These girls are picking up the dry manure

because it is believed to have medicinal properties. They will boil it in water and drink it like tea."

"Disgusting!" I exclaim again.

Even the new experience of riding on a cow becomes dull when you do it everyday. Yet despite the monotony of farm life, the longer we live in Krang Truop, the more fearful and anxious I become. Everywhere I venture I cannot shake the feeling that someone is watching, following, me. Though I have nowhere to go, each morning I hurriedly dress myself so I can catch a glimpse of Pa before he goes off to work. On most days, by the time I am awake, Pa and my brothers are already gone and Ma is busy sewing clothes for the family or working in the garden.

After getting dressed I do what I can to keep up my hygiene. Pa tells us it is important, so I try to make him happy. Since we no longer have toothbrushes or toothpaste, I use a handful of hay and run it over my teeth like a brush. To get to the back teeth, I have to reach into my mouth with my fingernails and scrape away the thick, yellow crust.

To wash, I use a bath stall similar to an outhouse. Inside, there is a big round container that looks like a three-foot-tall clay flowerpot, which Kim and the other cousins fill with water every evening. I undress and hang my clothes on a splinter of wood on the door. Then I reach into the container and take a bowl full of water and pour it over myself. There is no soap or shampoo, and as a result my hair becomes very sticky and knotted, and it is painful to comb.

Pa returns late at night looking dirty and tired. Sometimes, after a quick meal, Pa sits quietly outside by himself and stares at the sky. When he comes back into the hut, he falls quickly asleep. I hardly ever sit on his lap anymore. I miss his hugs and how he used to make me laugh at old Chinese stories. Pa's tales were often about the Buddhist gods and their dragons coming down to Earth to fight evil and protect people. I wonder if the gods and dragons will come help us now.

waiting station

"What's going on?" I ask Ma, rubbing my eyes. "Why did you wake me up?" I open my eyes to see the sky is still dark but that Uncle Leang, his wife, Aunt Keang, and all the cousins are up. Beside me, Chou rolls up her thin blanket, folds her clothes, and puts them in her pillowcase. Outside, Lee Cheun scoops ladles full of cooked rice and puts it on banana leaves. Keav pokes the crackling fire to cook the dried fish while Kim fills up the petrol container with water.

"Quiet. We have to go." Ma puts her hand over my mouth.

"I don't want to go. I don't want to walk again." I want to go back to sleep. Though we have been living at Krang Truop for two months and my blistered feet have healed, the thought of more walking makes my ankles throb with pain.

"Quiet," Pa admonishes me. "We don't want anyone to hear you crying. It is not safe for us to stay here anymore. We have to go and we will ride on a truck to get there."

"Why do we have to go, Pa?"

"It is no longer safe for us to stay here."

"Are we walking a long way?"

"No, your uncles talked the chief into arranging for us to be picked

up by a Khmer Rouge truck. The truck will take us to Battambang. That is where your grandmother lives."

"But I do not want to move anymore, Pa." Pa has no words to soothe me. Biting back my tears, I put on my flip-flops and walk toward Keav's extended hand. Pa and Ma turn to Uncle Leang and thank him for letting us stay with him. Uncle Leang looks at her, face hanging, eyes blinking rapidly, and blesses Ma for a safe journey. The cousins stand outside the hut to see us off. Their hands dangle lifelessly by their sides as they watch Pa lead us away.

By the time we arrive at the rendezvous area on the roadside, about thirty people have already gathered there. They squat and sit on the gravel road in four family groups. Many have almond-shaped eyes, thin noses, and light skin, which suggests they might also be of Chinese descent. Pure Khmer have curly black hair, flat noses, full lips, and dark chocolate skin. Our fellow travelers do not acknowledge our presence, instead they stare passively at the road. Like us, they carry with them light bundles of clothes and small packages of food. We sit on the gravel road next to them but no words are exchanged. In the dark of night we all wait for the truck. The world around us remains tranquil and asleep; all that can be heard is the chirping of crickets. The moments feel like forever. Then suddenly the glaring headlights of the military truck appear and it stops before us. Pa transfers me from his warm arms onto the hard, cold bed of the truck. I do not want to let go of him. I do not want to ever leave his safe arms.

The ride is bumpy and loud, but the cool dawn air keeps us reasonably comfortable. Ma stares off into the distance while Geak sleeps in her arms. My other siblings are half dozing, half awake while I find safety in Pa's arms again. Everyone is very quiet as the truck drives on. All morning the truck heads northwest as the sun climbs higher and higher in the sky, and the wind blows away what little protection the clouds have to offer. The truck driver does not have Pa's driving skills, nor does he care whether those of us in the back bounce and bump into one another. The truck drives all day and stops only in the evening for us to cook our food.

As soon as it stops, everyone jumps off to stretch their weary bodies. Pa lifts me out of the truck and puts me on the ground next to Chou.

All around us, people are shaking their legs crazily as if trying to get rid of animals that have crawled up their pant legs. Khouy walks in a circle, swinging his arms very quickly from side to side. He is a martial artist with a black belt in karate. At 5'7", Khouy is slender and fit. In Phnom Penh, I loved to sit and watch him practice karate. It amazed me that he could kick one leg up above his head and hold the stance for a long time. He could jump high in the air, do many fast kicks, and land safely on his feet all in a few seconds while screaming funny sounds and contorting his face. It always made me laugh. Now, he walks around faster and faster in a circle and his arms are like propellers about to carry him off like a helicopter. He is doing the same movements I've seen him do so many times before, but this time his face is not funny and I am not laughing.

After our short rest and meal, we get back on the truck and remain there all through the night. I wake up in Pa's lap in the morning to see that we have arrived at a "truck stop." There are people everywhere. Some are cooking breakfast, others are just waking up, and many are still asleep on the side of the road or in the grass. Sitting in the back of the truck, we dare not move until the soldiers instruct us to.

"We are in Pursat province. You are to wait here until the base people come to take you to live in their village," a soldier tells us and walks away.

"Why did we have to leave last night?" I ask Pa.

"Some of the new arrivals in Krang Truop are from Phnom Penh. Even though they are friends, it is dangerous to live there because they know who I am."

"Pa, they're our friends. They wouldn't tell on us and get us in trouble!"

"Friendship does not matter; they may not have a choice." Pa is very solemn as he speaks to me. I do not understand what he means but decide not to pursue this line of questioning.

"Are we going to Battambang on these trucks?" I ask quietly.

"No, this is not the route to Battambang. The soldiers have taken us to a different place."

"Can't we tell them we have to go to Battambang? That they have taken us to the wrong place?"

"No, we cannot argue with them. We will go wherever they choose to take us." Pa sounds fatigued as he puts me on the ground. He tells Kim to look after me while he tries to find out when we will be leaving. As he walks away into the crowd of people, I watch until his figure disappears.

Kim tells me that from now on I have to watch out for myself. Not only am I never to talk to anyone about our former lives, but I'm never to trust anyone either. It is best if I just stop talking completely so I won't unintentionally disclose information about our family. To talk is to bring danger to the family. At five years old, I am beginning to know what loneliness feels like, silent and alone and suspecting that everyone wants to hurt me.

"I am going to go look around," I tell Kim, bored.

"Don't go far and don't talk to anyone. We might have to leave very soon and I don't want to have to go looking for you."

I want to obey my brother's warnings not to go far, but I'm curious. When my family is looking elsewhere I sneak away from under their watchful eyes to explore the "waiting station." The farther I walk, the more I see of the hundreds of people at the camp. They talk, sit, or sleep anywhere they can. Many tents have wet clothes hanging all over their lines, piles of wood by the crackling fire, and homemade wooden benches. Looking as if they have been waiting for a long time, some lie so motionless I wonder if they are alive. I stop to look at one old woman. Dressed in a brown shirt and maroon sarong, she lies on the ground with her arms at her side and her head propped up by a small bundle. Her eyes are half closed, white hair strewn in all directions, and skin yellow and wrinkled. The young woman next to her spoon-feeds the old woman rice gruel.

"She looks dead to me," I say to the young woman. "What's wrong with her?"

"Gram's half dead, can't you tell?" she says to me in annoyance.

The longer I stare at her, the more my skin sweats. I have never seen anyone who is half dead before. Ignoring me, the young woman continues to feed her grandmother. One side of her mouth swallows the rice gruel while the other side drools and spits the food back out. I never thought this was possible. I just thought you were either

completely dead or alive. I feel sorry for the old woman but am fasci-
nated at the prospect of being caught between the two worlds. My fas-
cination overrides my fear of her.

"Are there any doctors or anyone who can help her?"

"There are no doctors anywhere. Go away! Aren't your parents
looking for you?"

She is right, of course. I hear Ma calling my name and beckoning
me to return. Luckily, my family is too busy boarding yet another truck
to be angry with me. As Pa lifts me onto the truck, I notice two very
thin middle-aged men in loose-fitting black pajama pants and shirts
standing next to us. While one writes something on small brown pads
of paper with his black pen, the other points at our heads and counts as
we climb onto the truck. I find myself a seat where I can watch the
countryside. Quickly, four other families clamber onto the truck and fill
up the empty space in the middle. Once all the families are on board,
the two men take their notes and count again, without smiling or
greeting us. After they are finished, they get into the front seats with the
truck driver and we begin to move.

The truck rolls away from the waiting area and onto a bumpy
narrow road crossing the mountains. The families are quiet and somber,
the only sounds come from the branches brushing against the side of
the truck and the slush of mud sticking to the tires. After what seems
like forever, I become bored with the scenery and climb onto Pa's lap.

"Pa," I say quietly, so the others cannot hear us, "the people at the
place we just left, why were they there?"

"They are waiting for the base people to come and take them."

"Take them like they've taken us?"

"Yes. The men wearing black clothes are representatives from
rural villages. At the waiting area, these representatives are given a list
of names and people they are to take back to their villages," Pa says
quietly.

"Those two men, are they our village representatives?"

"Yes."

"Who are the base people?"

"Shhh . . . I will tell you later."

"How come we left there so fast while all the others waited?"

"I bribed someone with one of your Ma's gold necklaces to put our names on a list so we could leave." Pa lets out a sigh and is once again quiet. I rest my head on his chest and think how lucky I am to have such a father. I know Pa loves me. Back in Phnom Penh, in the movie theater, I would always demand the seat next to Pa. When a movie got scary, I would grab onto his arm, signaling to him that I was ready to hop on his lap. Pa would then lift me from my chair and plop me on his lap so that his body became my chair, his arms my armrest. It seems so long ago now. He seems so serious and sad, and I wonder if I will ever see my fun Pa again.

anlungthmor

I wake up to find that we have stopped and all the families are getting off the truck. The village representatives have a few words with the truck driver before he drives away, leaving us in the middle of nowhere. All around us, green mountain peaks jut into the gray sky. July is the midpoint of the rainy season; the air, though cool, is heavy and humid. Thick, tall trees with wide, green leaves and fat elephant grass surround us. I sit next to Chou and Geak on our small piles of clothes, listening to the sound of shrieking birds while the others stretch their bodies. A few feet away, Pa and the fathers of the four other families who came with us on the truck listen to the representatives as they give out instructions.

"We have to walk from here up to the mountains," Pa tells us. Pa picks up Geak and carries her on his back. Khouy, Meng, Keav, and Kim gather up our bundles of clothes and follow the representatives as they lead us to a small, hidden trail up the mountain. Chou and I hold Ma's hand and trail behind the other families. I try to run to be up near Pa in case there are snakes or wild animals who eat young children in the mountains, but pebbles and rocks slow me down by getting in my flip-flops, forcing me to shake them out every few minutes. We hike up

the narrow path in silence. By nightfall, we arrive at our destination. The village chief takes all five families to his house and gives us rice and fish for dinner before the adults leave to hear further instructions. Afterward, he leads us to a little hut behind his house that is to be our new home. The hut sits on four wooden legs raised three feet off the ground. Its roof and walls are covered with bamboo leaves and straw.

"This village is called Anlungthmor and we will live here for the time being," Pa informs us that night. "Depending on when the truck arrives with the supplies, every week or two the chief will ration each family salt, rice, and grains. To supplement these rations, we will grow a vegetable garden in the back of the hut. Remember, do not talk about Phnom Penh. There are Khmer Rouge soldiers patrolling the village, reporting our activities to the Angkar. From now on, we are country folks just like everybody here."

Our whole family sleeps together lined up like sardines under a big mosquito net in the house. We huddle together to keep warm. On the second night, I become sick and have a terrible fever. My body aches all over and I throw up a lot. I feel hot and cold. I cannot sleep and have no appetite. Ma wraps me up in many layers of blankets, but still I cannot get warm. When I am very hot, I see ghosts and monsters coming to kill me. My heart races, causing searing pains to shoot up my spine and burn my flesh. I am scared of the monsters and run and run to get away, but no matter how fast or how far I run, I can never escape them. When I come to, Ma tells me that Kim and Chou were also sick and had the same nightmares of being tracked down and killed by monsters.

"It's the mountains and the weather," Pa tells us. "We will get used to it eventually. We have to watch what we eat. There are no doctors or medicines here, only homemade remedies." Pa should tell the mosquitoes to watch what they eat for they are the wicked things that make us sick.

We are not the only new people here. Khouy tells us that of the eight hundred people at Anlungthmor, approximately three hundred are new arrivals. But the village population changes every day because the Angkar constantly moves people in and out of the village, which is how we ended up in an empty house. Every day, Pa, Khouy, and Meng wake with the sun to work and when the sun sets come home. They work very hard, some days planting rice and vegetables and cutting lumber,

and other days building dams and digging trenches. No matter how hard they work, after the first month there is less and less food to eat. We survive on the fish my brothers catch each day. We can no longer afford to eat plain rice but have to mix it with mushrooms, banana stocks, and other leaves. After a few weeks, even the leaves are becoming scarce. Ma tells us only to pick the old dark green leaves and not the light green ones in our garden. She says that we need the light green leaves to grow, thus giving us more food. When we catch animals, we eat everything—feet, tongue, skin, and the innards.

One day, Kim comes home grinning from ear to ear because he has caught a small wild bird. Ma smiles widely and pats Kim's head before taking the bird from him. Kim has tied its legs together, but it struggles and tries to peck at Ma's hand.

"Go fetch a bowl and a knife quickly," Ma tells Chou. She takes the bird's wings and crosses them against each other on its back. With its wings secure, Ma instructs Chou to place the bowl under the bird. Holding its body between her knees, Ma takes its head and bends it backward, stretching its neck. As if sensing danger, the bird croaks louder and struggles to get away but to no avail. Ma's free hand picks up a knife and in one swift moment, the sharp edge slices into the bird's neck, silencing it. Thick blood spews out from the bird's open gash and drips into the bowl.

"Catch it all," Ma says anxiously to Chou. "It's good blood." Chou picks up the bowl and brings it close to the wound to catch all the blood. "Put it in a cool place in the shade so it will congeal faster; we can make rice soup with it. Tonight we will have a good dinner," Ma announces, smiling and finally letting go of the bird. Though dead and drained of blood, its body shakes violently in the dirt.

"Poor bird," I whimper, reaching over to softly pet its feathers. Its blood stains my hands, but I continue to pet it until its trembling body becomes completely still.

Eventually, food becomes so scarce that the village chief sends Meng, Khouy, and the other young men to the top of the mountain to dig for wild potatoes, bamboo shoots, and roots to feed the village. Each week, they leave on Monday and return exhausted on Wednesday or Thursday. On a good week, they come home with many bags of food

and the chief rations it out to all the other villagers. There are times when they return with very little and each person is given only one small potato per day.

It is our second month in Anlungthmor and we are amid one of the worst rainfalls ever. It starts every morning and rains throughout the day, stopping briefly only late at night. It rains so hard that my brothers are not able to go up the mountain to dig for potatoes and bamboo. What food we had planted in the garden has been washed away by the rain. To survive, my older siblings shake the trees at night, hoping to find June bugs. The younger kids, because we are closer to the ground, catch frogs and grasshoppers for food. The rain makes the ground soft and muddy. Chou, Kim, and I often slide around in the mud even when we're not looking for frogs. With brown mud covering our faces, hair, and clothes, we laugh and roll in the sludge like pigs. Within minutes, the rain pours over us, washing away the dirt and mud. We pull the wings and heads off the bugs we catch and roast them with salt and pepper.

Weeks go by and still it rains. The rain floods the village and the water rises to Pa's waist, drowning many animals. Pa tells us the flood is why all huts are built on stilts, high off the ground. Cold and hungry, the only food we have to eat are the fish and rabbits that float by. Pa ties a fish net to a long stick to catch them as they pass by in the rushing water beside our hut.

"Pa! Pa! Here comes something!" I scream excitedly one day.

"That's a good one. It looks like a rabbit."

"Look Pa, here comes another," Chou tells him.

Pa extends his hand to catch them with his net. He reaches in and pulls out two rabbits by the heads. The size of big rats, they hang limp and lifeless in his hands, their fur matted to their bodies. He takes the rabbits and places them on a wooden board. Their necks make a small crunching sound as he chops off their heads with his little knife. Kim then pours a bowl of water on the corpses to wash away the blood. Pa cuts open the skin from the neck all the way down to the bottom of the stomach. With that, he grabs the skin from the neck and pulls it off the bodies. Pa then separates the meat from the bones and cuts the flesh into very thin slices to soak in the lime juice that Ma has prepared.

Because everything is wet and there's a foot of water underneath us, we cannot make a fire. Pa feeds us young children slices of the rabbit meat. Though the lime juice cuts the taste a little, I still hate the texture of it. The flesh stretches and pulls in my mouth and it's hard to chew. My stomach tightens, wanting to throw the food back out. Sucking on a slice of lime, I force the meat to stay down because I know that there is no more food for me if I spit it out.

Eventually, the rainy season is over and the flood recedes, leaving behind wet, muddy ground. The whole village is in a state of panic for there is no food anywhere. "We have to leave," Pa tells us one night. "People are discontent. They are hungry. The native villagers are suspicious of everybody, and they are asking too many questions. We are different, your ma speaks Khmer with a Chinese accent, you kids have lighter skin, and, besides me, this family does not know much about farming, so the villagers will make us the first scapegoats for their problems." Pa says hunger and fear make people turn against one another, so once again we have to flee. Pa pleads with the chief to relocate us to another village before people have the chance to turn against us. In the morning, we will leave with only the clothes in our bags, trek down the mountain, and wait for a Khmer Rouge truck to pick us up.

"The killings have started," Pa tells my older brothers as we walk back down the mountain to our rendezvous area. "The Khmer Rouge are executing people perceived to be a threat against the Angkar. This new country has no law or order. City people are killed for no reason. Anyone can be viewed as a threat to the Angkar—former civil servants, monks, doctors, nurses, artists, teachers, students—even people who wear glasses, as the soldiers view this as a sign of intelligence. Anyone the Khmer Rouge believes has the power to lead a rebellion will be killed. We have to be extremely careful, but if we keep moving to different villages, we may stay safe."

It has become too familiar to me by now. When Ma wakes me up in the early morning, I do not ask her any questions. It has become a routine. After many hours of walking, we arrive at the same spot where we were dropped off months before. There, we wait all afternoon and into the night for the truck that the chief arranged to come and take us far away to where no one knows us. When the truck comes in the dark-

ness, we quietly climb in the back. We do not greet the families already on it but silently step over their bodies to find empty spaces to sit.

The truck takes us to the other side of the mountain to a village called Leak, where we wait for new orders from the soldiers. I wonder why the Angkar keeps uprooting and relocating people, herding them like cows from one location to another. For our family, the uprooting is a choice. Pa says we have to keep moving to stay safe. For many others, they have no say in the matter. It is as if no village wants us nor do the soldiers know what to do with us. Eventually, another truck comes to take us to our new home, the village of Ro Leap. I climb in and sit by myself in a corner of the truck while the rest of the family huddles closely together. Meng had said when we arrived at Anlungthmor five months ago that there were approximately three hundred new people there, now more than two hundred of the new people have died from starvation, food poisoning, and malaria. I look over to see Ma holding Geak very tightly to her breasts, as if to never let her go.

"Ma, am hungry," Geak cries.

"Shhh . . . It's going to be okay soon."

"Hungry, belly hurts." Geak continues to cry.

"I love you very much and I will make things better. When we get back home, we will go to the park and get you your favorite food. We'll get some Chinese pork dumplings. Won't that be fun? We'll have a picnic and a good swim, then go to the park and . . ." Geak is so thin that her cheekbones protrude out of her face. Her cheeks are now hollow, her skin hangs on her bones, and her eyes are dulled with hunger.

ro leap

Seven months after the Khmer Rouge forcefully evacuated us from our home in Phnom Penh we arrive in the village of Ro Leap. It is late in the afternoon. The clouds separate in the sky and the sun shines beams of white light on our new home. Ro Leap looks like all the other villages we passed through on our travels. Surrounded by the jungle, it is green and lush during the rainy season and dusty and flammable during the dry season. Looking up at the sky, I smile and thank the gods for giving me a safe arrival. This is our third relocation in seven months. I hope we will stay for a while.

The town square is situated forty feet from the road and consists of nothing more than a dried up piece of land and a few trees. The town square is a place where people gather to hear announcements, instructions, work assignments, or, in our case, wait for the village chief. Behind the town square, villagers live in the same kind of thatched-roof huts that sit on raised stilts, all lined up in neat rows about fifty feet from each other at the edge of the forest.

The truck driver orders the new arrivals to get out and wait for instructions from the village chief. My family quickly jumps off the truck, leaving me behind. Standing at the edge of the truck, I fight the

impulse to run and hide in the far corner. All around the truck, villagers have gathered to take their first look at us new people. These villagers are all dressed in the familiar loose-fitting black pajama pants and shirts with a red-and-white checkered scarf wrapped across their shoulders or around their head. They look like an older version of the Khmer Rouge soldiers that stormed into our city, except they do not carry guns.

"Capitalists should be shot and killed," someone yells from the crowd, glaring at us. Another villager walks over and spits at Pa's feet. Pa's shoulders droop low as he holds his palms together in a gesture of greeting. I cower at the edge of the truck, my heart beating wildly, afraid to get off. Fearing that they might spit at me, I avoid their eyes. They look very mean, like hungry tigers ready to pounce on us. Their black eyes stare at me, full of contempt. I don't understand why they are looking at me as if I am a strange animal, when in reality, we look very much the same.

"Come, you have to get off the truck," Pa says gently to me. My feet drag my body cautiously toward his open arms. As Pa lifts me in his arms, I whisper in his ear, "Pa, what are capitalists and why should they be killed?" Saying nothing, Pa puts me down.

There are five hundred base people already living in Ro Leap. They are called "base people" because they have lived in the village since before the revolution. Most of them are illiterate farmers and peasants who supported the revolution. The Angkar says they are model citizens because many have never ventured out of their village and have not been corrupted by the West. We are the new people, those who have migrated from the city. Peasants who have lived in the countryside since before the revolution are rewarded by being allowed to stay in their villages. All others are forced to pick up and move when the soldiers say so. The base people will train us to be hard workers and teach us to have pride in our country. Only then will we be worthy to call ourselves Khmer. I cannot comprehend why they hate me or why capitalists must be killed, but this will have to wait. I walk over and take hold of Chou's hand, and together we follow Ma to the gathering at the town square.

When I ask Kim what a capitalist is, he tells me it is someone who is from the city. He says the Khmer Rouge government views science,

technology, and anything mechanical as evil and therefore must be destroyed. The Angkar says the ownership of cars and electronics such as watches, clocks, and televisions created a deep class division between the rich and the poor. This allowed the urban rich to flaunt their wealth while the rural poor struggled to feed and clothe their families. These devices have been imported from foreign countries and thus are contaminated. Imports are defined as evil because they allowed foreign countries a way to invade Cambodia, not just physically but also culturally. So now these goods are abolished. Only trucks are allowed to operate, to relocate people and carry weapons to silence any voices of dissent against the Angkar.

Shuddering at Kim's explanation, I nestle closer to Chou and lean my head on her shoulder. While we wait for the chief, other trucks full of migrants continue to arrive. By the end of the day, approximately sixty families, about five hundred new people, now fill the town square. As the sun lowers itself behind the tree line, the chief finally makes his appearance to the crowd of new people. He is as tall as Pa, with an angular body and cropped gray hair that sits straight on his head like dense jungle bushes. Where his eyes should be are two dark pieces of coal separated by a sharp, thin nose, below which are thin lips that spit out saliva. The chief walks in a slow, casual stride, hands and legs moving precisely, deliberately. The black pajama pants hang looser on his body than those on the two soldiers who follow behind him. There is nothing remarkable about him, except that he is able to command the two men who wear rifles slung across their backs.

"In this village, we live by strict rules and regulations set for us by the Angkar. We expect you to follow every rule. One of our rules applies to how we dress. As you see, we wear the same clothes. Everyone wears his or her hair in the same style. By wearing the same thing, we rid ourselves of the corrupt Western creation of vanity." He speaks in the heavy accent of the jungle people, which is hard for me to understand.

With a flick of the chief's wrist, one soldier walks up to a family. He reaches out and takes a bag from a woman. She lowers her eyes as the bag slides off her shoulder. He rummages through the bag and looks in disgust at the colorful clothes inside. He dumps the contents of the bag

in the middle of the circle of people. One by one this is repeated. Bags
upon bags of clothes belonging to all the families in the square are
dumped into a pile. Lying on top of the pile is a pink silk shirt, a blue
jean jacket, and brown corduroy pants—all remnants of past lives to be
destroyed.

Before the soldier even approaches, Ma has gathered all our bags
and put them in a small pile in front of our family. The soldier picks up
our bags and begins to throw our clothes onto the pile. His hand
reaches into one bag and pulls out something red—my breath quickens.
A little girl's dress. He scowls as if the sight of such a thing turns his
stomach, then balls up the dress in his hand and throws it on top of the
pile. I follow the dress with my eyes, focusing all my energy on it,
wanting desperately to rescue it from the pile. My first red dress, the
one Ma made for me for the New Year's celebration. I remember Ma
taking my measurements, holding the soft chiffon cloth against my
body, and asking me if I liked it. "The color looks so pretty on you," she
said, "and the chiffon material will keep you cool." Ma made three
identical dresses for Chou, Geak, and me. All had puffy sleeves and
skirts that flared above the knee.

I do not know when the soldier finishes dumping all the clothes
onto the pile. I cannot take my eyes off of my dress. I stand there, with
Ma and Pa on either side of me. My insides are tied up in knots, a
scream claws its way up my throat, but I push it all down. "No! Not my
dress. What have I done to you?" I scream in my head, tears welling up
in my eyes. "Please help me! I don't know if I can handle it anymore! I
don't understand why you hate me so much!" I grind my teeth so hard
the pain in my throat moves up to my temples. My hands clench in
fists; I continue to stare at my dress. I do not see the soldier's hand reach
into his pocket and retrieve from it a box of matches. I do not hear his
fingers strike a match against the side of the box. The next thing I
know the pile of clothes bursts into flames and my red dress melts like
plastic in the fire.

"Wearing colorful clothes is forbidden. You will take off the clothes
you have on and burn those as well. Bright colors only serve to corrupt
your mind. You are no different from anyone else here and from now on
will dress in black pants and shirts. A new set will be issued to you once

a month." To drive his point home, the chief paces around, looking the
new people in the eye, pointing his long index finger at them.

"In Democratic Kampuchea," the chief continues, "we are all equal
and do not have to cower to anyone. When the foreigners took over
Kampuchea, they brought with them bad habits and fancy titles. The
Angkar has expelled all foreigners so we no longer have to refer to each
other using fancy titles. From now on, you will address everyone as
'Met.' For example, he is Met Rune, she is Met Srei. No more Mr.,
Mrs., Sir, Lord, or His Excellency."

"Yes, comrade," we reply collectively.

"The children will change what they call their parents. Father is
now 'Poh' and not Daddy, Pa, or any other term. Mother is 'Meh.'" I
hold on to Pa's finger even tighter as the chief rants off other new
words. The new Khmer have better words for eating, sleeping, working,
stranger; all designed to make us equal.

"In this village, as in the whole of our new and pure society, we all
live in a communal system and share everything. There is no private
ownership of animals, land, gardens, or even houses. Everything belongs
to the Angkar. If the Angkar suspects you of being a traitor, we will
come into your home and go through whatever we like. The Angkar
will provide you with everything you need. You new people will eat
your meals together. Meals will be served from twelve to two P.M., and
from six to seven P.M. If you come late, you will get nothing. Your meal
will be rationed to you; the harder you work, the more you'll eat. After
dinner each night, I will let you know whether or not there will be
meetings. The base people and our comrade soldiers will patrol your
work area. If they see you neglecting your duties and report that you are
lazy, you will get nothing to eat." My eyes follow the chief as he paces
around the circle of people. I pray that I will remember all he has said.

"You must follow all the rules set for you by the Angkar. This way,
we will never have to deal with the crimes and corruption of the city
people."

"Yes, comrade," the new people echo in unison.

"Each family will be assigned a house in the village. Those who do
not get a house today will be built one tomorrow. Your first work
assignment is to build houses for each other."

"Yes, comrade."

"Children in our society will not attend school just to have their brains cluttered with useless information. They will have sharp minds and fast bodies if we give them hard work. The Angkar cannot tolerate laziness. Hard work is good for everyone. Any kind of schooling carried out by anyone without the government's approval is strictly forbidden."

"Yes, comrade."

"All right, you can sit down and wait while we make arrangements for your housing." The chief spits into the dirt in front of us again and walks away. As soon as he is out of sight, the nervous crowd separates to seek out shaded areas to rest. I lie down on a mat that Ma has spread out next to Chou and fall asleep. I wake up many hours later to the sound of people whispering nearby. When my eyes focus, I see that a large crowd has gathered a few feet from us and Pa disappears into it. He comes back moments later and reports that a family, a doctor from Phnom Penh with his wife and their three children, have committed suicide by swallowing poison.

Though we are all supposed to be equal, there are nonetheless three levels of citizenship in the village. The first-class citizenry comprises the chief, who has authority over the whole village, his aides, and the Khmer Rouge soldiers. They are all base people and the Khmer Rouge cadres. They have the power to teach, police, judge, and execute. They make all decisions: work details, food rations per family, severity of punishment. They are the eyes and ears of the Angkar at the local level. They report all activities to the Angkar and have full power to enforce the Angkar's law.

Then there are the base people. If the first-class citizens are the all-powerful brutal teachers, the base people are the bullies who work closely with them. Though they are not omnipotent like the first-class citizenry, they lead almost autonomous lives away from the prying eyes of the soldiers. They live in their own houses on the other side of the village, separate from us. The base people do not eat communally or work with the new people. However, they are often seen on our side of the village, patrolling the area and telling us what to do. Many are related to the first-class citizens and keep the chief informed of our day-to-day activities.

The new people are considered the lowest in the village structure. They have no freedom of speech, and must obey the other classes. The new people are those who lived in cities and have been forced out to the villages. They cannot farm like the rural people. They are suspected of having no allegiance to the Angkar and must be kept under an ever-watchful eye for signs of rebellion. They have led corrupt lives and must be trained to be productive workers. To instill a sense of loyalty to the Angkar and break what the Khmer Rouge views as an inadequate urban work ethic, the new people are given the hardest work and the longest hours.

Even among the new people there are different classes. Those who were formally students or involved in professions such as civil service, medicine, art, or teaching are considered morally corrupt. Then it's the ethnic Vietnamese, Chinese, and other minority groups who are considered racially corrupt. When asked about jobs in their former lives, the new people lie and claim to be poor peasants, like Pa did, or small shopkeepers. In the Khmer Rouge agrarian society, only good workers are valuable, all others are expendable. Thus, the new people must work extremely hard to prove they are worth more alive than dead. Pa says because we are different—Chinese-Cambodian—we will have to work harder than the others.

After the chief issues us our meal bowls and spoons and assigns us our hut, we have only minutes to settle down before the 6 P.M. bell rings, signaling mealtime. Gripping my wooden bowl and spoon, I run with my family to the communal kitchen. The kitchen is nothing but a long table, with no chairs or benches, and under a thatched roof with no walls. In the middle of the open hall, there are a few brick ovens and one long table but no chairs or benches. On the long table sit two pots, one full of rice and the other salted grilled fish. There are six or seven base women stirring and scooping food from the pots. A long line of new people has already formed around the table. Like us, they have all changed from their city clothing into their black pajama pants and shirts, the only clothes we will wear from now on.

My heart lurches as I see the long line in front of me. Eyeing the many black pots filled with steamy food on the ground, I tell my stomach to be calm. The line moves quickly and silently. Under my

breath I count the heads before me, eliminating them one by one, anxiously waiting for my turn. Finally, it is Ma's turn. She puts Geak down and holds up two bowls. She bends her head and shoulders so she is lower than the cook, and quietly says, "Please comrade, one for me and one for my three-year-old daughter." The woman looks down blankly at Geak, who barely reaches Ma's thigh and puts two scoops of rice and two fish into Ma's bowl and one of each in Geak's bowl. Ma lowers her head and thanks the woman and walks away with her food, Geak trailing behind her.

My stomach growls loudly as I step up to the table. I cannot see into the pot and my mouth salivates at the smell of the rice and fish. I raise my bowl to my eye level to make it easier for the comrade to serve me. I dare not look up at her, afraid she might become angry with me for staring and not give me my food. Eyes focused on my bowl, I see her hand dump some rice in my bowl and drop a whole fish on top of it. Somehow, I manage to whisper "Thank you, comrade" and walk away, praying that I won't fall and spill my food.

Sitting in the shade underneath a tree, our family eats the food together. Though it is the most food we have eaten in a long time, before nightfall we are all hungry again. Realizing we have to find a way to get more food, Pa somehow arranges for Kim to work at the chief's house as his errand boy. The next night, Kim comes home with leftovers.

"The chief did not have any work for me to do so he tells me to work for his boys. The chief's two boys are my age and they like me," Kim answers. His mouth turns upward in an attempt to smile when we ask how his day went. "They boss me around and I always have to do jobs and errands for them, but look what they gave me! They said that from now on I can take their leftovers home!" We stare unbelieving at the rice and meat Kim displays on the table.

"You did a good job, little monkey," Ma tells him.

"Their leftovers are a feast! White rice and chicken! Look Pa, there's even meat left on the chicken!" I yell excitedly, staring at the juicy shreds of meat still clinging to the chicken bones.

"Quiet. We don't want others to hear us," Ma cautions me.

Hungrily, my siblings gather around Pa, our bowls in hand. One by one, Pa scoops up some rice and gives us a piece of bone. When it is my

turn, he gives me the piece with the most meat on it, the breastbone. I walk over to the corner of the hut and proceed to pick the meat off until finally there is no more. Then I chew on the bones to get the flavor and bone marrow out. That night I go to sleep with a full stomach.

Over the next few weeks, Kim and the chief's children become fast friends, and they allow Kim to bring us their leftovers every night. It is clear from the red marks on his face, cheeks, and legs that Kim suffers abuses from his new "friends" who spit at him and beat him. However, at ten years old, Kim knows he has to endure their cruelty to help feed his family. Each morning as he walks off to the chief's house, Ma watches and whispers, "My poor little monkey, my poor little monkey." In appearance, Kim is beginning to look more and more like a monkey. His black hair is sheared close to his head and thinned from malnutrition, exposing his large forehead. Brown skin stretches over his gaunt face, making his eyes and teeth appear to bulge, too big for his young boy's face. Though I lower my head as his black-clad figure disappears, I am grateful for the extra food he brings us.

My stomach knots each time I look at Pa's face as he receives the food from Kim. Pa is now so thin that his face is no longer the shape of a full moon. His soft body is emaciated, making him wince when Geak tries to crawl onto his lap. The round belly that I once loved to wrap my arms around is caved in, showing his rib cage. Yet he always takes the last and smallest portion of the leftovers. He eats the food tentatively, as if forcing each bite down when his heart wants to spit it back out. At times his eyes linger for many minutes on the fresh bruises on Kim's face, and he swallows even harder, trying to make the food go down. The pain on his face makes me feel such shame, but I am glad for my brother's sacrifice. Each night, in my dark corner of the hut, filled with shame and with quiet tears, I suck and chew the chicken bones until there is nothing left.

In our new home we have no time to get to know our neighbors, visit other villagers, take walks, or hold conversations with anyone outside the family. Social contact among the new people is almost nonexistent. Everyone keeps to themselves, fearing that if they share personal thoughts or feelings someone will report them to the Angkar. This hap-

pens frequently now because turning someone in to the chief can reap rewards and favors such as more food or, in some cases, life over death.

Because of the extra food Kim brings home, for the first few months, life is better for us in our new environment. My parents, my older brothers and sister work in the rice field while we younger kids stay behind to work in the community garden. I miss my family and see them only briefly each night when they return exhausted from working twelve to fourteen hours in the field. Three or four times a week after dinner, the new people sit through an hour or more of meetings. The village is closed off to the outside world and even to other villages. Mail, telephones, radios, newspapers, and televisions are all banned, so the only news we get comes from the chief.

"What was the meeting about tonight, Pa?" I ask, waking up from my sleep when he comes in late that night.

Kissing my forehead, Pa says the meetings are the same as on all the other nights. The chief teaches and explains to the adults the philosophy of the Angkar while all the new people sit and listen. The chief preaches and revers the achievements of the Angkar, the philosophy of the government to build this perfect agrarian society where there are no crimes, no deceit, no trickery, and no Western influence. The Angkar says our new society will produce many thousand kilograms of a rice surplus within two years. Then we'll eat as much rice as we want. And we will be self-reliant. Only by becoming self-reliant will the country be master of its own fate. The chief says the country will go through some hard times and not have enough to eat as it stops accepting charities from foreign countries. The chief says by all of us working hard to grow rice, we will soon be able to feed the country.

At night, fearing we will be heard, we say only a few quiet words to each other before going to sleep. In the dark, the soldiers patrol the area, listening and looking into the houses. If they hear or even suspect people discussing politics—especially capitalism—the entire family will be gone by morning. The soldiers tell us that the family has gone to a reeducation camp, but we know they have disappeared, never to be seen again.

Day after day we work, seven days a week. Some months, if we have been very productive workers, we are given half a day to rest. In those

hours, Ma and us girls wash our clothes in a nearby stream, but without detergent they are not very clean. I look forward to those hours off as our special time together. Of the five hundred or so new people in our village, there are only two or three babies among the families. Although I cannot fully understand her words, I overhear Ma say women are so overworked, underfed, and filled with fear that most cannot become pregnant anymore. Even when they do, many suffer miscarriages. Most newborn babies do not survive more than a couple of days. Pa says there will be a generation of children completely missing from our country. Shaking his head, he looks at Geak. "The first victims are always the children."

Pa says Geak will not become the Khmer Rough's next victim because the chief likes him. The chief allows Kim to bring extra food home, and he knows that things are easier for us because of that. Pa works harder and longer than anyone else in the village. Because of his humble upbringing, Pa has many skills and can do anything the chief asks of him. He is a skilled carpenter, builder, and farmer. Pa is always quiet and even seems enthusiastic about the work—a trait which proves to the chief that Pa is an uncorrupted man. He picks Pa to be the leader of the new people, a position that comes with a raise in the food ration.

Though the Angkar says we are all equal in Democratic Kampuchea, we are not. We live and are treated like slaves. In our garden, the Angkar provides us with seeds and we may plant anything we choose, but everything we grow belongs not to us but to the community. The base people eat the berries and vegetables from the community gardens, but the new people are punished if they do. During harvest season the crops from the fields are turned over to the village chief, who then rations the food to the fifty families. As always, no matter how plentiful the crops, there is never enough food for the new people. Stealing food is viewed as a heinous crime and, if caught, offenders risk either getting their fingers cut off in the public square or being forced to grow a vegetable garden in an area near identified minefields. The Khmer Rouge soldiers planted these landmines to protect the provinces they took over from the Lon Nol army during the revolution. Since the Khmer Rouge planted so many landmines and

drew no maps of where these mines are, now many people are injured or killed traversing these areas. People who work in these areas do not come back to the village. If people step on one and their arms or legs blown off, they are no longer of any value to the Angkar. The soldiers then shoot them to finish the job. In the new pure agrarian society, there is no place for disabled people.

The Khmer Rouge government also bans the practice of religion. Kim says the Angkar do not want people worshiping any gods or goddesses that might take away devotion to the Angkar. To ensure that this rule is enforced, the soldiers destroyed Buddhist temples and worshiping sites throughout the country with major destruction done to the area known as Angkor Wat, an ancient religious site important in Kampuchean history.

Covering more than twenty-five miles of temples, Angkor Wat was built by powerful Khmer kings as monuments of self-glorification in the ninth century and completed three hundred years later. In the fifteenth century, Angkor Wat was abandoned to the jungles after an invasion by Siam and forgotten about until French explorers rediscovered it in the nineteenth century. Since then, the battle-scarred temples with their beautiful statues, stone sculptures, and multilayered towers remain one of the seven man-made wonders of the world.

I remember clutching tightly to Pa's finger as we walked along wide crumbling corridors. The temple walls are decorated with magnificent detailed carvings of people, cows, wagons, daily life, and battle scenes from long ago. Guarding the ancient steps are giant granite lions, tigers, eight-headed snakes, and elephants. Next to them, sandstone gods with eight hands who sit cross-legged on lotus flowers watch over the temple ponds. On the walls beneath the jungle vines, thousands of beautiful apsara goddesses with big round breasts wearing only short wraparound skirts smile at visitors. I reached up and cupped one of the breasts, feeling the cold, rough stone in my palm, and I quickly removed my hand to cover my mouth in a fit of giggles.

Pa led me to a temple area where the trees were so tall that they seemed to reach the heavens. Their twisted trunks, roots, and vines wrapped themselves around the ruins like gigantic boa constrictors, crushing and swallowing the overturned stones. He lifted me over the

wobbly steps to the dark mouth of the temple cave. "This is where the gods live," he said quietly, "and if you call out to them, they will answer." Anxiously, I wet my lips and yelled, "Chump leap sursdei, dthai pda!" ("Hello, gods!") Then wrapped my arms around Pa's leg when the gods answered me: "Dthai pda! Dthai pda! Dthai pda!"

At the temples in this area, Khouy says the soldiers mutilated its animal guards, and either knocked or shot off the stone heads of the gods, riddling the sacred bodies with bullets. After they destroyed the temples, the soldiers roamed the country searching for monks and forced them to convert to the Angkar. Those monks who refused were murdered or made to work in minefields. To escape extermination, many monks grew their hair and went into hiding in the jungle. Others killed themselves in mass suicides. Although these monks maintained and took care of the temples, now they are left to the jungle once again. I wonder where the gods go now that their homes have been destroyed.

labor camps

By our third month in Ro Leap, things begin to worsen. The villagers work longer hours with decreased food rations. The soldiers roam our village daily, looking for young, able-bodied men to recruit into their army. If recruited, you must join. If you refuse, you are marked a traitor and could be killed. For this reason, my parents force Khouy to marry Laine, a young girl from a nearby village. Khouy, who is only sixteen, does not want to, but Pa says he must to stay out of the Khmer Rouge army. The Khmer Rouge are less likely to recruit him if they know he has a wife who will give sons to the Angkar. Laine also does not want to marry my brother, but her parents force her to as well. They fear that left alone she might be raped by soldiers and end up like Davi, another young woman in our village.

Davi is the teenage daughter of one of our neighbors. She is about sixteen years old and very pretty. Despite the war and the famine, Davi's body continues to grow into that of a young woman. Like all of us, her hair is cut short, but unlike us, her hair is thick and curly and frames her small, oval face nicely. People often comment on her smooth, brown skin, full lips, and particularly her large, round brown eyes with their long lashes.

Davi's parents never let her go anywhere by herself. Her mother follows her when she goes to collect firewood and guards her when she needs to relieve herself. Her parents are skittish about her, grabbing her arms and pulling her away anytime someone tries to talk to her. Davi is rarely seen without a scarf covering her head or mud on her face to hide her beauty. Yet no matter what they do, her parents cannot protect her from the gaze of the soldiers who patrol the village.

One evening, three soldiers went to the family's hut and told her parents they needed Davi and another friend to go with them. They said they needed the girls to help them pick corn for a special event. Davi's mother cried and wrapped her arms around her daughter.

"Take me," she begged the soldiers. "Davi is a lazy girl. I can work faster and pick more corn in less time than she can."

"No! We need her!" they retorted sharply. Davi cried harder at their words and clung desperately to her mother.

"Take me," her father pleaded on his knees. "I can work faster than either one of them."

"No! Don't argue with us. We need her and she must perform her duty for the Angkar! She will return in the morning." Then the soldiers grabbed Davi by her arms and pulled her from her mother's shaking hug. Davi sobbed loudly, begging them to let her stay with her mother, but the soldiers dragged her on. Her mother fell to her knees, palms together, and pleaded with them not to take her only daughter. The father, still on his knees, lowered his head to the ground, banged his forehead on the dirt, and also pleaded with the soldiers. As the soldiers took her away, Davi turned around many times to see both her parents still on the ground, palms together, praying for her. She looked back until she could see them no more.

The sounds of Davi's parents' anguished cries echoed into the night. Why were they doing this to her? In our hut the faces of my family were somber and hopeless. Khouy and Pa sat on either side of Keav, who was contorted and white with fear, wondering what they would do if the soldiers took her. Keav, who is fourteen—the same age as Davi—sat holding her knees to her chest, her eyes misted over, her shoulders heaving visibly. Hearing her sobs, Ma left Geak with Chou, crawled over to Keav, and wrapped her arms around her. Without a

word, the rest of us moved to our sleeping spots and tried to go to sleep. Shivering, I crawled over to Chou and grabbed her wet hand and lay on my back, staring at the ceiling. In the black night, we tried to sleep but were kept awake by Davi's mother, who wailed like a she-wolf who had lost her cub.

True to their word, the soldiers returned Davi to her parents the next morning. But the Davi they returned was not the same one they took away. Davi stood before her parents in front of their hut, hair disheveled, face swollen, shoulders slumped, arms hanging like dead weights. She could not meet the gaze of her parents. Without a word, she walked past them and into the hut. They stepped aside to let her enter and followed her in. Their hut was quiet from then on.

A few days after her abduction, the bruises on her face turned deep purple before they gradually disappeared. The scabs on her arms dried up and became little scars, barely visible. But to Davi, they would always be there. I see Davi sometimes in line at mealtime, but she no longer talks to anyone. Her body walks as if there is no more life in it, and her head is always down. No one speaks about that night and no one ever questioned her about what happened—neither her parents nor the villagers. Whenever I see Davi, I veer away from her path. If there is a gathering of people, they become quiet when they see Davi.

As the days go on, more and more people begin to treat Davi as if she were invisible. Sometimes, I catch Davi's eyes watching the villagers at the town square, when she lingers there long after the crowd has departed. Other times, she marches straight into the group of people, as if daring them to say something to her. The gatherers shuffle their feet, cough into their hands, avert their eyes, and walk off in the opposite direction. Often, Keav heads toward Davi only to clench her fists and walk back to us.

The soldiers do not stop with Davi. They come many more nights and take many other girls. Some of the girls are returned in the morning but many are not. Other times, the soldiers come back with the girl and tell her parents they have married. It is her duty, they say, to marry soldiers and bear sons for the Angkar. Many of the girls who are forced to marry soldiers are never heard from again. It is rumored that they suffer greatly at the hands of their "husbands." The soldiers are

often heard saying women have their duty to perform for the Angkar. Their duty is to do what they were made for, to bear children for the Angkar. If they do not fulfill their duty, they are worthless and dispensable. They are good for nothing and might as well die so their food rations can go to those who contribute to rebuilding the country. There is nothing the parents can do to stop the abduction of these young girls because the soldiers are all-powerful. They have the power of judge, jury, police, and army. They have the rifles. Many girls choose to escape from their abductors by committing suicide.

To protect Khouy from being conscripted into the army and Laine from being abducted by soldiers, they are married quickly in a quiet, secret ceremony with both sets of parents giving their blessings. After they are married, Khouy and Laine go to live at a labor camp where they have been assigned to work. Pa does not fear the Khmer Rouge soldiers will want Meng to join the army because he is physically weak, so Pa allows him to stay unmarried. However, the soldiers say that Meng, at eighteen, is too old to live at home with us, and they force him to go live in the labor camp with Khouy and Laine.

Unlike our village, only young men, some with wives and others single, live in the camp. There they do the hard manual labor of loading and unloading shipments onto trucks. Khouy reports that they mostly load rice and unload arms and ammunition. For their hard work, they are given more than enough food to eat. My brothers secretly dry their leftovers and bring them to us when they visit. In the beginning, Meng and Khouy were permitted to visit us every other week. But as time goes by, the soldiers make them work longer hours and allow them to return to Ro Leap once every three months.

When my brothers visit us, Khouy's new bride, Laine, having no family in our village, stays behind at their camp. For this reason, I know very little about my sister-in-law. I have seen her only that one time at the wedding ceremony and thought she was very pretty, even though her eyes were wet with tears. During his visits, Khouy speaks very little about his wife beyond the fact that she is alive and well. It is clear even to me that it is a marriage of convenience and not of love.

There are times when I stare at my brother from across the room and search for the martial artist who jumped in the air and made me

laugh. But the martial artist is gone now. In Phnom Penh, Khouy never just walked from one place to another, he sauntered and glided, stopping many times along the way to greet friends and pretty young women. Wherever he went, a crowd of people always surrounded him.

In our small grass hut at Ro Leap, Khouy sits next to Pa and talks incessantly. He sits with his back straight to the wall as if afraid to lean on it. With his legs crossed and his palms flat on the floor, he is ready to leap up instantly. He is still strong, but the energy and confidence that attracted girls to him are gone. At sixteen, he is already old and hard, and alone. Even with us, he wears a mask of courage that stretches tight over his inflexible face.

Whereas Khouy always put on a brave front, Meng's face hides nothing from us. When he speaks, Meng's voice softens and trembles as he tries to reassure Ma and Pa that everything is okay at the camp. Unlike Khouy, whose body is made more muscular from hard work, Meng's is thin and lanky. Sitting in our hut, he slouches into the bamboo walls and his breath sounds labored and exhausted with each word. When he looks at us, his eyes linger on our faces as if absorbing every single detail so he will not forget. Under his gaze, I shift my position uncomfortably and move away from his sight, troubled to receive such love from my brother when all around me there is only hate.

A few months after Khouy and Meng left, rumors that the Youns, or Vietnamese, have tried to invade Cambodia cause the Khmer Rouge to take many teenage boys and girls from their homes. One day, three soldiers come to the village and tell the new people gathered at the town square that the Angkar needs every teenage male and female to leave tomorrow for Kong Cha Lat, a teen work camp. Upon hearing the news, Keav's eyes well up with tears and she runs to Ma.

"Everyone has to honor and sacrifice for Angkar!" the soldiers yell. "Anyone who refuses Angkar's request is an enemy and will be destroyed! Anyone who questions the Angkar will be sent to a reeducation camp!" Keav and Ma turn to each other and embrace. Pa silently turns his head and takes Geak from Chou's arms.

In the morning, Ma packs Keav's black pajama pants and shirt in a scarf. Keav sits next to Ma with their hands touching. Quietly, we walk

out of the hut and over to the town square, where other teenagers and their families have already gathered. The other teenagers all have tears in their eyes as do their distraught parents. Keav and Ma embrace and hold on to each other so tightly that the knuckles of their fingers turn white. In a matter of minutes, the soldiers come and lead the children away while we watch in quiet despair.

My heart feels as if an animal has clawed it out. I try to muster a smile, so I can send my sister on her way with a final picture of hope. She is Pa's first daughter, and at fourteen she must survive on her own. "Don't worry, Pa, it will be all right. I will survive," she says and walks away, waving. In her black shirt that hangs below her bottom and pants that are frayed at the hem, she looks smaller than the rest of the group.

I remembered then that in Phnom Penh, when she was the most beautiful girl on our block, Ma said that she could have her pick of anyone to marry. Each month, Keav would travel with Ma to a beauty salon to have her hair styled and her nails painted. I used to watch Keav fuss over her school uniform, pressing and repressing her blue pleated skirt and white shirts so they looked as crisp and new as possible. Now the joy of beauty is gone from her life. With the red-and-white checked scarf covering her thinning oily black hair that peeks out beneath it, she looks more like ten years old than fourteen. Keav follows the soldiers, with twenty other boys and girls, and never turns to look at us. Chou and I stand together with tears in our eyes and watch Keav's figure until she is no longer in sight. I wonder if I will ever see her again.

At the other side of the town square some base children scurry back home. Though there are no gates, an invisible line divides the village in two halves. The new people know better than to cross the line. Occasionally, the base men walk through our side of the village, spying on the new people and inspecting their work. A few base children who have not yet gone home stand there now watching us with frowning faces. Rarely do I ever get to see them, or recognize them as individuals. I don't even know how many base children there are in the village. In their new-looking black pajama pants and shirts, their arms and legs fill out their clothes and their faces are round and fleshy. I narrow my eyes with envy and hatred.

"It is good for the family to be separated," Pa says quietly and goes off to work. Ma says nothing and continues to look in the direction Keav has disappeared.

"Why did she have to go? Why didn't Pa beg the chief to let her stay?" I ask Kim when my parents cannot hear me.

"Pa is afraid the soldiers might learn who he really is. The Khmer Rouge soldiers will hurt the whole family if they find out Pa worked in Lon Nol's government. If we are separated when they discover who Pa is, they cannot get to all of us."

I never understand how Pa knows things, he just always does, and he keeps us informed so we will not be careless with our information.

"Pa, will they kill us?" I ask him later on that night. "I heard the other new people whispering at the town square that the Khmer Rouge soldiers are not only killing people who worked for the Lon Nol government but anyone who is educated. We have education, will they kill us too?" My heart races as I ask him. Pa nods grimly. That is why he has told us to act stupid and never discuss our lives in the city.

Pa believes the war will last for a long time and this makes the very act of living sad for him. Every day we hear tales of other families who cannot see the end to their terror and thus commit suicide. We live knowing we are in danger of being discovered at any moment. My stomach churns with nausea at the thought of death. But I do not know how to go on living with such sadness.

I remember painfully the anger I felt toward Ma when she spanked me for breaking her fine china plates, or screamed at me for jumping on the furniture, for fighting with Chou, or trying to sneak candies from the cabinet. Then, as a five-year-old used to getting my own way, I stormed through the apartment during my tantrums. Lying in my room, in a tearful sulk, I often wished I were dead. I wanted to make her suffer for what she did to me. I wanted her to feel hurt and guilty, to know that she drove me to kill myself. Then from the heavens, I would look down and gloat over her misery. That would be my revenge. Above the clouds, I would look down at her puffy, sorry face, and only when I believed she had suffered enough would I return to forgive her. Now I realize that when you die, you don't get to come back to life whenever you want to. Death is permanent.

To fight death, the new people work hard planting rice and vegetables. Yet it seems that the more crops we plant, the less food rations we receive. The harder we work, the thinner and hungrier we become. Still we plant and harvest while the trucks come and go with our crops in order to continue the war. While Ma and Pa help the war effort in the fields, Kim returns home each night from his work as the chief's errand boy bruised and injured from his own war. Handing the leftover food to Pa, Kim talks loudly about his day as Ma touches his bruises, whispering softly, "Thank you, my little monkey." Without a word, Pa takes the food and rations it to us.

Sitting on our step with Chou one evening, I see Kim's figure walking slowly home. Above him, angry clouds cover the sky so that no stars can show him the path home. In his hand, he carries the leftovers wrapped in his kromar and my stomach lurches with happiness in anticipation. As he nears us, I see his shoulders heavily hunched over and his feet drag as if he is trudging through mud.

"Kim, what's wrong?" Chou asks him. Not answering, Kim silently climbs into the hut, with Chou and I following closely behind.

In the dark, Kim walks to Pa and kneels before him. With his head down, he says in a trembling voice, "Pa, the chief told me not to go back to his house."

Pa is still and breathes softly.

"I'm sorry, Pa," Kim says. "I'm sorry, Pa," Kim repeats, his words softly floating in the air. Hearing his despair, Ma puts Geak down and crawls over to Kim. Reaching him, she wraps her arms around his head, pulling him into her chest.

"Thank you, little monkey," she whispers in his hair, stroking his hair as his shoulders heave up and down.

The wind outside blows violently now, trying to part the clouds but to no avail. The stars are still hiding themselves from us. Chou and I reach for each other's hand and brace against the chills. Since the day we first arrived in Ro Leap five months ago, the chief's steady supply of leftovers has kept us from starving. Now we will again go to bed hungry. After what seems like a long silence, Pa tells us that we will get through this somehow.

The next day, standing in the rows of ripe red bell peppers, tomatoes,

orange pumpkins, and green cucumbers, I thought of Keav. It is now March and a month since she had left. Keav loves pumpkinseeds and used to eat them noisily at the movie theater. Thinking of her makes the sun burn hotter on my skin and my pores push out more water, drenching my clothes.

Next to me, Kim wipes his forehead and continues his work in silence. Our job is to fill up the baskets and deliver them to the cooks in the communal kitchen. As my fingers pluck the green beans, my mouth waters. Feeling the fuzzy hair of the beans between my thumb and finger, I crave to put it in my mouth before anyone sees me, but instead I drop it in the basket.

"I'm hungry," I say quietly to my brother.

"Don't eat the vegetables. The village's chief will beat you if you get caught."

Heeding his order, I continue with my work, stopping every once in a while to steal a look at my brother. In Phnom Penh, while Pa took us girls to the swimming pool on Sundays, Kim could usually be found in the movie theater across the street from our apartment. When we returned, we would be greeted at the door by Bruce Lee, the Chinese God, the Monkey King, or a number of kung fu masters ranging from the Drunken Disciple or the Dragon Claw to the Shaolin Monk. Throughout the day, Kim, in character, would jump, sway, twirl, punch, and kick at Chou and me whenever we were in the room with him.

Remembering the little monkey of Phnom Penh, I look away. I wish Kim could go back to work for the chief and continue to bring us their leftovers. But the chief doesn't want Kim to work for him anymore. Neither Kim nor Pa was given any explanation to why he sent Kim away. But Pa suspects that it has something to do with someone named Pol Pot. Lately, the base people in the village are whispering the name as if it is a powerful incantation. No one knows where he comes from, who he is, or what he looks like. Some people are saying that maybe he is the leader of the Angkar, while others argue that the Angkar's leadership is comprised of a large group of men. If it was Pol Pot who gave the order to place more soldiers at the village level, the increase has created a shift in the power balance. In the beginning, the chief was all-powerful and ruled the village with his enforcer soldiers.

Now that the number of soldiers has multiplied, they wield more power and the chief's role has been reduced to that of a manager.

"Kim, where are the soldiers taking all the food?" I ask.

"When the Angkar formed armies, there wasn't enough money to buy guns and supplies for the soldiers. The Angkar had to borrow money from China to buy the guns and weapons. Now it has to pay China back," Kim explains as he continues to drop the vegetables into our straw basket.

"If China is helping the Angkar and giving them money, why then do the soldiers hate us Chinese so much? The other kids hate me because of my whiter skin. They say I have Chinese blood in me," I whisper to him. Kim stands up straight and sees that the other children are out of hearing distance from us.

"I don't know. We should not talk about this. The Angkar hates all foreigners, especially the Youns. Maybe the peasants cannot tell the difference between a Chinese and a Youn, who also have light skin. To someone who's never left the village, all white-skinned Asians look alike."

Later that night, Pa tells Kim that the Angkar wants to expel all foreigners. It wants to bring Democratic Kampuchea back to its glorious past. The time when Kampuchea was a large empire with territories encompassing part of Thailand, Laos, and what is now South Vietnam. The Angkar says we can only do this if no one else owns us.

I do not care why or how the Angkar plans to restore Cambodia. All I know is the constant pain of hunger in my stomach.

new year's

It is April again and soon it will be New Year's. After New Year's, I will be six years old and am still only as tall as Pa's hips. Ma is worried that I will stay this height forever. Ma and Pa worry that malnutrition will stunt my growth and I will never grow to be big like them. I have not looked at myself in a mirror since we left the city. Sometimes, I try to see my reflection in a pond, but the water is always dirty. The blurred child staring back at me looks hollow and distorted, not at all like the little girl in Phnom Penh whose neighbors called her "ugly."

The Khmer Rouge's Kampuchea does not permit the celebration of the New Year or any other holidays. Still, I dream and relive the New Year's celebration we had in Phnom Penh. In Cambodia, New Year's is our biggest and most important holiday. For three days, stores, restaurants, businesses, and schools are closed. There is nothing to do but enjoy the food and festivities. Every day there are parties at friends' houses. At these gatherings, the host serves roast pig, duck, beef, sweet cakes, and beautiful candies. The part I liked best was when the parents took the children around to their friends. Children are not given presents during this holiday. Instead, we are given money—brand-new

crisp bills in decorated red paper pouches. Of course, all that no longer matters to me; my thoughts now are focused solely on food.

Dreaming of food makes my stomach growl with pain. I'd give anything now for a tiny piece of moon cake or a leg of roasted duck. My mouth waters at the thought, and a wave of sadness washes over me. I know that no matter how hard I dream, I am only wishing for the impossible. I hope Ma and Pa don't know what we kids think about all the time. They want us to forget about our past lives and to survive in the present. It is no use thinking about food knowing you will not get any. Still, it is hard to think of anything else. Hunger eats at my sanity.

Many people in the village are risking their lives to steal corn from the nearby fields. I see the way they sneakily eat food, quickly hiding it when they see me walk by. I want to ask them to share some with me, but I know it is useless for then they will have to admit their crime. As much as I want to become a thief myself, I do not have the courage to do it. It seems a lifetime ago when I was rich and spoiled in Phnom Penh, when children stole from me and I did not care. I could afford to be stolen from, but I judged them harshly for doing so. I thought thieves were worthless, too lazy to work for what they wanted. I understand now that they had to steal to survive.

On New Year's eve, I have my greatest dream and my worst nightmare. I am sitting alone at a long table. The table is covered with all of my favorite food in the world. There is food everywhere as far as my eyes can see! Red and crispy roasted pig, brown and golden duck, steaming dumplings, plump fried shrimp, and all kinds of sweet cakes! Everything looks and tastes so real that I do not know it is a dream. I shove everything into my mouth at once with both hands, licking my fingers deliciously. Yet the more I eat the hungrier I become. I eat with great anxiety and urgency, fearing the Khmer Rouge soldiers will come and take it all away from me. I am so greedy, I do not want to share the food with anyone, not even with my family. In the morning, I wake up feeling depressed and guilty. I wake up wanting to scream, yell at Geak, and beat up Chou because I do not know what to do with my despair. Always the hunger pains are there, never ending, never leaving me. Often, I feel guilty because in my dream, I gorge and hide the food from even Geak.

Every minute of the day, my stomach grumbles as if it is eating itself. Our food ration has been steadily reduced to the point that the cooks are now only getting a small twelve-ounce can of rice for every ten people. My brothers' food rations are so small that they have very little to give us when they visit. They try to come often, but the soldiers make them work harder, leaving no time to visit.

The cooks continue to make rice soup in a big pot and serve it to the villagers. During mealtime, my family lines up with our soup bowls in our hands along with the other villagers to receive our ration. The cooks used to serve us rice gruel, but now there are only enough grains in the pot to make soup. When it is my turn to receive the food, I watch anxiously as the cook stirs the rice soup. Holding my breath nervously, I pray she will take pity on me and scoop my ladle of soup from the bottom of the pot, where all the solid food rests. Staring at the rice pot, I let out a breath of hopelessness when I see her take the ladle and stir the soup at my turn. Both hands tightly gripping my bowl, I take my two ladlefulls and walk to my shaded spot underneath a tree, away from all the others.

I never eat my soup all at once, and do not want my own family to take mine away. I sit quietly, savoring it spoonful by spoonful, drinking the broth first. What's left at the bottom of my bowl is approximately three spoonfuls of rice, and I have to make this last. I eat the rice slowly, and even pick up one grain if I drop it on the ground. When it is gone I will have to wait until tomorrow before I can have more. I look into my bowl, and my heart cries as I count the eight grains that are left in my bowl. Eight grains are all I have left! I pick up each grain and chew it slowly, trying to relish the taste, not wanting to swallow. Tears mix with the food in my mouth; my heart falls to my stomach when all the eight grains are gone and I see that the others are still eating theirs.

The population in the village is growing smaller by the day. Many people have died, mostly from starvation, some from eating poisonous food, others killed by soldiers. Our family is slowly starving to death and yet, each day, the government reduces our food ration. Hunger, always there is hunger. We have eaten everything that is edible, from rotten leaves on the ground to the roots we dig up. Rats, turtles, and snakes caught in our traps are not wasted as we cook and eat their

brains, tails, hides, and blood. When no animals are caught, we roam the fields for grasshoppers, beetles, and crickets.

In Phnom Penh, I would have thrown up if someone told me I would have to eat those things. Now, when the only alternative is to starve, I fight others for a dead animal lying in the road. Surviving for another day has become the most important thing to me. About the only thing I have not eaten is human flesh. I have heard many stories about other villages where people have eaten human flesh. There was a story about a woman in a village nearby who turned to cannibalism. They say she was a good woman, not the monster the soldiers portray her to be. She was so hungry that when her husband died from eating poisonous food, she ate his flesh and fed it to her children. She did not know that the poison in his body would kill her and her children as well.

A man in our village came upon a stray dog in the road one day. The poor dog did not have much meat on it, but the man killed and ate it anyway. The next day, the soldiers arrived at the man's door. He cried and begged for mercy, but they did not pay any attention to him. He raised his arms as a shield, but they did not protect him from the blows of the soldiers' fists and rifle stocks. He was never seen again after the soldiers took him away. His crime was that he did not share the dog meat with the community.

I feel sorry for this man's fate, for I would have done the very same thing to my dog. In Phnom Penh, our family had a friendly little puppy with a wet nose. It was a tiny thing with shaggy long hair that dragged on the ground. The dog loved to hide underneath big piles of clothes on our oriental rugs. Our housekeeper was quite fat and did not know that the dog liked to hide. It was a terrible sight when she stepped on and killed the dog. Pa threw the body away before any of us girls saw it. It shames me now to know that I would eat it if it were alive today.

Thinking about food makes my stomach growl with hunger. Pa tells me today is New Year's. Though my feet ache I decide to go for a walk in the nearby fields. Pa has been granted permission from the chief for me to stay home because I am sick. After a few hours of lying in our hut, the growls in my stomach demand that I search for food. My eyes probe the ground, hoping to find some food to fill my hungry stomach.

It's a hot day and the sun burns right through my hair, searing my greasy scalp. I run my fingers through my hair feeling for the lice that make my head itch. With no shampoo or soap, it is a constant battle to keep myself clean, and as a result, my hair clumps together in greasy knots, which makes it hard for me to catch the lice. I pause in the shade underneath a tree for a short rest.

In Phnom Penh, I could run very fast around our home, barely avoiding the corners and sharp edges of furniture. Even on school nights, I would seldom go to sleep until late. I am now always so tired. Starvation has done terrible things to my body. After one month of having very little to eat my body is thin all over, except for my stomach and my feet. I can count every rib in my rib cage, but my stomach protrudes outward, bloated like a ball between my chest and hips. The flesh on my feet is so swollen it glistens as if it will pop open. Curious, I push my thumb into my swollen feet, pressing the flesh inward and creating a big dent. Counting under my breath I wait to see how long it takes for the dent to fill itself up. After a while, I make more dents on my feet, legs, arms, and face. My body is like a balloon. The dents I make reinflate slowly. Even walking is a difficult task because my joints hurt whenever I move. When I do move, seeing where I am going becomes a challenge because my eyes are nearly swollen shut. When I do see well enough to walk, my lungs yearn for enough air, and being short of breath, it takes a laborious effort to control my balance. Most days, I have neither the energy nor the desire to walk around, but I must walk today to search for food.

Slowly, I make my way to the blackened forest in the back of the village. A couple times a year, the soldiers set sections of the forest ablaze to create more farmland. I don't know why they do this since we haven't the strength to work the land already cleared. This part of the forest has just been burned a few days before and the ground is still hot and smoking. I search the ground for animals and birds that might have been trapped or killed in the fire, providing me with ready-cooked food. Last month, in another part of the forest the Khmer Rouge razed to create more farmland, I found an armadillo curled up in ball, its shell burnt and crisp. Still, it took some work on my part to uncurl the ball and get to the tasty cooked meat inside. Today, I have no such luck.

A long time ago Pa told me that April is a very good luck month. In the Cambodian culture, New Year's always falls in April, which means that all the children born before New Year's become a year older. In the Cambodian calendar year, Kim is now eleven, Chou is nine, I am six, and Geak is four. In Cambodia, people don't celebrate the day on which they were born until they've lived past their fiftieth year. Then families and friends gather to feast on sumptuous food and honor the person's longevity. Pa told me that in other countries, people become a year older only after having passed the exact day and month that they came into the world. On this day every year, friends and families gather to celebrate with food and presents.

"Even children?" I asked him, incredulous.

"Especially children. Children get a big sweet cake all to themselves."

My stomach swishes at the thought of having a sweet cake all to myself. I pick up a piece of charcoal from the ground. Tentatively, I put it in my mouth and chew it. It does not taste like anything, just chalky and a little salty. I am six years old and instead of celebrating with birthday cakes, I chew on a piece of charcoal. I pick up a couple more pieces for later and put them in my pockets as I head toward home.

Passing through the village, the stench of rotten flesh and human waste hangs heavily in the air. Many of the villagers are getting sicker and sicker from disease and starvation. They lie in their huts, whole families together, unable to move. Concave faces have the appearance of what they will look like once the flesh rots away. Other faces are swollen, waxy, and bloated, resembling a fat Buddha, except they don't smile. Their arms and legs are mere bones with fleshless fingers and toes attached to them. They lie there, as if no longer of this world, so weak they cannot swat away the flies sitting on their faces. Occasionally, parts of their body convulse involuntarily and you know they are alive. However, there is nothing we can do but let them lie there until they die.

My family does not look very different from them. I think how I must appear to Ma and Pa. Their hearts must break at the sight of me. Perhaps that's why Pa's eyes cloud over when he looks upon us. As I near my hut, the stench and heat overwhelm me, causing my temples to throb. The pain in my feet travels up to my stomach. Showing no

mercy, the sun burns through my black clothes, scorching the oil on my skin. I tilt my face up to the sky, forcing myself to look directly into the sun. Its brightness stings my eyes, making me temporarily blind.

As April turns into May and May into June, the leaves shrivel, the trees turn brown, and the river streams dry up. Under the summer sun, the stench of death is so strong in the village, I cover my nose and mouth with my hands and breathe only the air that filters through my fingers. There are so many dead people here. The neighbors are too weak to bury all the corpses. Often the bodies are left in the hot sun, until the smell permeates the surrounding air, causing everyone passing by to pinch their noses. The flies come buzzing around the corpses and lay millions of eggs on the bodies. When the bodies are finally buried, they are nothing more than large nests of maggots.

For lack of anything else to do when my body gets too sick to work in the garden, I often watch the villagers dispose of the corpses. I see them dig a hole underneath the hut of the dead family and cringe as they push the bodies into the hole. The dead families are buried together in one grave. There were times when such scenes terrified me, but I have seen the ritual performed so many times that I now feel nothing. The people who die here have no relatives to grieve for them. I am sure that my uncles do not know of our whereabouts either.

One of our neighbors in the village is a widowed mother of three. She has been alone since soldiers murdered her husband. Her name is Chong and her girls Peu and Srei are five and six, and she had a baby boy of about two. The boy has become the village's latest victim of starvation. I saw him before he died: his body was all swollen, very much like mine, with bloodless skin that looked like white rubber. Chong held him in her arms everywhere she went. Sometimes she carried him in a scarf tied diagonally across one shoulder and her back, his lifeless feet dangling in the air. Once she tried to breast-feed him at our house, but nothing would come out of her body. Her breasts were empty sacks hanging against her ribs, but nevertheless she lovingly put them in the boy's mouth. He never responded to his mother's nipple. He never moved or cried but lay in her arms as if in a coma. Every once in a while, he jerked his head or moved his fingers to show that he was still alive, but we all knew he would not make it. There was nothing we

could do for the baby. He needed food, but we had none to spare. At our house, Chong held her baby and talked to him as if he weren't dying, just sleeping. He died quietly in his sleep a few days after they visited us. Still, his mother continued to carry him with her, refusing to believe he was dead until the chief forced the baby from her arms and buried him.

The two girls and Chong have taken a turn for the worse since the death of the boy. A few days after his death, his two sisters decided to go to the forest and look for food by themselves. They were so hungry they ate mushrooms that turned out to be poisonous. After they died, Chong ran hysterically over to our house. "They were shaking all over! They kept calling me to help them, and I couldn't! They kept crying. They didn't even know what happened to them!" Ma catches Chong in her arms as she falls to her knees.

"They are resting now. Don't worry, they are sleeping." Ma holds Chong in her arms.

"They turned all white, the hair on their bodies stood up and blood came out of my babies' pores! My babies shook and cried for me to help them, for me to take their pain away. I couldn't do anything for them. They rolled on the ground screaming in pain, asking me to make it stop. I tried to hold on to them, but I wasn't strong enough. I watched them die! I watched them die! They died crying for me, but I couldn't help them." Chong sobs uncontrollably, sliding to the floor, and lays her head on Ma's lap.

"There is nothing we can do now. They are resting." Ma strokes Chong's arm, trying to soothe her pain. But no one could save her from the pain; she cries in howls. She reached her hands into her shirt to massage her chest as if trying to exorcise the pain from her heart.

Standing beside Ma, I watch the girls being buried near their house. I cannot see their bodies, but earlier two villagers had brought out two small bundles wrapped in old black clothes. The bundles looked so small that it is hard to imagine they were once the girls I knew. I wonder if the Angkar cares that they are dead. I remember when we first arrived at Ro Leap, the chief told us the Angkar would take care of us and would provide us with everything we need. I guess the Angkar doesn't understand that we need to eat.

I turn to look at Geak, who is sitting under a tree with Chou, away from the burial procession. She is so small and weak. The lack of food has made her loose so much of her beautiful hair and it is now little more than wispy patches on her head. As if sensing my stare, she turns her head toward me and waves. My poor little sister, I cry silently, when will it be your turn to be bundled up like them? Geak waves at me again and even attempts a smile, baring her teeth. A wave of heaviness descends upon me. By smiling, she only manages to stretch her skin back even more, and I can see what she will look like when she is dead and her skin dries over her bones.

Chong sobs loudly as the villagers put the girls in a little hole. When she sees the villagers cover her girls with dirt, she runs over to the grave and attempts to climb in. Tears, phlegm, and drool from her eyes, nose, and mouth drip all over her shirt. "No," she cries. "I'm all alone. I'm all alone." Two male villagers pull her out of the grave and hold her back until the last shovel of dirt is piled on top of Peu and Srei. When the job is done, the villagers walk away to the next hut to dig the next grave. "This one will be easier," a man says as he shakes his head. "No survivors in the family."

After the deaths of her children, Chong has now gone crazy. Sometimes I see her walking around still talking to her kids as if they are there with her. Other times her eyes clear up and she realizes they are dead, and screams, beating her fists on her chest. A few days later, Chong comes to our house with great news for Ma. "I have found the perfect food—don't know why I didn't think of it before! It's safe and it doesn't taste bad either," she says excitedly to Ma. Then her eyes fog over, her hands wave about her in agitated motions, and she whispers, "I could have saved my children."

"Wait, what is it? What is it?" Ma asks anxiously.

"Earthworms! They're fat and juicy. You take the dirt off, cut them open, wash them, and cook them. It isn't bad, cook 'em like you do noodles. I've tried it! Here's a little bowl." She hands her bowl of earthworms to Ma.

"Thanks," Ma manages to say.

"I have to go. I have to go find my children." Chong smiles at Ma and rushes off.

I feel like retching at the thought of eating them. Earthworms feed off of dead things in the ground. For me, eating them would be like eating dead people. I try to picture a nice clean bowl of worms, but the picture changes to worms crawling on the rotten flesh of the dead we bury, writhing and squirming their way into the body by the thousands. "Don't worry, I still have some jewelry left that we can trade for food. We won't have to do this," Ma says to me.

We are some of the few very fortunate people in the village who have possessions to trade with the base people for food. Our situation is not as bad as others because we still have gold, diamonds, and precious gems. At Uncle Leang's hut, Ma managed to hide them from the soldiers by sewing them in the straps of our bags, which we kept even after they burned our clothes. This jewelry, though beautiful, is now almost worthless because of the war. An ounce of gold buys only a few pounds of rice, if we're lucky. Most of the time, we get less than that. Among the many crimes that exist in the Khmer Rouge society, bartering for food is viewed as an act of treason. If caught, the trader is whipped into confessing the names of all parties involved. The Khmer Rouge believes one individual should not have what the rest of the country does not have. When one person secretly acquires more food than the others have there is an inequality of food distribution in the community. Since we are all supposed to be equal, if one person starves, then all should starve.

A few weeks ago, Kim told me that maybe the Angkar isn't to blame. He says the name Pol Pot is passing through many lips in the rice fields and village. Many are saying that Pol Pot is the leader of the Angkar but still no one knows who he is. They whisper that he is a soldier, that he is brilliant, and that he is the father of the country. They also say he is fat.

They say he has kept his identity a secret to guard against assassins. They say that he liberated us from foreign domination and gave us independence. They tell us Pol Pot makes us work hard because he wants to purify our spirit and help us achieve beyond our potential as farmers. The say he has a round face, full lips, and kind eyes. I wonder if his kind eyes can see us starving.

After the villagers buried her children, we see less and less of Chong now. She has come to be known in the village as "the crazy lady." She

eventually ate some poisonous food and died the same way her daughters did. Her body was found by one of the villagers the next day, all contorted and bloody. They buried her in the ground next to her children.

We survive this period because Pa is friendly with the chief. The base people do not eat at communal kitchens but cook for themselves. Among them, the chief's family is the fattest and wears only new black, shiny clothes, not the faded gray rags we have on. Pa is able to get extra rice in exchange for the gifts he gives to the chief. Pa lies and tells the chief that he was only a shopkeeper in Phnom Penh, that he found the jewelry in the deserted houses during the evacuation. Pa gives him Ma's ruby bracelets, her diamond rings, and much more in exchange for a few pounds of uncooked rice. Pa puts the rice in a bag, inside a container, and hides it beneath a small pile of clothes so that the other villagers cannot see it. On some nights when we really need it, Pa allows Ma to cook a tiny portion of the rice and mask the smell by burning damp, decayed leaves in the fire. This extra rice is our family's defense weapon against completely starving to death.

One morning, Chou wakes all of us with her loud cries. "Pa, someone was in the container last night!" All eyes turn on the exposed rice container, the lid lies crooked on top and slightly ajar.

"Maybe some rats got into it and stole some. Don't worry, tonight I will seal it very tight," he says. "This rice belongs to all of us."

As Pa speaks, I know that he thinks someone in our family has stolen the rice. The story of the rat is not true and everyone knows it. Convinced that he realizes it was me, I hide my eyes from him. Shame burns my hand like a hot iron branding me for all to see: Pa's favorite child stole from the family. As if to rescue me, Geak wakes up and her cries of hunger interrupt the incident. "It was me, Pa!" my mind screams out. "I stole from the family. I am sorry!" But I say nothing and do not confess to the crime. The guilt weighs heavily on me. I had gotten up in the middle of the night and stolen the rice. I wish I had been still in between the sleeping and waking worlds when I did it, but that is not true. I knew exactly what I was doing when I stole the handful of rice from my family. My hunger was so strong that I did not think of the consequences of my actions. I stepped over the others'

sleeping bodies to get to the container. With my heart pounding, I slowly lifted off the top. My hand reached in and took out a handful of uncooked rice and quickly shoved it into my hungry mouth before anyone woke and made me put it back. Afraid that the crunch of uncooked rice might wake the others, I softened the grains with saliva. When it was soft enough, my teeth ground the rice grains, producing a sweet taste that slid easily down my throat. I wanted more, I wanted to eat until I was full and worry about the punishment later.

"Bad! You are bad!" my mind scolds me. "Pa knows."

A long time ago, Pa told me people should be good not because they are afraid of getting caught but because bad karma will follow them through their lifetime. Until they make amends, bad people will come back in the next life as snakes, slugs, or worms. At six years old, I know I am bad and deserve whatever low life-form I will be reincarnated as in the next life. Who else but a bad person would cause the starvation of her family for her own selfish stomach?

From that day on, I stay more and more to myself. I stop going to Pa to ask him questions or to just sit near him. I stop looking at Geak, my four-year-old sister, slowly disappearing from malnutrition. My only constant companions are the growls in my stomach. Mean-spirited and restless, I fight constantly with Chou, who is older and more timid than I, and she only fights back with words. On the other hand, I often push her to fight with me physically. I want to be punished for the rice I stole from them, for someone to hurt me. Ma, however, allows our fights to go directly to her temples, giving her headaches. Pa is the only one who still has self-control, and our constant fights do not drive him over the edge.

During one fight, I push Chou too far, and she pushes me back. That was all the reason I needed to charge at her. Knowing she is no match for me, she screams to Ma for help. Angry, Ma picks up a coconut shell and throws it at me. The hard shell hits my head with a bang, as a flash of white pain explodes in my skull. Dizzy, I lean against the wall for balance, breathing slowly. Then something drips down my forehead, running down my cheek. Raising my hand, I wipe my cheek as droplets of blood fall onto my shirt. Staring at her with vehemence, I sit down and yell at Ma, "I am going to die because of you!"

Her face darkens with worry as she realizes what she has done. Quickly, she rushes over to me and tends to my wound. "Look at what you made me do," she says, her voice breaking. "You kids just would not stop and you, Loung, always start these fights. You get on my nerves too much." My lips quiver with shame for being bad. Ma is crying because of me, because I am bad and can do nothing right. Later that evening, Pa comes home and tells me I am not going to die, that it is only a bad cut. I trust Pa and believe him. He leaves me and goes to speak to Ma.

Ma avoids looking at him as he approaches her. My parents almost never fight. Pa is always so much in control of himself that I have never seen him lose his temper. This time he speaks loud, angry words to Ma. She sits in the corner of the room, arranging and rearranging our black clothes and our food bowls. Standing, Pa hovers over her. "Why did you do that? You could have hit her eyes or worse. Then what would we have done? How would a blind child survive here? You have to think of things like that now!" Saying nothing, Ma quietly wipes her eyes with her red scarf. Pa says many other things to Ma, but I stop listening.

When Pa leaves for work, Ma, holding Geak, comes to me. "I didn't mean to hurt you. You kids fight too much and I lost my head. Why are you always fighting with everyone?" That is as much of an apology as any child will get from an adult in Cambodia. I look at her, grit my teeth, and turn my head away. When I don't want to listen to anyone, I go inside myself to a place no one else can reach. As Ma talks on, I ignore her. Noticing this, she sighs and finally walks away. When she and Geak leave the hut, a tornado of anger rises up in me, quickening my breath. Black and strong, I direct this anger at Ma for making me feel all this pain. Staring blankly at my empty rice bowl, I act as if I do not care what she said to me. For a brief moment, I even wish her dead. I wish her dead for showing me that I am bad. Inside, I hate myself for not being good and for always being the troublemaker in the family.

Moments later, Kim calls Chou to return to the communal garden for our work assignment. Seeing me, he glares and marches on ahead of us without a word to me. Chou runs over to me and grabs my hand. I bow my head down. I know our fight was my fault, and yet Chou is

not angry with me. For her, the fight is over; she has already forgiven me. I wonder if she knows that I choose her to fight with because I know she will always love and forgive me. With our fingers entwined, we walk together to the garden.

That night, lying on my side between Chou and Geak, I stare at Ma sleeping next to Pa. My anger subsides and the bottom of my stomach opens, drawing me deeper and deeper into a pit of despair. I remember her in Phnom Penh, her laugh as I bounce on her lap as we ride in a cyclo. She was so beautiful. No one from our past would recognize her. Her red lips are purple and dry, her cheeks are sunken, there are deep shadows under her eyes, her porcelain white skin is brown and wrinkled from the sun. I miss the sound of my mother's laughter in our house. I miss my mother.

Unlike Pa, Ma was never used to hard work or labor. She was born in China and moved to Cambodia as a little girl. After they were married, Pa took care of Ma in every way. Now he urges Ma to work harder than the other new women in the community. Ma also has to be extra careful because she speaks Khmer with a Chinese accent. Pa fears that this will make her a target for the soldiers who want to rid Cambodia of outside ethnic poison. Ma is proud of her heritage but has to hide it before it proves dangerous to us all. Pa says that the Angkar is obsessed with ethnic cleansing. The Angkar hates anyone who is not true Khmer. The Angkar wants to rid Democratic Kampuchea of other races, deemed the source of evil, corruption, and poison, so that people of the true Khmer heritage can rise to power again. I do not know what ethnic cleansing means. I just know that to protect myself, I often have to rub dirt and charcoal on my skin to look as dark as the base people.

keav

Six months after Keav left our village and sixteen months since the Khmer Rouge took power, a young girl arrives at our village in the morning looking for Ma and Pa. "I come with a message from Keav," she says. "You must come to the hospital. She is very sick and she wants to see you."

"Why? What's wrong with her?" Ma manages to ask, shifting Geak on her hip.

"The nurse believes it is something she ate. She has a terrible case of diarrhea. You must come now. She has been sick all morning and asking for you all this time." Pa cannot get off work to go see Keav, and we do not know how sick she is. After receiving permission from the chief, Ma leaves with the girl to see Keav.

Keav still lives in Kong Cha Lat, a teenage work camp with about 160 laborers. The teenagers are separated in two houses, one for the boys and one for the girls. At the camp, they work from dawn until dusk in the rice fields. The girls are given less food than the boys but are expected to work just as hard. Both their food rations consist only of watery rice soup and salted fish.

After Pa and Kim leave for work, Chou, Geak, and I wait for Ma to return. Since we have no instruments to tell us the time, and we're no good at guessing it from the sun's position in the sky, the wait feels like forever. While Chou fans the flies off Geak, who is asleep beside her, I pace the ground in front of our hut. Each step I take, the earth beneath seems to shift, throwing me off balance. Each breath I take, the air rushes quickly down my throat, choking me. In my mind, I envision Keav at her camp.

Keav woke one day to notice that her stomach was bloated and rumbling, making sounds as if something was swishing around inside. She ignored it, believing it was merely hunger pains. She took a deep breath, tears welling up in her eyes. Always there are the hunger pains. Sometimes the hunger pains hurt so much that they spread to every part of the body. It has been a long time since she'd had enough to eat. She rubbed her hand on her stomach, telling it to settle down.

Following the rules, she rolls her straw mat off the floor and leans it against the wall. The dirt floor is hard and full of black ants and other bugs. At night, she always makes sure she closes her mouth tightly and pulls her blanket up above her head, hoping to leave no openings for the bugs to crawl in. She looks around her camp, her eyes focusing on a few faces she recognizes among the eighty girls she lives with. She smiles at them but is greeted with blank stares. Clenching her teeth together, she turns away from them and inhales deeply. She knows she cannot show her emotion, or the supervisor will think she is weak and not worth keeping alive. Unlike our family's hut in Ro Leap, she does not have the privacy of her own space to let go of her emotions. At the camp, if she cries she will be judged by 160 pairs of eyes that will think her weak. And she misses us so. This time the tears spill over and she quickly wipes them with her sleeves before anyone sees.

In my mind's eye, I see Keav breathing deeply and trying to fill the void in her heart. Her lungs expand and take in more air as she chases our images away. This loneliness. How is she to survive this loneliness? To live in a place where no one cares about her and everyone is out to get her. She has no protection there. She is utterly and completely alone. She misses Pa so much, misses his protection and the way he looks after her and worries about her. She misses Ma's arms around her, stroking her hair.

She walks over to the water tank and scoops out a bowl of water to wash her face with. She uses a piece of her old black pajama shirt to try and clean her

teeth, remembering how Pa wanted her to take care of herself. She rubs the cloth across her teeth a few times, but her gums are too sore and she quits. She looks at her reflection in the water and gasps. She is ugly. Would anyone believe that she was once a very beautiful girl? She is fifteen and looks no bigger than a twelve-year-old. Her fingers gently touch her protruding cheekbones. In Phnom Penh, she often protected her skin with cleanser and moisturizers. Now damaged by the sun it is marked with scars and pimples. Her oily hair is so thin that her scalp peeks through. It is cut short, in the same block style as the rest of the eighty girls, and makes her look like a young boy. She glances at her body and she recoils. Her arms and legs are like sticks, but her stomach is fat and bulges out like she is pregnant.

Tears flow easily from her eyes, but it is okay. She could disguise them by splashing water on her face, pretending to wash her eyes. She is fifteen and has never held a boy's hand, never been kissed by a boy, never felt a lover's warm embrace. There are a lot of nevers in her life, not that it matters now. She only longs for them because she wanted someday to experience the love Ma and Pa have for one another.

She wraps her red scarf around her head and walks toward the rice fields. Every day she works in the rice fields, planting and harvesting rice. Everyday, it is backbreaking work. It is only five A.M., but today she could see that the sky is hazy and cloudless. The air is already hot and humid. In an hour, the haze dissipates to expose a white sky. Her black pajama pants and shirt absorb the sun's rays and sweat drips out of all her pores. With the sun beating down on the top of her head, the heat and humidity make it difficult for her to breathe.

An hour passes and her stomach continues to growl, making loud, angry noises. She ignores it, hoping it will eventually settle itself. Talking and singing isn't allowed during work. Planting rice now has become an automatic, physical action, requiring no concentration. Thus, she has a lot of time to spend with herself in her head, too much time even. Her mind grows lazy and wanders around too many topics—her schoolwork, a cute boy she met in Phnom Penh, movies she saw—but always it comes back to our family. She misses us so much.

Another hour passes, and her stomach is now in great pain, causing her to double over. She wraps her arms around her stomach, runs to the bushes, pulls her pants to her ankles, and lets the poison run out of her. She pulls her pants up and walks back to the fields but soon has to rush to a bush again. After several visits to the bushes, she finally walks over to the supervisor.

"*Please, I am very ill. It is my stomach. May I take the rest of the day off and visit the infirmary?*" She pleads with the supervisor. The supervisor looks at her with disgust and contempt.

"*No. I do not believe you are sick. We all have hunger pains. You are just a lazy, worthless city girl. Go back to work.*" Keav's heart shatters at being so denigrated.

Another hour passes, but her stomach refuses to settle down. In that hour, she spent ten minutes in the rice field and the rest of the time in the bushes. She is then so sick and weak that she has to drag her body to the supervisor.

"*Please, I am very sick. I cannot stand up anymore.*" As sick as she is, Keav's face burns with embarrassment as she follows the supervisor's gaze to her leg. On her last trip, Keav soiled her pants.

"*You smell terrible. All right, you have permission to go to the hospital.*" Finally, with permission slip in hand, Keav staggers back to her camp and collapses.

An hour after she leaves the field, Keav finally arrives at the makeshift hospital where there are many patients waiting to see the nurses. The hospital is a decrepit old building with many cots lined up on the ground. When Keav approaches a nurse and reports her illness, the nurse takes her arm and leads her to a cot to lie down. Without taking her pulse or touching her, the nurse asks Keav a few brief questions about her symptoms and hurries away, saying she will return later to check on her and bring some medicine. Keav knows this is a lie. There is no medicine. There are no real doctors or nurses, only ordinary people ordered to pretend to be medical experts. All the real doctors and nurses were killed by the Angkar long ago. Still Keav is glad to be out of the sun.

At Ro Leap, when the sun hovers directly over my head, the lunch bell rings at one P.M. Rushing out of our hut, Chou, Geak, and I meet Pa and Kim at the communal kitchen to receive our ration. Sitting in the shade, we eat our meal of thin rice soup and salted fish in silence. Chou feeds Geak from her own bowl, being careful Geak doesn't spill or drop anything. Her round stomach, small head, sticklike arms and legs look disproportional to the rest of her body. All around us, groups of five to ten people sit together and quietly consume just enough food to live for another day.

I look up and see Ma's figure returning. Her face is red and puffy from crying. We know something is seriously wrong, yet none of us are

ready for the shock of the news. "She's not going to live, she's not going to make it," Ma weeps as she whispers the words. "Keav is not going to survive the night. She is very sick and has a bad case of dysentery. They believe she ate poisonous food. She is so very thin and sick just from one morning of diarrhea." Ma drags her palms from her eyes down to her cheeks as she describes Keav to us. She tells us there is no flesh left on Keav's body. Keav's eyes are sunken deep into their sockets, and she can hardly open them to look at her. When she first saw Ma, she did not recognize her. Keav wheezed and gasped for air just from trying to talk to her. Ma breaks down and weeps loudly.

When she finally did speak, she kept asking for Pa. "Ma, where's Pa? Ma, go get Pa. I know I am going to die and I want to see him one last time. I want him to bring me home to be near the family," Ma tells us. "That is her last wish, to see her family and be near them even after she's gone. She said she is tired and wants to sleep but will wait for Pa to get there. She is so weak she cannot raise her hand to wave the flies away from her face. She is so dirty. They didn't even clean her mess up until I got there. They just let her lie there in her sickness and dirty sheets. No one is taking care of my daughter."

After Ma and Pa receive permission from the chief to go get Keav, they hurriedly leave together. I sit on the steps of our hut with Kim, Chou, and Geak, watching our parents disappear to bring my oldest sister home to us. Kim and Chou sit quietly, lost in their own thoughts. Geak crawls over to me and asks where Ma went. Receiving no answers from us, she climbs down the steps to sit on the ground. Picking up a branch, she draws circles, squares, and crude pictures of our hut in the dirt. As we wait, the minutes turn into hours, the hours into eternity, and the sun refuses to lower in the sky to make time pass faster.

I follow them in my mind as they travel to the hospital to find my sister. I imagine Keav there, waiting for our parents.

Keav remembers the feel of Ma's hand softly touching her forehead. It is the best thing in the world to have someone love you. Though she can not feel her body much, it is nice to have Ma's hands on her, cleaning, wiping, smoothing her hair. She misses them so much! She misses Ma so much now! The memory brings a small smile to her lips. She smiles again thinking of Ma, but soon the smile turns to tears. She cries silently, finally letting go of her emotions. She

wishes Ma didn't have to see her like this, worrying about how she appears to Ma during her last visit. Ma is so shocked and sad to see Keav in this condition. Ma cries a great deal and tells her profusely how much she is loved. Ma gently holds her hands and kisses her forehead. She wants to sit up for Ma, but her body is so weak that the slightest movement is painful. There is so much she wants to say to Ma but talking is difficult.

She is frustrated at being trapped in a body that refuses to move. When Ma leaves, Keav can only turn her head to watch her disappear. "Come back quickly, Ma," she whispers. She knows Ma does not want to leave her, but Keav wants to see Pa one last time. She misses him and the rest of her family so much. A wave of sadness washes over her and seeps into every inch of her body, taking her breath away. A sadness so enormous and overwhelming she does not know what to do with it. A black fly buzzes over and lands on her hand. She is too weak to swat it off. A strange chill runs up her spine. She knows it to be pure fear. Her heart weighs so heavy, and it is getting more and more difficult to breathe. "Pa, I'm so afraid," she cries into the thin air. "Please come see me soon."

When, at last, I see their distant figures return, my siblings and I rush toward them. My heart breaks when I see my parents return without my sister. Their faces are drawn and long. I run to them for news of my sister's condition, though in my heart I know she is already dead. Ma, having lost her oldest daughter, runs to her youngest daughter, four-year-old Geak, and clasps her tightly.

"Keav was already dead by the time we got there," Pa speaks wearily. "She died shortly before we arrived. The nurse said she kept asking if we had arrived yet, saying how she wanted to be home and nowhere else. We got there too late. I asked the nurse if I could take her body home, but they no longer knew where she was. They had thrown her body out because they needed her bed for the next patient. We tried to look for her among the dead on the floor but could not find her." The nurse went on to tell Pa that more than a dozen girls died that day from food poisoning. She said it is lucky they were notified at all. Most of the time, they don't know where to contact the parents. Those they have no contacts for, they bury right away. Keav's body must have gotten mixed up with them. "They acted as if we should be thankful we were told. Now she's dead, and we cannot find her." Pa

tries to control his anger but his face contorts. His shoulders shaking, Pa hides his tears from us and covers his face with his hands.

"I asked them if I could have Keav's belongings," Ma whispers hoarsely. "The nurse went to look for them but came back with nothing. When I saw her, Keav still had the gold watch, a gift from us that she kept hidden. When she knew she was dying she took it out and wore it for the first time. The nurse said she does not remember seeing a watch on her wrist and does not know where it is." Most likely, someone had stolen it off her wrist.

I cannot listen anymore. I run and run, finding myself heading for the woods. There, beneath a large tree, next to a thick bush, I hide from the rest of the world. Hugging my knees tightly to my chest, I rest my head on my forearms. I cup my hands over my mouth and scream out in pain over the cruel death of my sister. The sound burns in my throat, fighting to be released, but I hold it in as tears stream out of my eyes.

People have always said that Keav and I were similar in many ways. We looked almost identical to each other and were also alike in personality. We were both headstrong and always ready to fight. Keav's last wish was not granted; she did not get to see Pa before she died. I wrap my arms around my stomach and double over in pain, falling to the ground. In the thick grass, my tears pour out for my sister and seep into the earth.

That night, lying on my back, my hands crossed over my chest, I ask Chou what happens to people when they die.

"No one knows for sure, but it is believed that at first they sleep peacefully, not knowing they are dead. They sleep for three days, and on the third day they wake up and try to return home. That's when they realize they are dead. They are sad but have to make peace with themselves. Then they walk to a river, wash the dirt off their bodies, and start their journey to heaven to wait for their next reincarnated life."

"When will they be reincarnated?"

"I don't know," Chou replies.

"I hope she won't be reincarnated here," I say quietly. Chou reaches out for my hand and holds it gently as she wipes her eyes with her sleeve. I think about what Chou has just told me. I imagine Keav sleeping peacefully somewhere. On the third night she wakes up

only to realize that she is dead. It saddens me to think of her pain upon finding out she cannot return home. I imagine Keav in heaven, watching over us, finally happy again. I picture her the way she looked before the war, and wearing a white gown and washing in the river. I see her the way she looked in Phnom Penh, not the way Ma described her.

The reality of Keav's death is too sad so I create a fantasy world to live in. In my mind, she is granted her last wish. Pa gets there in time to hear Keav tell him how much she loves him and he gives her our messages of love. He holds her in his arms as she dies peacefully feeling love, not fear. Pa then brings Keav's body home to be buried, to be forever with us, instead of being lost.

I wake up the next morning feeling guilty because I did not dream about Keav at all. Pa is already off to work. Ma's face is red and swollen, and, as always, she is holding Geak. Ma and Keav never got along well. Keav was wild and temperamental. Ma wanted her to change, to be more ladylike, more subdued. I wonder about the regrets Ma must have over their relationship, regrets about all those times they fought in Phnom Penh over what music Keav listened to or the clothes she wore.

Ma turns and looks at me, her eyes cloud over. For a brief moment I want to reach out to her and give her some comfort, but I cannot and turn away from her staring eyes. Our lives will never be the same again after Keav's death. Hunger and death have numbed our spirits. It is as if we have lost all our energy for life.

"We all have to forget her death and continue." Pa tries hard to encourage us. "We have to go about our ways as if nothing has happened. We don't want the chief to think that we can no longer contribute to their society. We have to save our strength to go on. Keav would want us to go on; it is the only way we will survive."

pa

Time passes by slowly. We are in the middle of our summer because the air is hotter and drier now. It seems to be about four months since Keav died. Though the family does not talk about her, my heart still weeps when I remember that she is no longer with us.

The government continues to reduce our food rations. I am always hungry and all I think about is how to feed myself. Each night, my stomach growls and aches as I try to sleep. Our family remains dependent on Khouy and Meng to bring us food whenever they can steal away from their camp to visit us. However, the Angkar keeps them so busy that they are unable to visit us as often as before.

We live under the constant fear of being discovered as supporters of the former government. Every time I see soldiers walking in our village, my heart leaps and I fear they are coming for Pa. They don't know that Pa is not a poor farmer, but how long will it be before they realize we are all living a lie? Everywhere I go I am obsessed with the thought that people are staring at me, watching me with suspicious eyes, waiting for me to mess up, and give away our family secret. Can they tell by the way I talk, or walk, or look?

"They know," I overhear Pa whisper to Ma late one night. Lying on my back next to Chou and Kim, I pretend to be asleep. "The soldiers have taken away many of our neighbors. Nobody ever talks of the disappearances. We have to make preparations for the worst. We have to send the kids away, to live somewhere else, and make them change their names. We must make them leave and go to live in orphanage camps. They must lie and tell everyone that they are orphans and don't know who their parents are. This way, maybe, we can keep them safe from the soldiers and from exposing one another."

"No, they are too young," Ma pleads with him. Unable to stop my eyes from twitching, I roll over to my side. Ma and Pa become quiet, waiting for me to go back to sleep. Staring at Kim's back, I force myself to breathe regularly.

"I want them to be safe, to live, but I cannot send them away. They are too young and cannot defend themselves. Not now but soon." His voice trails off.

Beside Chou, Geak kicks and moans in her sleep, almost as if she senses impending doom. Ma picks her up and puts her down between Pa and herself. I roll over once more, this time facing Chou's back. I spy Ma and Pa asleep facing each other on their sides with Geak in the middle, their hands touching above Geak's head.

The next evening, while sitting with Kim outside on the steps of our hut, I think how the world is still somehow beautiful even when I feel no joy at being alive within it. It is still dark and the shimmering sunset of red, gold, and purple over the horizon makes the sky look magical. Maybe there are gods living up there after all. When are they going to come down and bring peace to our land? When I focus my eyes back on the earth, I see two men in black walking toward us with their rifles casually hanging on their backs.

"Is your father here?" one of them asks us.

"Yes," Kim answers. Pa hears them and comes out of the hut, his body rigid as our family gathers around him.

"What can I do for you?" Pa says.

"We need your help. Our ox wagon is stuck in the mud a few kilometers away. We need you to help us drag it out."

"Could you please wait for a moment so that I can talk to my family?" The soldiers nod to Pa. Pa and Ma go inside the hut. Moments later, Pa comes out alone. Inside, I hear Ma sobbing quietly. Opposite the soldiers, Pa straightens his shoulders, and for the first time since the Khmer Rouge takeover, he stands tall. Thrusting out his chin and holding his head high, he tells the soldiers he is ready to go. Looking up at him, I see his chest inflates and exhales deeply, and his jaw is square as he clenches his teeth. I reach up my hand and lightly tug at his pant leg. I want to make him feel better about leaving us. Pa puts his hand on my head and tousles my hair. Suddenly he surprises me and picks me up off the ground. His arms tight around me, Pa holds me and kisses my hair. It has been a long time since he has held me this way. My feet dangling in the air, I squeeze my eyes shut and wrap my arms around his neck, not wanting to let go.

"My beautiful girl," he says to me as his lips quiver into a small smile. "I have to go away with these two men for a while."

"When will you be back, Pa?" I ask him.

"He will be back tomorrow morning," one of the soldiers replies for Pa. "Don't worry, he'll be back before you know it."

"Can I go with you, Pa? It's not too far. I can help you." I beg him to let me go with him.

"No, you cannot go with me. I have to go. You kids be good and take care of yourselves," and he puts me down. He walks slowly to Chou and takes Geak from her arms. Looking into her face, he cradles her and gently rocks her back and forth before bending and gathering Chou into his arms also. His head high and his chest puffed out like a small man, Kim walks over to Pa and stands quietly next to him. Letting go of Chou and Geak, Pa stoops down and lays both hands on Kim's shoulders. As Kim's face crumbles, Pa's face is rigid and calm. "Look after your Ma, your sisters, and yourself," he says.

Pa walks away with a soldier on either side of him. I stand there and wave to him. I watch Pa's figure get smaller and smaller, and still I wave to him, hoping he will turn around and wave back. He never does. I watch until his figure disappears into the horizon of red and gold. When I can no longer see Pa, I turn around and go inside our house, where Ma sits in

the corner of the room crying. I have seen Pa leave the house many times in Phnom Penh, but I have never seen her this upset. In my heart I know the truth, but my mind cannot accept the reality of what this all means.

"Ma, don't cry, the soldiers said Pa will be back tomorrow morning." I lay my hand on hers. Her body shakes at my touch. I walk outside to where my siblings are sitting on the step and sit next to Chou, who holds Geak in her arms. Together we wait for Pa, sitting on the stairs, staring at the path that took him away. We pray it will bring Pa back to us tomorrow.

As the sky turns black, the clouds rush in to hide all the stars. On the steps, Chou, Kim, Geak, and I sit waiting for Pa until Ma orders us in to sleep. Inside the hut, I lie on my back; my arms folded across my chest. Chou and Kim breathe deeply, quietly, but I do not know if they are asleep. Ma is on her side, facing Chou. She has one arm around Geak, and the other rests above Geak's head. Outside the wind blows in the branches, and the leaves rustle and sing to each other. The clouds part, and the moon and stars shine and give life to the night. In the morning, the sun will come up and the day creatures will wake. But for us, time stands still that night.

I wake up the next morning to see Ma sitting on the steps. Her face is swollen and she looks like she has not slept all night. She is crying softly to herself and is miles away. "Ma, is Pa back yet?" Not answering me, she squints her eyes and continues to look at the path that took Pa away. "The soldiers said Pa would come back in the morning. I guess he's late. He's late, that's all. I know he will return to us." As I speak, my lungs constrict and I gasp for air. Fighting for breath, my thoughts race and I wonder what this all really means. It is morning and Pa is not back! Where is he? I sit with my siblings, facing the road, looking for Pa. I think up reasons why Pa is late returning to us. The wagon is broken in the mud, the oxen would not move, the soldiers needed Pa to help them fix the wagon. I try to believe my excuses and make them reasonable, but my heart is filled with fear.

Telling the chief we are ill, we receive permission to stay home. All morning and afternoon, we wait for Pa to walk back to us. When night comes, the gods again taunt us with a radiant sunset. "Nothing should be this beautiful," I quietly say to Chou. "The gods are playing

tricks on us. How could they be so cruel and still make the sky so lovely?" My words tug at my heart. It is unfair of the gods to show us beauty when I am in so much pain and anguish. "I want to destroy all the beautiful things."

"Don't say such things or the spirits will hear," Chou warns me. I don't care what she says. This is what the war has done to me. Now I want to destroy because of it. There is such hate and rage inside me now. The Angkar has taught me to hate so deeply that I now know I have the power to destroy and kill.

Soon darkness covers the land and still Pa has not returned. We sit on the steps waiting for him together in silence. No words are exchanged as ours eyes search the fields waiting for him to come home. We all know that Pa will not return, but no one dares to say it out loud for it will shatter our illusion of hope. With darkness, the flies disappear and the mosquitoes appear to feast on our flesh. Ma holds Geak in her arms. Every once in a while, Ma's arms fan Geak's body to chase away the mosquitoes. As if picking up on Ma's pain, Geak kisses her cheek softly and caresses her hair.

"Ma, where's Pa?" Geak asks, but Ma only responds with silence.

"Go inside, all you kids, go inside," Ma tells us in a tired voice.

"You should come in with us. We can all wait inside," Chou says to her.

"No, I'd rather wait out here and greet him when he returns." Chou takes Geak from Ma and goes into the hut. Kim and I follow her, leaving Ma sitting on the steps by herself, waiting for Pa to return.

Listening to Geak and Chou breathing softly, my eyes stay wide open. After he hid from the soldiers for twenty months, they finally found him. Pa always knew he couldn't hide forever. I never believed he couldn't. I cannot sleep. I worry about Pa, and about us. What will become of us? We have taken our survival for granted. How will we survive without Pa? My mind races and fills my head with images of death and executions. I have heard many stories about how the soldiers kill prisoners and then dump their bodies into large graves. How they torture their captives, behead them, or crack their skulls with axes so as not to waste their precious ammunition. I cannot stop thinking of Pa and whether or not he died with dignity. I hope they did not torture him. Some prisoners are not dead when they are buried. I cannot think

of Pa being hurt this way, but images of him clawing at his throat, fighting for air as the soldiers pile dirt on him flood my mind. I cannot make the pictures go away! I need to believe Pa was killed quickly. I need to believe they did not make him suffer. Oh Pa, please don't be afraid. The images play over and over again in my head. My breath quickens as I think about Pa's last moment on earth. "Stop thinking, stop or you'll die," I hiss to myself. But I cannot stop.

Pa told me once that the really old monks could leave their bodies and travel the world as spirits. In my mind, my spirit leaves my body and flies around the country, looking for Pa.

I see a big group of people kneeling around a big hole. There are already many dead people in the hole, their bodies sprawled on top of each other. Their black pajama clothes are soaked with blood, urine, feces, and small white matter. The soldiers stand behind the new group of prisoners, casually smoking a cigarette with one hand, while the other holds onto a big hammer with clumps of hair sticking to its head.

A soldier leads another man to the edge of the hole—my heart howls with agony. "It's Pa! No!" The soldier pushes on Pa's shoulders, making him kneel like the others. Tears stream out of my eyes as I whisper thanks to the gods that the soldier has blindfolded Pa. He is spared from having to see the executions of many others. "Don't cry, Pa. I know you are afraid," I want to tell him. I feel his body tense up, hear his heart race, see tears flowing out from under the blindfold. Pa fights the urge to scream as he hears the sound of a hammer crack the skull next to him, smashing into it. The body falls on top of the others with a thump. The other fathers around Pa cry and beg for mercy but to no avail. One by one, each man is silenced by the hammer. Pa prays silently for the gods to take care of us. He focuses his mind on us, bringing up our faces one by one. He wants our faces to be the last things he sees as he leaves the earth.

"Oh Pa, I love you. I will always miss you." My spirit cries and hovers down over him. My spirit wraps invisible arms around him, making him cry even more. "Pa, I will always love you. I will never let you go." The soldier walks up to Pa, but I will not let him go. The soldier cannot hear or see me. He cannot see my eyes burn into his soul. "Leave my Pa alone!" My eyes dare not blink as the soldier raises the hammer above his head. "Pa," I whisper, "I have to let you go now. I cannot be here and live." Tears wash across my body as I fly away, leaving Pa there by himself.

Back in the hut, I slide next Chou. She opens her arms and takes me in. Our bodies cradling each other, we cry. The cool air chills the beads of sweat on my skin, making my teeth chatter. Beside us, Kim holds on tight to Geak.

"Pa, I cannot bare to think that you struggled for breath lying on top of the others in that hole. I must believe the soldier took pity and used one of his bullets on you. I cannot breathe, Pa. I am sorry I had to let you go." My mind swirls with pain and anger. The pain grows larger in my stomach. The pain spasm convulses as if it is eating away my linings. Turning on my side, I dig my hands into my stomach and squeeze it violently to make the physical pain stop. Then the sadness surrounds me. Dark and black it looms over me, pulling me deeper and deeper into it. And then it happens again. It is almost as if I am somewhere else for the moment and I simply black out the part of me that feels emotion. It is as if I am alive but not alive. I can still hear the faint noise of Ma's muffled cries outside, but I do not feel her pain. I do not feel anything at all.

Ma is up before anyone else the next morning. Her face is all puffy, her eyes are red and swollen shut. Chou gives Ma some of the very little food we have left, but she will not eat. I join them on the steps, daydreaming about our lives back in Phnom Penh when I was happy. I cannot allow myself to cry because once I do I will be lost forever. I have to be strong.

By the third day, we all know that what we feared most has happened. Keav, and now Pa, one by one, the Khmer Rouge is killing my family. My stomach hurts so much I want to cut it open and take the poison out. My body shivers as if evil has entered it, making me want to scream, beat my hands against my chest, and pull out my hair. I want to close my eyes and blank out again, but I don't know how to do it at will. I want my Pa here in the morning when I wake up! That night I pray to the gods, "Dear gods, Pa is a very devout Buddhist. Please help my Pa return home. He is not mean and does not like to hurt other people. Help him return and I will do anything you say. I will devote my entire life to you. I will believe you always. If you cannot bring Pa home to us, please make sure they don't hurt him, or please make sure Pa dies a quick death."

"Chou," I whisper to my sister, "I am going to kill Pol Pot. I hate him and I want to make sure he dies a slow and painful death."

"Don't say such things or you will get hurt."

"I am going to kill him." I do not know what he looks like, but if Pol Pot is the leader of the Angkar then he is the one responsible for all the miseries in our lives. I hate him for destroying my family. My hate is so strong it feels alive. It slithers and moves around in the pit of my stomach, growing bigger and bigger. I hate the gods for not bringing Pa back to us. I am a kid, not even seven years old, but somehow I will kill Pol Pot. I don't know him, yet I am certain he is the fattest, slimiest snake on earth. I am convinced that there is a monster living inside his body. He will die a painful, agonizing death, and I pray that I will play a part in it. I despise Pol Pot for making me hate so deeply. My hate empowers and scares me, for with hate in my heart I have no room for sadness. Sadness makes me want to die inside. Sadness makes me want to kill myself to escape the hopelessness of my life. Rage makes me want to survive and live so that I may kill. I feed my rage with bloody images of Pol Pot's slain body being dragged in the dirt.

"As long as we don't know for certain that your pa is dead, I will always have hope that he is alive somewhere," Ma declares to us the next morning. My heart hardens at her words, knowing I cannot allow myself the luxury of hope. To hope is to let pieces of myself die. To hope is to grieve his absence and acknowledge the emptiness in my soul without him.

Now that I have accepted the truth, I worry about what will happen to Ma. She was very dependent on Pa. He had always been there to make things easier for her. Pa was raised in the country and was accustomed to hardship. In Phnom Penh, we had live-in house-keepers to do just about everything for us. Pa was our strength and we all needed him to survive, especially Ma. He was good at surviving and knew best what to do for us.

I hope Pa comes to me again tonight. I hope he visits me in my sleep and meets me in my dreams. I saw him last night. He wore his tan military uniform from the Lon Nol government. His face was once

again round like the moon and his body was soft. He was so real standing next to me, big and strong like he was before the war.

"Pa!" I run to him and he picks me up. "Pa, how are you? Did they hurt you?"

"Don't worry." He tries to soothe me.

"Pa, why did you leave us? I miss you so much it hurts my stomach. Why didn't you come and find me? Pa, when will you come and find us? If I go to the orphanage camp will you be able to find me?" I rest my head on his shoulder.

"Yes, I will."

He's my pa, and if he says that he will find me, I know he will.

"Pa, why does it hurt so much to be with you? I don't want to hurt, I don't want to feel."

"I am sorry you are hurt. I have to go." Hearing this, I grip his arms tighter, refusing to let go. "Pa, I miss you so much. I miss sitting on your lap like I did in Phnom Penh."

"I have to go, but I will look after you always," Pa says softly, putting me down on the ground. I hold on to his finger and beg him not to leave me.

"No! No! Stay. Pa, stay with us. Please, don't leave. I miss you and I am scared. What will happen to us? Where will you go? Take me with you!"

Pa looks at me, his eyes brown and warm. I reach out my hands to him, but the farther I reach, the farther away he moves until he fades away completely.

My body fights to sleep when the sun shines through our door to tell us it is morning. I want to stay asleep forever just so I can be with him. In the real world, I don't know when I will ever see Pa again. Slowly, I open my eyes with Pa's face still lingering in my vision. It is not the face of the gaunt old man the soldiers took away but the face of the man I once thought was a god.

It was during our trip to Angkor Wat that I first thought Pa was a god. I was only three or four years old then. With my hand in Pa's, we entered the area of Angkor Thom, one of the many temple sites there. The gray towers loomed large before us like stone mountains. On each of the towers, giant faces with magnificent headdresses looked out in different directions over our land. Staring at the faces I exclaimed, "Pa,

they look like you! The gods look like you!" Pa laughed and walked me into the temple. My eyes could not leave those huge round faces, with their almond-shaped eyes, flat noses, and full lips—all of Pa's features!

Waking up I try to hold on to these images of Pa even as we resume our lives without him. Ma returns to the field, working twelve to fourteen hours a day and leaves Geak behind with Chou. With Geak toddling after us, Chou and I and the other children work in the gardens and do menial labor in the village. It has been over a month since Pa was taken away. Ma seems to have recovered and is trying to get on with her life, but I know I will never see her truly smile again. Sometimes late at night, I am awakened by the sound of Ma sobbing on the steps, still waiting for Pa. Her body slumped like an old woman, she leans against the door frame, her arms wrapped around herself. She looks out into the field at the path Pa once walked, crying and longing for him.

We miss him terribly and Geak, being so young, is the only one able to vocalize our loneliness, by continuing to ask for Pa. I am afraid for Geak. She is four years old and has stopped growing because of malnutrition. I want to kill myself knowing that it was I who stole the food from her mouth that one night. "Your pa will bring us lots of food when he returns," Ma tells Geak when she asks for Pa.

The soldiers come to our village more and more often now. Each time they leave, they take fathers from the other families. They always come in pairs—though never the same pair twice—with their rifles and casual excuses. When they come, some villagers try to hide their fathers by sending them off to the woods or having them be conveniently gone. But the soldiers wait, standing around the chief's house, slowly smoking their cigarettes as if they have all the time in the world. After they finish the pack, they walk to their victim's hut and loud cries and screams from inside follow. Then there's only silence. We all know they feed us lies about the fathers coming back the next morning. Still there is nothing we can do to stop them. No one questions these disappearances, not the chief, not the villagers, not Ma. I hate the soldiers now as much as I hate the Angkar and their leader, Pol Pot. I etch their faces into my memory and plan for the day when I can come back and kill them.

There have been rumors in the village that Pa was not killed in a Khmer Rouge mass execution. Rumors spread that the soldiers made

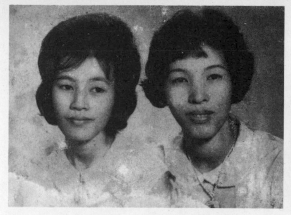

Ma (right) and her sister.

My mother, Ung, Ay Choung.

Pa, at right, with his military friends.

My father, Ung, Seng Im. I always thought his face looked like the stone faces of the gods at Angkor Wat.

Left to right: My mother (holding Keav), Meng, Khouy, my grandmother, my aunt, and Uncle Keang.

Left to right: Meng, Keav, Ma (holding Kim), Khouy, and Uncle Keang.

Left to right: Kim, Keav, Khouy, Meng, Chou, and Ma on a family trip to Angkor Wat.

Left to right: Me, Chou, Kim, and Keav.

My brother Khouy. I always perceive him to be so hard and sad. He rarely smiles, so I treasure this happy photo.

Left to right: Me, Chou, and Keav.

My father is wearing the plaid shirt, smiling.

Chou and me (right), 1975.

Two pictures of Kim superimposed together.

Kim, Ma, Geak, me, Chou, and Khouy. The only surviving picture of Geak.

Meng, me, and my sister-in-law Eang, on our first day at the refugee camp in Thailand. We had just gotten off the boat at Lam Sing, 1980.

Khouy (top row, far left in black) and family gather at Grandfather's gravesite in Cambodia on the day we set aside each year to remember our ancestors, 1988.

Chou and her husband, Pheng, 1985.

Chou, with her family on an outing.

Khouy, his wife Morm, and their family, 1991.

Kim, his wife Huy Eng, their daughter Nancy, and a friend's son, 1998.

Meng, in the center, talking with friends and family during his 1995 trip to Cambodia.

Wat Ta Prom, the temple where my father told me the gods live. Photo © Sally Strickland.

Chou, me, and Meng's two daughters, Victoria and Maria. This photo was taken in 1995 when I visited Cambodia with Meng and his family. It's the end of the trip and Chou is seeing us off.

Me and a little girl selling goods on the street at Angkor Wat. Photo © 1999 Michael Appel.

Pa a prisoner on a faraway mountain and tortured him every day. But he survived and escaped to the top of the mountains. The soldiers, hunting for him, have not have been able to catch him. People passing by our village say they have seen someone fitting Pa's description. They tell tales of Pa forming his own army, trying to recruit more soldiers to fight the Khmer Rouge. Upon hearing these rumors, Ma's face lights up and her eyes shine once again with hope. For a few days, she walks off to work with a little more life in her step and even twelve hours later the glimmer of a smile is still on her face. At night, she continuously fusses over our appearance, wiping the dirt off our faces, combing the knots out of our hair. She believes the stories wholeheartedly. "If he has escaped, it will not be long now before he comes searching for us. Until we know for sure of his fate, we must never give up hope." Once again, she devotes herself to sitting on the steps waiting for Pa's return.

Weeks pass after we hear the rumors about Pa and still he has not returned. I know Ma misses him and believes he is alive somewhere. Eventually, she stops waiting for him and tries once more to resume her life. Time passes slowly without Pa in our lives. Even with our own ration of food, our survival depends on our older brothers bringing more food to us each week. When Khouy gets sick, coughing up blood, we are forced to fend for ourselves. Khouy is a strong young man, but he pushes himself too hard at work. His work consists of constantly loading and unloading one hundred kilograms of rice onto trucks to be sent to China. Meng also cannot come because the soldiers are keeping him busy with work. We are all very worried for them both.

Life is hard without Pa. People in the village look down on Ma because she is not good at field work. It is too dangerous to have friends so she does not talk to anyone. The villagers also look down on her white skin and often make rude comments about "lazy white people." To my surprise, Ma becomes a hard worker and is surviving without Pa. On the days when Ma is assigned to work with fifteen other village women fishing for shrimp in nearby ponds, I go with her, leaving Chou behind with Geak. My job in the group includes fetching water for the shrimp catchers, helping untangle their nets, and separating the shrimp from weeds. Though hungry, we are not allowed to eat the shrimp we catch because it belongs to the village and must be

shared with all. If anyone is caught stealing, the chief can publicly humiliate her, take away her possessions, and beat her. The punishments for such acts are grave, but our hunger does not allow this to stop us from sometimes stealing.

"Loung," Ma calls me. "I need some water, come here." She stands up and wipes her brows with her sleeve, leaving a trail of mud on her face. Scooping a coconut shell of water out of the bucket, I run over and hand it to her. "Here," she whispers, "give me your hand fast while no one is looking." Ma turns around and takes another careful look at the others to make certain we are not being watched. She quickly gives me a handful of baby shrimp as she takes the water cup from me. "Quick, eat them while no one is looking." Without hesitation, I shove the raw crawling baby shrimp into my mouth, shells and all. They taste of mud and rotten weeds. "Chew quickly and swallow," Ma tells me. "Now, you look out for me while I eat some. If anyone is looking, call me." I see Ma in a very different light now and have more pride in her strength. Somehow, one way or another, we find ways to stay alive.

ma's little monkey

It is two years since the Khmer Rouge rolled into Phnom Penh with their trucks; four months since the soldiers took Pa away and Kim became head of our household. It has been almost a year since we last heard from Meng and Khouy. New Year's has come and gone, making us all a year older. Geak is now five, I am seven, Chou is ten, and Kim is twelve. Now head of the household, Kim takes seriously Pa's words for him to look after us. At dawn each morning, he wakes before us and runs to the town square for our work assignment. At the hut Ma gets us girls up and spends a few minutes with each of us. Before she is done combing Geak's hair and washing her face, Kim is back with the day's instructions. As I slowly rise from my slumber, he is already telling Ma where to go. After Ma's left for the fields, we all walk to the community garden together with Geak clinging to Kim's back. Though Kim's face looks like a monkey more than ever, Ma has not called him by this nickname since they took Pa away. Now he is only Kim to us.

A few miles down the road from our village there is a cornfield. We have had a good rainy season this year and the corn is ripe for picking. However much we fear the punishment for stealing, our desperation is too strong to stop us. "Why not, Ma?" Kim argues. "We work morning,

noon, and night planting these crops and now that they are ripe we're told we can't eat them. We are all starving."

"It is just too dangerous, Kim. You know what the soldiers will do to you if you get caught."

"Ma, we are starving to death. Many people are dying in the village. Yet the government trades our crops to buy guns to kill more people."

"Shh . . . don't talk so loud. It is a crime to speak against the Angkar. If the soldiers hear you they will take you away and kill you."

"Ma, I am going to go and get us some corn tonight." With a determined look, Kim has made his decision.

"Be careful," Ma says to him and turns away.

Chou and I do not try to stop him from going either, even though we know it is dangerous. Pol Pot has many soldiers with guns and rifles guarding the cornfields every night. The soldiers have the right to punish thieves any way they see fit, killing them if they choose. Their power is so omnipotent that no one dares question their actions. However fearful I am, my hunger makes me want to go myself, but I do not have the strength or courage to actually do it. I hear tales that the soldiers rape the girls they catch stealing, no matter how young they are.

When the sky grows dark, Kim picks up two bags, straightens his twelve-year-old body, and leaves. Part of me is glad Kim is doing this and my mouth salivates at the thought of the food he will bring back. I can almost taste it already! I cannot wait until he gets back. My stomach moans for sweet, juicy corn. Yet I also fear for Kim's safety; we have already lost Pa and Keav. I do not want to bury another member of our family.

It is getting late and Kim is not back yet. What could take him so long? I look at Ma, who is holding onto Geak for comfort. Chou sits by herself in the corner of the room, staring out into her own world.

"Gods, this cannot happen to me again! If you let my brother die, I will never forgive you. You can just go to hell—for I know there are no gods in the world now," I scream to the spirits in my mind. As if answering my call, Kim suddenly climbs into our hut. He is smiling and carrying two bags of fresh corn. I rush up to him and help him carry them into the house. Seeing Kim, Ma smiles and puts Geak down so that she can greet him.

"What happened? You took so long, we were worried to death," Ma says as she ushers him in with her arm around his shoulders.

"Ma, it is so easy! I never knew stealing could be so easy! There is so much corn and no one can guard all the fields at once. I must have eaten at least five ears raw!" As Kim begins to tell Ma what he did, I edge myself closer and closer to the bags of corn. My nose inhales the aroma and my eyes fixate on the yellow ears. I cannot wait to sink my teeth into it.

"Can I go with him next time, Ma?" I am getting greedier and greedier with the thought that two of us can bring home more corn than Kim can by himself.

"No, you are not to go with him, and that is final!" With those words, Ma goes outside to cook our corn on a fire we started earlier in the evening. She digs a hole for the corn under the fire and spreads the fire over the makeshift stove. With Pa and many of the fathers in the village gone, the soldiers patrol our huts less and less, so it is relatively safe. For the next couple of weeks, Kim continues to steal corn for us whenever we run out. Each time he leaves, we wait with fear and guilt for his return. Each night, it seems to take him longer and longer.

Kim slings two empty bags over his shoulders and climbs down the steps of the hut. His knees buckle when he reaches the ground. Quickly, he straightens himself before anyone notices. He knows Ma and the girls are depending on him so he has to be very strong for them. There is no need to make them any more frightened than they already are by letting us know how scared he really is. He tries to show them he is fearless, but each time he goes out on this mission, he is always afraid of losing his nerve. He wants to run back to the hut and never carry out this dangerous task again. But he has to, he has to take care of his family. He looks up at the sky and sees no stars. The clouds are moving furiously fast, blocking any moonbeams from touching the earth.

"Okay," he says under his breath, "it's time to be brave." With that, he forces his feet to carry him away into the darkness. He knows Ma and the girls' eyes are still upon him, baring down on his back, but he must not turn to look at them lest his courage fail him.

He jogs in quick, little steps. He knows that not to be seen he has to dart and hide from one bush to another. "Like the foxes hiding from

humans during a hunt." The thought almost makes him smile. The sky is very dark now, and the moisture in the air is turning into a thick fog. It is good luck for him. Pa must be watching over him. The thought of Pa almost brings his adrenaline down. All the kids think they are Pa's favorite, but he knows he is. After all, Pa always told the story about his birth and the dragon to everyone.

Thinking of Pa takes his breath away. There is such pain in his heart and the burden is too heavy to handle. He cannot run away from it. His pining for our father is unbearable, but he is the man of the house now and cannot speak openly of his suffering. Something wet and salty drips into his mouth, focusing him again on his mission. He realizes it is his own tears and he lifts up his shirt to quickly wipe his eyes. He misses Pa so much, but he cannot allow himself to think of this now. He has to take care of the family.

He is twelve years old and only stands as tall as Ma's shoulders, but he knows he is strong. He has to be; he has no choice. Geak's face floats into his mind and he fears for her. He sees her hollow eyes and her protruding stomach as she loses more and more strength each day. He hears her cries when she begs Ma to give her food. He sees Ma tell Geak time and time again that there is no food. He doesn't know how long she will live if he doesn't do this. This little bit of food he's able to bring to her prolongs her life just a little more, keeping her with us just a little longer. The images fuel his anger, pushing him nearer and nearer to the cornfields.

The clouds grow darker and bigger in the sky and seconds later he feels droplets of rain on his arms. Suddenly it seems as though the whole sky has opened up and pours down the tears of every Cambodian, drenching him to the skin. In some ways the rain is a blessing, as it lightens the humidity in the air. He remembers how he used to read that in some countries, the rain is cold and makes you sick, forcing people to stay indoors. Not so in Cambodia. Here the rain is warm, and in Phnom Penh, it meant it was time to go outside and play. The rain was, and still remains, our friend, even under the Khmer Rouge.

Then he sees the field ahead of him. It is thick with stalks of corn, each with three or four ears, standing twice the size of the small boy. His eyes scan the area all around him. His heart beats faster, this time

out of anger. Why are the killers starving us when all this is available? His adrenaline is pumping now, and with forced courage, he runs from his hiding place into the cornfield. Raindrops splatter on the leaves of the stalks all around him, splashing into his eyes, but he does not care. He picks the first ear off the stalk, hurriedly shucks it, and buries his teeth into it. Hmmm, the sweet, nourishing juices flow out of the corner of his mouth onto his shirt. After he fills his stomach, his fingers work busily to fill the bags.

He is so busy that he does not hear the footsteps running in his direction. His heart stops when two hands grab him from behind and throw him to the ground. The rain has made the ground all muddy and he slips as he tries to get back on his feet. Through his wet eyelashes, he sees two Khmer Rouge soldiers, their rifles slung across their backs. One soldier grabs him by the arm and pulls him off the ground, but his knees buckle. His head spins. He is shivering with cold and an ever increasing terror. A hand slaps him hard on the face, making his ears ring. The pain is sharp and cutting, but he bites his jaws together to stop its hurt. "Please, Pa," the voice in his mind screams, "please help me. Don't let them kill me."

"You bastard!" they yell at him. "How dare you steal from the Angkar! You worthless shit!" They scream other obscenities at him, but he is too stunned to hear them. More hands push him down. "Get up!" They continue to yell. He is on all fours now and following their orders when a hard-booted foot kicks him in the stomach, knocking his breath away. He is in the mud again, gasping for breath. Another foot stomps on his back and pushes his face into the mud. He opens his mouth, gasping for air, but instead chokes on a mouthful of mud. He is sick with terror, and he does not know what to do next. A hand pulls him up by the hair and a soldier is staring at him. "Are you ever going to come back and steal anything ever again from the Angkar?" he asks Kim.

"No, comrade," Kim whimpers as blood drips out of his mouth. But that isn't enough for them. More hands and more legs continue their assault on him. The same questions are asked of him and the same answer is given.

Then one soldier takes his rifle off his shoulder and points it at him. Kim cries then, tears pouring out faster than the rain can wash away.

"Please, comrade, spare my life, don't kill me," he begs them, his body trembling. One soldier laughs at him. He is no longer a boy trying to be the man of the house, trying to be brave, wanting to take care of his family. He is just a twelve-year-old boy now, looking into the barrel of a rifle. "Please comrade, don't kill me. I know I've done a bad thing, I will never do it again." The soldier stands there, his rifle rigid in his hand. Then he turns the rifle around and smashes its butt into Kim's skull. White pain flashes everywhere in his body as he falls down but dares not cry. "Please comrade, don't—"

"Just go," the soldier interrupts him. "Take your bags and go. Don't ever come back because next time I will shoot your brains out." Kim rises unsteadily to his feet and limps home.

At home, Chou, Ma, Geak, and I sit quietly waiting for Kim to return. "Chou, Kim's really late tonight. I'm worried about him," I say to her.

"It's hard to see out there. He's probably lost his way. It's raining pretty hard." Upon hearing me, the night turns black with evil as the wind howls and a thunderstorm cracks its lightning whips above us. Ma quietly tries to calm Geak, who is afraid of the storm. I turn and see Ma put her hands over her mouth to stifle a scream. My gaze turns to the direction where Ma is looking. Against the backdrop of the dark, I see Kim's twelve-year-old body leaning against the door. In his hand are two empty rain-soaked bags. He is drenched from the rain, but I see the unmistakable color of blood on his clothes and marks on his muddy face. His eyes are half closed, he is shaken, but he does not cry. Ma rushes over to him and gently touches his wounded face. She cries over his cut swollen lips and cringes as she touches the blood dripping from his skull.

"My poor little monkey, my poor little monkey. Look what they have done to you. They have hurt you, my poor little monkey."

Kim is quiet and does not resist Ma's help taking off his wet shirt. I bite my lip at seeing my brother's body so badly beaten. Raw, red marks and painful bruises are everywhere on his rib cage and back. I want to rush over to him to take away his pain, but instead I stand numb in the corner of the room. I see the pain in his face and feel the heaviness in his heart at not being able to bring us food. I stand in my corner with

more conviction than ever to kill these soldiers, to avenge the blood that drips from my brother's skull. Someday, I will kill them all. My hatred for them is boundless.

"It was raining too hard and I did not hear them coming."

"My poor monkey, they hurt you."

"They hit me on the head with the butt of their rifles." Kim finishes telling us his story and still he does not cry. He flinches when Ma puts a wet rag on his bruised and bleeding head. "I am sorry I didn't get us any corn tonight," he says to all of us as he lays down, closes his eyes, and falls asleep.

Fearing he might die and I will not know about it, I walk over to him every few minutes and put my hand under his nose to feel his breath. "Pa," I call quietly. "Pa, don't let Kim die. Pa, I feel so bad, all this for corn to feed us. Pa, I am bad because I am also sad that we have no corn." Crouching beside Kim, I squeeze my stomach with my hands, trying to chase the pain away. "Pa, I am going to kill them all. I am going to make them suffer." My head hurts and I press my index fingers against my temples to try and stop the explosion. The stronger my anger, the more I am overcome with feelings of sadness and despair. "I can't die, Pa. There's nothing we can do but go on living. But, one day, they will all suffer as we are suffering now."

After that night, Kim never stole again. These days he is quieter and more withdrawn. With Pa gone and my older brothers at their camp, Kim is the man of the house. But in reality his is only a little boy, a little boy who feels helpless and unable to protect his own family.

leaving home

One month has gone by since Kim was caught stealing corn. The Angkar has increased our food ration and as a result, fewer and fewer people are dying from starvation. Those who have survived the famine are slowly getting stronger. It seems as if every three months the Khmer Rouge has either increased or decreased our food ration without warning or explanation. For two or three months we have food to eat, just enough to keep us alive, then nothing to eat for another few months, then we have a little bit of food again. Kim speculates that it has to do with the rumors of the Youns—the Vietnamese—attacking the borders. Every time the Angkar thinks the Youns will invade Cambodia, the soldiers stock up on food and supplies and ship more rice to China in exchange for guns. When it turns out the Youns are not attacking us, the Angkar stops buying arms and our rations increase.

Even without the pressure to find food for us, Kim is different now and not like the brother I remember from Phnom Penh. He is quieter and rarely says more than a few words. We are all different now: Chou and I have stopped fighting, and Geak, who also has become more and more withdrawn, has stopped asking for Pa. Ma, though, still sits many nights at the door waiting for Pa to return.

Though I am sad and many days wish I am dead, my heart continues to beat with life. My eyes well up at the thought of Pa. "I miss you so much, Pa," I whisper to him. "It is so hard to live without you. I am so sick of missing you." It is hopeless because no amount of tears will bring him back. I know Pa does not want me to give up, and as hard as it is to endure life here day to day, there is nothing for me to do but go on.

Strange things are going on in the village as entire families disappear overnight. Kim says the Khmer Rouge terror has taken a new toll. The soldiers are executing the entire families of those whom they've taken away, including young children. The Angkar fears the survivors and children of the men they have killed will rise up one day and take their revenge. To eliminate this threat, they kill the entire family. We believe this to be the fate of another one of our neighbors, the Sarrin family.

The Sarrin family lived a few huts down from ours. Like our family, the soldiers also took the father, leaving behind the mother and their three young kids. The kids are our age, ranging from five to ten years old. A few nights back we heard loud cries coming from their direction. Their cries continued for many minutes, then all was quiet again. In the morning I walked to their hut and saw that they were no longer there. Everything they owned was still in the hut: the small pile of black clothes in the corner of the room, the red checked scarves, and their wooden food bowls. It has been maybe three days now and still the hut stands empty. It is as if the family magically disappeared and no one dares to question their whereabouts. We all pretend not to notice their disappearance.

When she returns from work one evening Ma hurriedly gathers Kim, Chou, Geak, and me together, saying she has something to tell us. With all of us sitting in a circle waiting for her, Ma nervously walks around the hut outside to make sure no one can hear us. When she joins us, her eyes are filled with tears.

"If we stay together, we will die together," she says quietly, "but if they cannot find us, they cannot kill us." Her voice shakes when she speaks. "You three have to leave and go far away. Geak is four and too young to go. She will stay with me." Her words stab my heart like a thousand daggers. "You three will each go in different directions. Kim,

you go to the south; Chou will head to the north; and Loung to the east. Walk until you come to a work camp. Tell them you are orphans and they will take you in. Change your name; don't even tell each other your new names. Don't let people know who you are." Ma's voice grows stronger with determination as the words pour out. "This way if they catch one of you, they cannot get to the rest because you will have no information to give them. You will have to leave tomorrow morning before anyone else is up." Her mouth says many more words to us, but I cannot hear them. Fear creeps its way into my body, making it tremble. I want to be strong and fearless, to show Ma she does not have to worry about me. "I don't want to go!" I blurt the words out. Ma looks at me firmly. "You have no choice," she says.

The next morning Ma comes to wake me, but I am already up. Chou and Kim are dressed and ready to go. Ma packs my one pair of clothes, wraps my food bowl in a scarf, and ties it diagonally around my back. Slowly I climb down the steps to where Chou and Kim are waiting for me.

"Remember," Ma whispers, "don't go together and don't come back." My heart sinks as I realize Ma really is sending us away.

"Ma, I'm not going!" I plant my feet to the ground, refusing to move.

"Yes, you are!" Ma says sternly. "Your Pa is gone now, and I just cannot take care of you kids. I don't want you here! You are too much work for me! I want you to leave!" Ma's eyes stare at us blankly.

"Ma," my arms reach out to her, pleading with her to take me into her arms and tell me I can stay. But she swats them back with a quick slap.

"Now go!" She turns me around by the shoulders and bends down to give me a hard swat on the butt, pushing me away.

Kim is already walking away from us with his eyes looking ahead and his back rigid. Chou follows slowly behind him, her sleeves continuously wiping her eyes. Reluctantly, I drag myself away from Ma and catch up with them. After a few steps, I turn around and see that Ma has already gone back into the hut. Geak sits at the door, watching us leave. She lifts her hand and waves to me silently. We have all learned to be silent with our emotions.

The farther I am away from the village, the more my anger overtakes my sadness. Instead of missing Ma, my blood boils with resentment toward her. Ma doesn't want me around anymore. Pa took care of us and kept us together. Ma cannot do this because she is weak, like the Angkar says. The Angkar says women are weak and dispensable. I was Pa's favorite. Pa would have kept me home. Ma has Geak. She has always had Geak. She loves Geak. It is true that Geak is too young to leave, but I am not yet eight. I have nobody. I am completely alone.

The sun climbs to the backs of our heads, scorching them. The gravel path burns and digs into the soles of my feet and breaks through the hard calluses. I move off the gravel to walk on the grass. June is only the beginning of the rainy season so the grass is still plump and green. In November, the grass will shrivel up and become sharp like pins. The soles of my feet are so thick and callused that not even the pin grass can cut through them. However, when the grass is tall like it is now, the blades cut my skin like paper. It has been a long time since I have worn shoes. I don't remember when I stopped. I think it was when we arrived in Ro Leap that they burned my red dress. In Phnom Penh, I had black buckle shoes that went with my school uniform; the soldiers burned those too.

Soon it is time for Kim to go off on his own path. He stops us and again repeats Ma's instructions without emotion. Although he is only twelve his eyes have the look of an old man. Without words of good-bye or good luck, he turns and walks away from us. I want to run to him and put my arms around him, hold him the way I held Pa and Keav in my mind. I don't know if or when I will ever see him again. I don't want to bear the sadness of missing him. With my hands clenched into fists by my sides, I stand there and my eyes follow his body until I can no longer see him.

Though it goes against Ma's warnings, Chou and I cannot separate ourselves so we head off in the same direction. With no food or water, we walk in silence all through the morning as the sun beats down on us. Our eyes look everywhere for signs of human life but find none. All around us, the trees are brown, their green leaves, wilted in the heat of the white sky, hang quietly on the branches. The only sound comes from our feet and the pebbles that roll away from our toes. As the sun

climbs above our head, our stomachs grumble in unison, asking for food which of course we don't have. In silence, Chou and I follow the red dirt trail winding and stretching before us. As our bodies grow tired and weak, we long to sit and rest in the shade, but we force ourselves on; we do not know where or when our trail will end. It is afternoon when we finally see a camp.

The camp consists of six straw-roofed huts, very much like ours, except they are longer and wider. Opposite them are two open huts that are used as the communal kitchen and three smaller huts where the supervisors live. The camp is surrounded by huge vegetable gardens on all sides. In one, about fifty young children squat in a row, pulling weeds and planting vegetables. Another fifty children lined up at the wells are in the process of watering the gardens. Buckets of water are passed from one person to another, the last person with the bucket pours the water onto the garden and runs the bucket back to the well.

Standing at the gate, we are greeted by the camp supervisor. She is as tall as Ma but much bigger and more intimidating. Her black hair is cut chin-length and square, the same style as the rest of us. From her large, round face, her black eyes peer at us. "What are you doing here?"

"Met Bong, my sister and I are looking for a place to live." In Khmer I address the supervisor as "comrade elder sister" with as much strength in my voice as I can muster.

"This is a children's work camp. Why are you not living with your parents?"

"Met Bong, our parents died a long time ago. We are orphans and have been living with different families, but they no longer want us." My heart races with guilt as the lies spill out of my mouth. In the Chinese culture it is believed that if you speak of someone's death out loud, it will come true. By telling the comrade sister my parents are dead, I have put a marker on Ma's grave.

"Did they die at the reeducation camp?" Met Bong asks. I hear Chou's gasp for breath and warn her not to say anything with my eyes.

"No, Met Bong. We were farmers living in the countryside. I was too young to remember, but I know they died fighting for the Civil War." I am amazed how easily the lies come out of my mouth. Met

Bong seems to believe the lies, or maybe she simply does not care. She is in charge of a hundred kids and does not care if her workforce is increased by two more.

"How old are you and your sister."

"I am seven, and she is ten."

"All right, come in."

This is a girls' camp for those who are considered too weak to work in the rice fields. We are considered useless because we cannot help out the war effort directly. Yet from morning till night we work in the scorching sun, growing food for the army. From sunrise to sunset, we plant crops and vegetables in the garden, stopping for only dinner and lunch. Each night we fall into an exhausted sleep, wedged closely together on a wooden bamboo plank with fifty other girls, the other fifty in another hut.

Nothing at the camp is wasted, especially water. The well water is strictly for the gardens and cooking; to wash ourselves and our clothes we must walk a mile to the pond. After a long day of roasting in the sun, no one is thrilled about the walk for a wash, so we rarely bathe. Everything is collected and reused: old clothes become scarves, old food is dried and saved, and human waste is remixed as topsoil.

After our first evening meal, Chou and I are told to gather around the bonfire for nightly lessons. When we get there we see that all the other children are already there. We squat on the ground waiting for the Met Bong to read the latest news or propaganda from the Angkar. In a voice full of fury and adulation, Met Bong yells out, "Angkar is all-powerful! Angkar is the savior and liberator of the Khmer people!" Then one hundred children erupt into four fast claps, their fisted arms raised to the sky, and scream "Angkar! Angkar! Angkar!" Chou and I follow suit, though we do not understand the propaganda of what Met Bong is saying. "Today the Angkar's soldiers drove away our enemy, the hated Youn, out of our country!"

"Angkar! Angkar! Angkar!"

"Though there are many more Youns than Khmer soldiers, our soldiers are stronger fighters and will defeat the Youns! Thanks to the Angkar!"

"Angkar! Angkar! Angkar!"

"You are the children of the Angkar! Though you are weak, the Angkar still loves you. Many people have hurt you, but from now on the Angkar will protect you!"

Every night we gather to hear such news and propaganda, and are told of how the Angkar loves us and will protect us. Every night I sit there and imitate their movements while hatred incubates inside me, growing larger and larger. Their Angkar may have protected them, but it never protected me—it killed Keav and Pa. Their Angkar does not protect me when the other children bully Chou and me.

The children despise me and consider me inferior because of my light skin. When I walk by them, my ears ring from their cruel words and their spit eats through my skin like acid. They throw mud at me, claiming it will darken my ugly white skin. Other times, they stick their legs out and trip me, causing me to fall and scrape my knees. Met Bong always turns the other way. At first, I do nothing and take their abuse silently, not wanting to attract any attention to myself. Each time I fall, I dream of breaking their bones. I have not survived this much to be defeated by them.

While washing up for dinner one evening, one of the bullies, Rarnie, walks up and pinches my arm. "Stupid Chinese-Youn!" She hisses at me. My face burns and my blood boils with hatred. As if possessed by a will of their own, my arms reach for her neck and my hands close around her throat, squeezing hard. Her face turns white with confusion. She gasps for air, chokes under the pressure of my fingers. She grabs my arms, her nails scratching my skin. I refuse to let go. Sharp pain explodes on my shin as she kicks me. My anger makes me feel six feet tall, and I lunge at her with my body, knocking her to the ground. Sitting on her chest, my eyes pierce hers. My hands slap her face. I yell "Die! Die!" Rarnie's eyes widen with fear as blood pours out of her nose and stains my hands. Still I cannot stop. I want to see her dead. "Die! I hate you! I am going to kill you!" My small fingers wrap themselves around her throat again, trying to squeeze out her life. I hate her. I hate them all.

Two hands grab me by my arms, twisting them painfully back. Another set of hands grabs my hair, pulling it back, dragging me off Rarnie. Still I struggle to free myself, my feet kicking dust in her face. "I'm going to kill you!" I scream at her as a large hand slaps my cheek,

sending me to the ground. "Enough!" Met Bong screams. "There will be no killing tonight!"

"She attacked me first!" Rarnie, sitting up, points at me.

"I don't care who started it." She points to Rarnie, "Go and wash up." She then turns to me: her eyes bore into me, she leans toward me, and yells, "You are so strong to get into a fight? You have to water this whole garden tonight. You cannot sleep until you finish. And no food for you tonight!" Before leaving, Met Bong instructs another girl to guard me and make sure I do as I am told.

As I struggle to get up, the crowd around me slowly dissipates. Chou comes over and offers her hand, but I refuse it. I grab the water pail and start to water the garden. I work while the girls eat their dinner, recite propaganda at the nightly lessons, and get ready to go to bed. I do not cry, scream, or beg for mercy. I occupy my mind with thoughts of revenge and massacre. In my head, I make a list of all the wrongs done to me. I will make them suffer twice the blows I've suffered by their hands. Many hours into the night, Met Bong approaches and tells me to go to sleep. Without looking at her, I drop my pail and walk in my hut to fall into an exhausted sleep.

The girls stop abusing me after the fight with Rarnie. But they continue to pick on Chou because she looks weak and shows her fear. It has been three weeks since Chou and I arrived at the camp. Trailing behind a group of girls, carrying our spare set of black pajama clothes in our hands, we walk to the river for our first wash.

"Chou, don't let them beat you up! Don't let them think they can get away with it," I tell her.

"But they can beat me and get away with it. I cannot win against them."

"So what? I can take any one of them, but if they gang up on me, they can beat me. I don't let them know that. I don't care if I win, but I will draw blood. I will get in my punches.

"Chou, I dream of the day when we have power again. I will come back for them. I will get them back and beat them until I am tired. I won't forget, not ever."

"Why would you want to remember? I dream of the day when things are nice again, and I can leave all this behind."

Chou does not understand. I need the new memories that make me angry to replace the old ones that make me sad. My rage makes me want to live just to come back and take my revenge. At the pond, the girls run into the water still fully dressed, splashing and laughing at each other's attempt to swim. While Chou scrubs the grime off her clothes, I float face up in the water. Thinking of Keav, I allow myself to sink as the water laps over my cheeks, eyes, and nose. Rising above the surface again, I feel the weeks' mud dissolve and slide off my skin, my nails, the creases in my neck and toes. The water washes away the dirt, but it will never put out the fire of hate I have for the Khmer Rouge.

child soldiers

The months pass and the government continues to increase our food ration, allowing me to grow a little stronger. It has been three months since we left Ro Leap and last saw Kim, Ma, and Geak. I think about them every day and wonder how they are. At night when all the other children are fast asleep, Chou and I whisper to each other about Ma and Geak. I hope that Meng, Khouy, and Kim are able to visit Ma and make sure she is well. My heart lifts a little knowing that Ma has Geak to keep her from being too lonely.

The other children have stopped picking on me because I am a fighter. While I have also improved my reputation as a worker, because she is weak, Chou has been taken out of the garden and demoted to a cook. She actually likes it better because she no longer has to associate with the other children.

But since I am strong, it was only after three months of being at the camp when Met Bong told me she had some "good news."

"You are the youngest girl here, but you work harder than everyone else. The Angkar needs people like you," she says and smiles. "It's really too bad you are not a boy," she adds. When she sees that I am not jumping with joy at the news, her face scowls. "Your number one duty

is to the Angkar and no one else. You should be happy with yourself. This camp is for the weaklings. The camp you are going to is for the bigger, stronger children. There you will be trained as a soldier so you can soon help fight the war. You will learn many more things there than the children here." Her face beams with pride when she finishes.

"Yes, Met Bong, I am happy to go," I lie. I don't understand Met Bong's elation. I do not want to sacrifice for the country that killed my pa.

At the break of dawn, I pack my clothes and my food bowl. Chou stands beside me with her head down. I do not want to leave Chou behind, but I cannot refuse the reassignment. Hooking our elbows together, we walk to the gate to meet Met Bong.

"Chou, you're older than me, stop being so weak," I whisper as we hug, our arms wrapped tightly around each other. "We will always be sisters even though you were found in a trashcan." Chou cries harder, her tears wetting my hair. Met Bong breaks our bond and tells me it's time to go. Chou refuses to let go of my hand. With all my strength, I pull it from her grasp and run away. Though my heart aches, I do not look back.

Met Bong leads me to another camp an hour's walk away. I do not know what to expect of the new camp, but when Met Bong says it is a child soldier training camp, I presume it will be a big place with many weapons and soldiers living there. But the new camp is almost identical to the old one. It is supervised by another Met Bong with similar features and characteristics, who is just as zealous a believer in the Angkar as my previous supervisor. While they talk, I am left alone to contemplate my new home.

The new work camp sits at the edge of a rice field and is surrounded by forest. All around the huts, tall palm trees sway lightly in the wind. In one, a young boy is cutting down a cluster of palm fruits with a silver cleaver. He looks about twelve or fourteen years old, has a round face, black wavy hair, and a small, dark sinewy body. I marvel at how his toes and fingers grip the tree like a monkey. While one hand holds on to a few sturdy leaves, the other wields the cleaver, separating the fruit from the tree. As if sensing my stare, the boy stops his work

and turns to me. Our eyes meet and hold for a few seconds. He smiles and waves to me, but the cleaver is still in his hand. This familiar gesture of human friendship that I have become so unused to is made all the more unfamiliar as he chops the air with the knife. I smile back at him before turning my attention back to the camp.

The camp houses about eighty girls, their ages ranging from ten to fifteen. I have yet to turn eight. Unlike the other camp, not all the girls are orphans. Many have families living in nearby villages. All have been selected by either their village chief or work supervisor to live here. There is a similarly operated boys' camp not far from us on the other side of the rice field, with approximately another eighty boys supervised by their comrade brother, or Met Bong Preuf. I am told that occasionally the two camps gather together for lessons on the Angkar, and afterward, they celebrate the Angkar's victories with dances and songs.

My first night at the camp the two groups gather around a roaring bonfire to listen to the latest propaganda. The two Met Bongs stand before us and take turns preaching their message. "The Angkar is our savior! The Angkar is our liberator! We owe everything to the Angkar! We are strong because of the Angkar!" Having heard it many times, I know when to break into the obligatory claps and screams. "Our Khmer soldiers today killed five hundred Youns trying invade our country! The Youns have many more soldiers, but they are stupid and are cowards! One Khmer soldier can kill ten Youns!"

"Angkar! Angkar! Angkar!" we scream our replies.

"The Youns have many more weapons, but our Khmer soldiers are stronger, smarter, and fearless! The Youns are like the devils and some refuse to die!" Their voices rising higher and higher, the Met Bongs tell us how our Khmer soldiers kill the Youns! Our Khmer soldiers gut the Youns with knives, spilling their insides on the dirt. They cut off the Youns' heads as warnings to other Youns invading Kampuchea. The Met Bongs pace around the circle of children as if possessed by powerful spirits, their arms shaking furiously at the sky, their lips moving faster and faster as they spit words about the glory of the Angkar and our unbeatable Khmer soldiers—words condemning the Youns and detailing their gory fate. The children's furor matches that of the Met Bongs.

"You are the children of the Angkar! In you lies our future. The Angkar knows you are pure in heart, uncorrupted by evil influences, still able to learn the ways of the Angkar! That is why the Angkar loves you above all else. That is why the Angkar gives you so much power. You are our saviors. You have the power!"

"Angkar! Angkar! Angkar!" we thunder in appreciation.

"The Youns hate you. They want to come and take away the Khmer's treasures, including you. The Youns know you are our treasure." Squatting down, the Met Bongs look us in our eyes and tell us the Youns have already infiltrated our towns and villages to try to capture us. But the Angkar will protect us if we give it our total loyalty. This means we must report to the Angkar suspected infiltrators and traitors. If we hear anyone at all—our friends, neighbors, cousins, even our own parents—speak things against the Angkar, we must report them to the Met Bongs. My heart stops. Though the Met Bongs' lips continue to move and words continue to come out, I can no longer hear them. Pa was against the Angkar! That must be why Pa was killed. Ma is against the Angkar and they must never know this. With my fist raised I scream the obligatory "Angkars!"

When the speeches are over, the circle opens up and the kids gather to one side of the fire. Four boys get up from the crowd, with mandolins and homemade drums in hand. They stand to the side of the crowd and start to play their instruments. They beat the drums and strum the mandolins while their feet tap the ground. They look at each other, brows arching, eyes narrowing, mouths opening with bared teeth. But they do not look angry; in fact, they look happy! When they finish, they tease each other about who missed what notes. All of a sudden, they burst into loud laughter! The sound is nasal, shrill, and genuine. I have not heard anyone laugh genuinely since the Khmer Rouge takeover. In Ro Leap, we lived with so much fear that there was no room for laughter. We were afraid to laugh lest it draw attention to our family.

After the boys quiet down, five girls walk up to the front and stand facing the crowd. All are wearing beautiful black shirts and pants, not the faded, gray-black I have on, but shiny and new, with bright red scarves around their waists. They wear red ribbons across their foreheads with red fake flowers made of dyed straw. Forming a line, they sing and

dance for us. All the songs are about worshiping the powerful leader of the Angkar, Pol Pot, the glory of Angkar society, and the unbeatable Khmer soldiers.

They dance scenes depicting farmers at work, the harvesting of rice, nurses helping wounded soldiers, and soldiers winning battles. There is even a song about a woman soldier hiding her knife in her skirt and thrusting it into the heart of a Youn. Though I dislike the songs, it is music nevertheless, and it is something of a respite from the life I have been living. In the nearly two years I lived in Ro Leap, there was no music or dancing. The chief told us the Angkar had banned it. This must be a privilege that we, as child soldiers, have been granted.

Watching the girls sing and dance, a strange feeling comes over me. Though the words they sing describe images of blood and war, the girls smile. Their hands move gracefully in unison, their bodies sway and twirl to the rhythm of the music. After the dance, they hold hands and giggle as if they have had fun. This thought warms me, bringing a smile to my lips. Laughter has become a distant memory and I cherish the echo of a different time. In Phnom Penh, Chou and I used to take Keav's clothes out of her drawers and play dress-up with them. At fourteen, Keav was beautiful and stylish, and bought only the latest fashions. Her clothes were so grown-up and pretty, just like Ma's. Long, flowing dresses, short shimmering skirts, and ruffled-collar shirts filled her closet. Chou and I slipped in and out of her clothes, laughing and giggling, calling each other Madame and Mademoiselle. Then we'd go into Keav's jewelry box and put on her necklaces and earrings. Keav inevitably came home and caught us. Screaming and yelling, she swatted at our bottoms as we ran out of the room.

After the performance, all of us are invited to dance. The girls get up and dance with each other and the boys group tightly together. I have always loved music and dancing. For a few minutes, my feet move to the beat of the drums, my arms sway to the rhythm of the song, and my heart is light and joyful. After the dancing is over, Met Bong comes over and says, "For a young girl, you are a good dancer."

"Thank you," I reply softly. "I like to dance."

"What is your name again?"

"Sarene," my lips easily say my new Cambodian name.

"Sarene, I want you to join the dance troop. We're putting together shows for the soldiers. This would mean taking time off work for rehearsal. We only dance for fun now, but we will dance for the soldiers if a unit comes to the village."

"Thank you, Met Bong. I would like it very much." After she leaves, I cover my hand over my mouth, stifling a scream. Me! A dancer! I get to get off work for rehearsal and travel. New clothes! Fake flowers in my hair! For the first time since the takeover, I feel young and light. A smile crosses my face.

The reality, though, is more painful and tiring than I had imagined. Every morning before we start rehearsing, Met Bong wraps our fingers together with elephant grass. Then she forces our hands to bend backward creating a beautiful curve when the hand is unwrapped. The process is incredibly painful and it takes many years to achieve a permanent curve. She cuts the grass bondage after an hour, leaving my fingers stiff and throbbing with pain. Then in our line formation, she teaches us a few simple steps each day. When I am not busy with dance rehearsals, I work from morning until midafternoon in the rice field. The rest of the time I spend learning the songs and listening to Met Bong preach the philosophy of the Angkar.

On my first day of field work, after only a few steps in the muddy water, my ankles and toes start to itch. I lift one foot out the water and scream loudly. There are fat black leeches all over my ankles, feet, and between my toes. I have seen leeches before, but never ones so big and fat. These are bigger than my fingers. Black and slimy, they attach themselves to my flesh with suction cups, sucking my blood! Their bodies writhe and vibrate, making my skin itch and tingle. Frantically, I try to peel them off, my fingers grabbing their cold squishy bodies. The leeches stretch with my pull, become longer. They refuse to let go. Finally, I get one head off but the other end stays firm and continues to take more blood.

A workmate comes over to me and laughs. For a brief second the sound of laughter startles me. "You are so stupid! This is the only way to get them off." She pulls out a stalk of grass. Her hands hold both ends of the stalk, and she swipes the grass down and around my ankle. The leeches fall off onto the ground, leaving my ankle bleeding.

"This way both heads come off at once. Next time, put the legs of

your pants down, and tie them tight around your ankles so nothing can get in." I had rolled my pants up so as not to get them wet. I was wondering why everyone wore them down.

"What about my feet and toes?" I ask anxiously. The girl shrugs her shoulders.

"There's nothing much we can do. They don't hurt and they can't take much blood. I pull them off at the end of the day. Get used to them."

I shudder at the thought and wonder if I can. From afar, Met Bong screams for me to stop being lazy and get back into the water. My heart beats quickly. Laziness is the worst crime against the Angkar. I tie my pants tight around my ankles with long grass and jump back into the rice paddy. In the water, the warm mud oozes itself between my toes and after a few steps, my feet and toes begin to tingle and itch again. "Get used to it!" I mutter to myself. Gritting my teeth with determination, I bend over to plant the rice. The work is back-breaking and boring, and the sun burns my black pajama clothes. As the hours pass, my mind wanders to Keav. This is what she did every day until she died. Sweat drips down my face and chin as my stomach convulses. I have no time to be weak. At the end of the day, I did forget about the leeches clinging to my toes, but I did not forget about my sister.

It is September, two months since I last saw Chou. Met Bong is training the younger children to protect themselves now. She tells us Pol Pot senses troubles ahead and we must prepare ourselves. Pol Pot is sending soldiers into villages and towns and taking all children eight years and older from their homes, including base children. Depending on their size and age, the children are given different jobs and training. They are put in camps to grow food, make tools, work as porters, and train as soldiers on bases like ours.

"You should be proud," she says. "Your training with me puts you far ahead of these other children."

"Met Bong," I ask, "I have done nothing but work in the field and watch the older girls train."

"It is very easy to train someone to use weapons," she replies, "but to train the mind is much more difficult. I have been training your mind all

these months. I have tried my best to place Pol Pot's words in your head and to tell you the truth about the Youns. Children must be taught to follow orders without hesitation, without question, and to shoot and kill even their traitor parents. That is the first step in the training." I seethe when I hear her words. Rage boils quietly inside me, but I contain it. I will never kill Ma for them. Not ever!

The New Year passes over without any celebration or joy. The January breeze turns into April heat and I am one year older. Life at the camp continues as always while I divide my time between the field and the training lessons. Like Keav, I am alone here, even though I eat the same food and sleep in the same hut with eighty girls. Besides our obligatory discussions about the power of Pol Pot and his army, we live together in silence. We keep to ourselves because we are all hiding secrets. My secret is our lives in Phnom Penh. For another girl, it may be that she has a handicapped brother, has stolen food, possesses a pair of red pants, is nearsighted and used to wear glasses, or has tasted chocolate. If she is found out, she can be punished by Met Bong.

Though I know the danger of developing a friendship with the girls, sometimes I wistfully think about it. Without Chou, I am alone. Until now, I've always had Chou to play with, fight with, and talk to. In Phnom Penh, Khouy and Meng were already adults, Keav was a teenage girl, Kim a prepubescent, and Geak a baby. Chou and I were closest to each other. When I was sad and upset, it was she whom I invariably sought out to share my feelings. I never realized how much I would miss her now that we are apart.

At the new camp, the nearest thing to friendship comes from the palm tree boy. I do not know his name and have never spoken to him. He comes to our camp often, sometimes by himself and sometimes with his father. I learned from Met Bong that he lives with his family in a nearby village. He and his father share the job of collecting palm sap and fruit for the village's chief. The boy and his father often give Met Bong some palm fruit to eat. If they are there when I am around, the boy usually throws a palm fruit in my direction, smiling and waving to me with his hand still clutching the cleaver.

Every day, our nightly lessons grow longer and longer. It seems Pol Pot has replaced the Angkar as the source of power. I don't know why or how it happened. I do not know anything more about him, except for what Met Bong tells us at our nightly lesson. Met Bong says he is the one responsible for bringing the Khmer Rouge to power. He is the one who will restore Kampuchea to its ancient glory. Met Bong's voice rises as she speaks his name, as if uttering "Pol Pot" brings her closer to his power. Since the Khmer Rouge takeover of Phnom Penh, I have heard of Pol Pot but I never knew exactly what his position with the Angkar was. Now it seems that it is the Angkar that is working for him, and that we all work for him. More and more each day, we call out his name in place of the Angkar. In the propaganda reports, we now give thanks to Pol Pot, our savior and liberator, and not to the Angkar. It seems that nothing is accomplished without the credit going to Pol Pot. If our rice production is increased this year it is because Pol Pot made it happen. If a soldier is a strong and skillful fighter, it is because Pol Pot taught him. If the soldier gets killed, then he did not listen to Pol Pot's advice. Every night we praise and commend Pol Pot and his Red Khmer soldiers for defeating the enemy.

In violent details we hear of the soldiers' mighty strength and supernatural powers to kill the Youns. The Youns are superstitious and believe that if their body parts are not buried together when they die, then their souls are doomed to wander the earth for all eternity. These souls cannot rest or be reincarnated back to earth. Knowing this, our soldiers cut off the Youns' heads and hide them in bushes or toss them in the jungle so they cannot be found. All this information we get in gory detail until we too become desensitized to the violence.

Within the next month, one by one the older boys and girls leave the camp with nothing more than the clothes they are wearing. They are sent off to help the war. Some go to live in other camps, where they learn to make poison stakes, and others follow the soldiers as porters. As porters they carry supplies, food, medical aid, and weapons for the soldiers and are often put in the line of fire. Many of the children have been moved to so many locations that their parents do not know where they are. Once gone, many of them are never heard from again.

Then the boys' camp closes altogether. Met Bong says Pol Pot needed the boys to go and live in the mountains so they are closer to the other soldiers. There the soldiers can protect them. She tells us Pol Pot knows best but still she seems angry with their move. On the boys' last night, while the children were sleeping, I got up because I had to go to the bathroom. From the bushes, I spied Met Bong and Met Preuf together by the fire. They were sitting on the ground, their shoulders touching. They talked softly, but the words were drowned out by the crackles of the fire. Met Bong then rested her head on the male supervisor's shoulder and he put his arms around her. She is, after all, a young woman, and anywhere else this would be an everyday scene. I wonder why she is allowed companionship when we are not. When the boys left, they took their instruments with them. Now Met Bong still requires the girls to practice with the hope that soon the boys will return and we can all dance again.

Soon our camp population is reduced to forty girls, ranging in age from ten to thirteen. Now it is our turn, Met Bong tells us, to increase our training and fulfill our duty to Pol Pot. She gathers the girls together and instructs us to sit in a circle. "You are the children of the Angkar. You are here because you are the brightest and fastest. You are fearless and are not afraid to fight. The Angkar needs you to be our future." She says this slowly, deliberately, filling us with pride. "One day soon you will join the older girls to fight the Youns, but for now there are many things you will need to learn."

Met Bong stands up and disappears, only to return moments later with an armful of tools. They clang noisily as she drops them in a pile in front of us. Sitting before us she says, "All these tools you know already. We use them to harvest rice, plant vegetables, and build houses. But in the hands of fighters, they are also weapons of war. The round sickle, the hoe, the rake, the hammer, the machete, the wooden stick, and a rifle." She reaches for the sickle and holds it up. "The sharp edge can take off the enemy's head," she says. "The point of the sickle can pierce a person's skull." My eyes widen as these images are imprinted on my brain. The top of my skull tingles. I look to see the other children listening intently, displaying no emotion. "The hammer smashes the enemy's skull; the machete cuts them. When you have to protect

yourself, make whatever you have into weapons," Met Bong shares with us. I stare blankly at her, absorbing her words, showing no feeling while my hate for her grows stronger. These are the weapons Pol Pot's men used on their victims, victims like Pa. I blink rapidly several times trying to chase away the images.

Met Bong picks a rifle from the pile, the same kind I have seen many times before on the shoulders of the Khmer Rouge soldiers. "This is a weapon I wish we had more of but they are very expensive. The ammunition for them is very expensive too, so we have few rifles to waste. The rifle is easy to shoot. Anyone can learn to use them— even a child can shoot it." She calls me from the circle of forty girls. "This is one way to carry it," she says as she puts the rifle on my shoulder, its butt digging into my chest. It rests heavily on my shoulder, perhaps a fifth of my weight. Met Bong then instructs me to sling one arm over it, balancing its weight with my arm. I do this easily but against my will. She then takes the rifle and slips the strap on my shoulder. The rifle hangs on my back a foot from the ground, its butt bouncing lightly on my calf. "Obviously, it is too long for Sarene to carry this way," Met Bong says.

I focus on it, realizing that this is the weapon that made Kim bleed, the same weapon that smashed into his skull. My hand shakes slightly, but I steady it by clutching the stock tightly until my knuckles turn white. "Your extended left hand holds and balances the rifle. Your right hand aims and squeezes the trigger. See, it's easy!" Met Bong's voice sounds enthusiastic and jubilant, but I feel neither her joy nor passion, only my hatred for her and Pol Pot. "When the bullets come out of the rifle, they travel in a straight line. Many soldiers say they can escape the bullets by running in a zigzag." She calls each child one by one and teaches her how to hold the rifle. After our first lesson, Met Bong assures us that this is only one of many lessons to come.

During the day, no one can hurt me, but at night, as I drift off to sleep, sandwiched among forty girls, away from Chou, my mind wanders and dreams of my family, keeping me awake. In the morning, my head throbs and I am drained of energy. I cannot allow this weakness to control me, or let it seep into my spirit. If this happens I know I will die because the weak do not survive in Kampuchea.

The nights when I do not dream of my family, I have nightmares of something or someone trying to kill me. The dream always begins the same way. The sky is black and echoes with the thunder of monsoon storms. I am crouching in a bush and sweat runs down my forehead and stings my eyes. Shivering, I bring my knees closer to my chest. I hold my breath when I hear leaves rustling all around me, then foot-steps. Instinctively, I know something is after me; it is looking for me in nearby bushes, looking to kill me.

Two giant hands separate the leaves and expose me. My body is par-alyzed when I see what stands before me. It is both a man and a beast. It hovers above me, coal black eyes bulge out of its sockets, and large, flat nostrils flare from his fat, furry face. Fear grips me as I notice the silver machete in its hand, gleaming sinisterly in the moonlight. As the beast bends down to grab me, I run and make my escape between its legs. It turns around and slashes at me with the machete, barely missing my leg. As I run I hear the blade landing nearer and nearer to me, slicing through the bushes around me. The faster I run the faster it runs after me. It chases me until I am cornered.

Then the jungle closes in on me, forming thick walls. There is no escape. The beast raises the machete over its head, aimed directly at me. I am sick of it now. I'm sick of being chased and tired of running. My blood boils with rage as I hurl my body into it, knocking it off balance. It drops the machete. I ram my body into it once more and it crashes down onto the ground. I get up and grab the machete. Time freezes as I chop off its hand. Its stump squirts blood all over me, but I do not care. Again and again, I raise the machete and hack off pieces of its body until it lies motionless, dead. In the morning I wake up soaked in sweat and fear, yet strengthened by the nightmare since I turn out to be the victor.

The dreams are always the same, but the character changes. The "enemy," a Khmer Rouge soldier or a wild beast, a monster or a ghostly man-creature, comes after me with knives, guns, axes, machetes. There is always a struggle until I obtain control of the weapon and kill the enemy before it can kill me. In the end, I, the hunted, turn and become the killer.

. . .

Each night before we can sleep, Met Bong gathers us together in the hut for another hour of propaganda reports. She lights one candle and holds it in her hand. The orange glow lights up her face while the rest of us are in the dark. At one meeting, as I lean against the straw wall and slowly fall asleep, a loud scream shocks me awake. With my heart pounding, I wonder if it was me who screamed. But then I see that the girls have closed in tightly around Met Bong.

"What happened?" Met Bong asks the girl who screamed.

"I felt. . . it was a big hand. I was leaning against the wall. A hand reached through the straw and grabbed my arm, then my throat. It was wet and cold. I know it's a Youn coming to get us." The girl's lips tremble, her face is yellow in the light, looking very much like an apparition. Met Bong turns to the older girls and tells them to go look.

"Take the guns—make sure they are loaded. Shoot anything that moves." After the older girls leave, the group huddles together in the middle of the room, facing the walls. Images of the Youns attacking and killing us run in my mind, filling me with fear. In Phnom Penh, Pa once told me the Youns are just like us but with whiter skin and smaller noses. However, Met Bong describes the Youns as savages who are bent on taking over our country and our people. I do not know what to believe. The only world I know beyond this camp is the one Met Bong describes to me. Sitting in the dark, I find myself starting to believe her message about the enemies.

A few minutes later, the girls return and report that whatever was out there is now gone. In the moonlight, they saw large footprints around the compound. "The Youns are attacking us," Met Bong informs us. Her hands grip the rifle tightly to her chest. "When they take over the towns, they infiltrate them and open up the prisons. The Youns are running around raping girls and pillaging towns, and the prisoners who are against Pol Pot are with the Youns. We have to protect ourselves," Met Bong rambles on frantically. After that night Met Bong institutes a new policy and we now take turns guarding the camp at night.

I am asleep when a hand roughly jerks my shoulders. "Wake up, it's your turn to stand guard," a voice says to me from the dark. Grumpy, I sit up and rub the sleep out of my eyes. She puts the rifle in my hand,

which is heavy, and I cradle it against my chest because my fingers are not long enough to wrap around its stock. I walk over to the doorway and sit down.

The sky is dark and cloudless, allowing the full moon to shine through, giving everything an eerie, silvery glow. The cool wind blows quietly. All is quiet, except for the crickets. I live with forty others, but I am so alone in this world. There is no camaraderie among the children, no blossoming friendships, no bonding together under hardship. We live against each other, spying on one another for Pol Pot, hoping to win favors from Met Bong. Met Bong says Pol Pot loves me, but I know he does not. Maybe he loves the other children, the uncorrupted base children with their uncontaminated parents. I came to this camp under false pretenses and lies. They think I am one of them, one of the pure base children.

I have never seen Pol Pot in person or in pictures. I know little about him or why he killed Pa. I do not know why he hates me so much. In the night when my defenses are down, my mind flashes from one member of my family to next. I think of Ma, Keav, Chou, and my brothers. My throat swells when Geak's face floats into my mind. "No," I tell myself, "I have to be strong. No time to be weak." But I miss Pa so much it hurts to breathe. It's been almost a year now since I held his hand, saw his face, felt his love.

The night sky looms ever more black in front of me. "Oh Pa," I whisper to the air. As if answering me, something rustles loudly in the tall grass. I hold my breath and look around the compound. I know I heard something! My heart races. Everything out there is moving toward me. The tree trunks expand and contract as if they are breathing. The branches shake and swing, transform into hands. The grass sways like waves heading toward me. They are coming at us! My finger squeezes the trigger and the shots go everywhere! The rifle jerks back, hitting me hard against my ribs. "I'll kill them! I'll kill them!" I scream.

Then a hand grabs the rifle from me while another slaps my face. With my eyes open wide, I put my arms up to shield against another assault.

"Wake up!" Met Bong screams at me. "There's nothing out there! We have no bullets to waste!" I flinch as she raises her hand again but then decides against hitting me.

"But Met Bong, you said——" I plead in a small voice.

"I said shoot when you see something real, not ghosts," Met Bong interrupts me as laughter erupts from the girls.

"Don't forget about the bodiless witches," a voice calls out to me as they all head back to sleep.

Many claim she's only a myth——the bodiless witch, an ordinary person by daytime and a witch at night. The only way to tell if someone is a bodiless witch is by the deep wrinkle lines around her neck. At night when these witches go to sleep their heads separate from their bodies. Dragging their intestines along, they fly around to places where there's blood and death. The heads fly so fast that no one has ever seen the faces, only their shiny red eyes and sometimes the shadow of their heads and entrails. Once she finds a dead body, the bodiless witch nestles against the corpse all night. Their tongues lick blood and eat flesh while their innards writhe around them.

That night I clutch the gun tight to my chest, my finger resting on the trigger, alternately aiming at the sight of the Youns and up in the sky for the witches.

gold for chicken

Seven months have passed since I left Ro Leap. My fingers tremble as I button my new black shirt. I want to impress Ma with my new clothes. I wish I had a mirror, but there isn't one around. Since there are no hairbrushes or combs, I run my fingers through my greasy hair to smooth it out. Nervously, I walk out of the compound of the camp; in a couple of hours, I will be with Ma.

The Youn scare is over for now and all is quiet again at the camp. Every few months, Met Bong allows all the children to have a day of rest. Many take the opportunity to visit their families. My breath quickens as my feet take me closer and closer to Ro Leap. Since Met Bong believes I am an orphan, I say I am visiting Chou but instead will go see Ma. Ma does not know I am coming; she might not even be home. She told me not to come back. What if she doesn't want to see me or won't see me?

Following the same path Chou and I took out of Ro Leap, I march crisply toward the village. The surroundings seem to have changed very little since I last saw them. The red dirt trail winds and dips behind small foothills, shaded by tall teak trees. When I left I was a scared kid who cried and begged Ma to let me stay with her. Though I tried to be

strong, I was weak and did not know how I could fend for myself
without Ma's protection. But I am no longer that scared child. My only
fear now is that Ma will not be happy to see me. The memory of her
hand swatting my behind to make me leave Ro Leap still burns in me.
On today's journey, the trees look smaller and less haunted, and the
path has an end—a destination.

Finally I see the village. It looks familiar yet it's changed. The town
square is deserted and quiet as I cross it to face the rows of huts. My
lungs expand and contract rapidly as I remember Pa lifting me off the
truck when we first arrived. I freeze his face in my mind, his warm eyes
beckoning me to him, his arms holding me, protecting me while a base
person spits at him. Inhaling deeply, I force myself closer to our hut.
Like entering a ghost town, images of Keav telling Pa she will survive,
Kim's swollen cheeks, my hand reaching into the rice container, earth-
worms writhing in a bowl float before my eyes. The memories haunt
and follow me like my shadow as I climb slowly up the steps to our hut.
Ma is not there. My knees ache as I force my feet to move to the vil-
lage's garden.

There I see them. Their backs are to me. Ma's squatting in the
garden, pulling out weeds. Her black pajama clothes are gray and faded.
The noon sun burns down on her, but she keeps working. Stiffening
my back, my eyes skip over to Geak, who is sitting under a tree,
watching Ma. She is still so little, so thin. Her hair is growing out again,
but it is still very fine. She is almost five and looks much smaller than I
did when I was that age. Ma says something to her, and she laughs a
small, frail laugh. My heart leaps. They have each other. They will always
have each other.

"Ma," I call out loudly. Her back stiffens. Slowly, she turns her head,
her eyes squinting in the sun. It takes her a few seconds to recognize
me, then she stands quickly and runs toward me. Tears fall from her eyes
as she puts her hands over me, touching my head, my shoulders, my
face, as if to make sure I am real.

"What are you doing here? What if you get caught?"

"Ma, it's okay. I have a permission slip."

She takes the slip and quickly reads it. It is only a piece of paper
saying I can leave my camp and no mention of a designated location.

"All right, you stay here with Geak while I take this to the chief and ask for some time off." Before I can say anything she's gone, leaving me standing there by myself, already missing her. I feel a gentle hand tug on my little finger and I look to see Geak's face staring up at me, her eyes big and wet. She barely reaches my chest. Though she is five, I always think of her as a baby. Maybe because she is weak and does not fight. I smile and reach my hand out to her. Together we walk to a shady tree and wait for Ma's return.

Sitting under the tree, I hold on to Geak's hand. It is small in my palm, brown from the sun with black dirt burrows in her nails and the wrinkles around the knuckles. Her nails are brittle. I continue to stare at her hand, too afraid to look at her face and see my guilt in her eyes. I do not know what to say to her. She has never been a talkative child; she is the sweet-natured one and I am the cranky one. Leaning over, I put my arms around her tiny shoulders and rest my cheek gently on her head. She does not move or struggle but allows me to hold her.

Ma comes back with a bowl of rice and permission to take a few hours off. "It's past lunch, but I got this for you from the chief."

I take the bowl and we walk back to our hut.

"The chief gave you time off?"

"Only a few hours. He is not a bad man."

"Ma, Geak still looks really sick," I say once we are sheltered in our hut.

"I know, I'm very worried about her. I'm afraid she won't grow anymore. We are given plenty of rice now, but we had all those periods of virtually no food.

Pangs of guilt gnaw at my stomach.

"She needs meat," Ma continues. "Last week, I tried to trade a pair of my ruby earrings for a small chicken . . ." Her eyes are sad as she recounts her story to me.

It was dusk and the sky turned red as it phased into night. When she and Geak finished their meal of rice and fish, Ma went to her secret hiding place under the small pile of clothes and took out one of Pa's old shirts. Reaching into the pocket, she took out a pair of ruby earrings. Sadness overcame her as she remembered Phnom Penh, a place long ago where she collected expensive antique jewelry. She shook her head as if to chase away the memory. No time for that now. She had to

get going before it got too dark. She told Geak she would be back soon and quickly left.

As she walked the twenty minutes to a nearby village, her body grew weak. Her joints ached with every step. She hated leaving Geak alone. She knows Geak cries for her whenever she leaves, even for only a few minutes. Her poor baby girl. "Seng Im," she whispered to Pa, "I'm so tired. I'm thirty-nine and growing old, so fast and so alone. Remember? We were to grow old together. Seng Im, I'm too old to live like this." The memory of Pa brought tears to her eyes. She knows it's no use, but still she talks to him.

Ma approached the village. Her heart raced, pumping the blood too quickly and making her dizzy. "Act casual," she thought. "They cannot suspect." If they knew what she was doing here, if she got caught, there would be big trouble. She shuddered when she thought of what they would do to her. Pa had traded inside the village with the base people for rice and other grains. But Ma wanted to trade for meat to feed Geak. The other women assured her the operation is completely discreet and safe. Slowly, she walked into the village. No one stopped her to ask questions. If they did, she would tell them she was visiting a friend. A sigh of relief escaped her when she saw the house. In it lives a certain woman who works in the chicken farm. Other women in the village told Ma this woman had stolen chicken for them in exchange for jewelry. They described in detail the woman and her hut, so it was easy for Ma to pick it out. She walked over and called out, "Good evening, comrade sister. It is your friend visiting you." The woman looked out of her hut, and though she did not recognize Ma, she invited her in.

Once safely inside Ma whispered to her, "Comrade sister, I have come to ask for your help. I am told that you work in a chicken farm. I have a young daughter who is sick. She needs some meat. Please, comrade sister, help me." Ma unfolded her scarf and showed the woman the earrings. "If you are able to help me, I will give the pair to you."

"Yes, yes, I can get you a small chicken, but I cannot do it now. You have to come back tomorrow. Come at the same time tomorrow." With that, she hurriedly sent Ma away.

The next night Ma returned to the village with her earrings. Her steps were faster and lighter tonight, a smile spreading over her face as

she thought of giving Geak the chicken to eat. Ma can't even remember the last time she and Geak had meat. Ma walked to the house and the woman invited her in. As she sat down across from the woman, Ma realized the woman was agitated and nervous. Then Ma heard the sound of footsteps behind her, coming from a dark corner of the room. Her heart lurched and fear took over her body as she stood. "What's going on?" she managed to whisper to the woman.

A man emerged from the shadows and blocked her escape. "Please comrade, I have a daughter——"

His hand came down hard across Ma's face.

Ma's hand blocked her face, her eyes blinked back tears.

"Give me the earrings," the man commanded. With shaking hands, Ma reached into her pockets, found the earrings, and put them in his open palm.

"Give me everything you have," he demanded her.

"Comrade, please forgive me for I do not have any more. This is all I——" her voice trembled. He balled up his fist and punched her in the stomach. Ma doubled over and fell to her knees. His foot kicked her thighs, then many more kicks landed on her body. She was lying on the floor now, gasping in pain.

"Please comrade," she begged, thinking of Geak, "have mercy, I have a young, sick daughter."

His foot dug into her stomach. White spots flashed before her eyes. She felt as if her insides had been ripped out. She gasped for more breath as his hands pulled her to her feet. He dragged her to the door and pushed her out the steps.

"Don't come back, ever!" he yelled at her. Her knees buckled on the steps. She fell, her body slamming against the stairs. Landing in the dirt, she picked herself up and ran.

Back at Ro Leap, Ma lifts her shirt and shows me the bruises where the man beat her. The marks look raw. Black and blue, they run across her protruding ribs. She lifts her skirt up and shows me the big red and purple patches covering her white thighs. Looking at her face, a rage rises up in me. The image of some stranger beating my mother brings to life such hate in me. And all for a chicken!

"Ma, I want to kill him!" I tell her.

"Shh . . . Don't talk crazy," she shushes me. "Don't say it out loud or we will be in trouble. I am lucky to be alive at all. I feel sad Geak did not get her meat."

Hearing her name, Geak walks over to Ma and sits on her lap. Ma smoothes her hair and kisses the top of her head.

"I'll have to be more careful from now on," Ma continues. "I worry about who will take care of Geak if something happens to me." Ma stares at Geak and sighs. Her biggest worry is that her sick child does not get what she needs. I look at Geak; she is quiet in Ma's arms. It strikes me then how she does not have much command over the language to complain about her hunger. How does a five-year-old tell us about her stomach hurting, her heart aching for Pa, and her fading memories of Keav. I know she hurts and feels pain. It is rare when she does not thrash and cry in her sleep. Her eyes look lost. "I'm so very sorry," I say to her with my eyes. "I'm sorry I am not good like the rest of the family."

"Chou visited us a few weeks ago," Ma says. "She was able to get permission slips to visit every other month now. She said the old Met Bong was taken away by soldiers and the new one is nice. She tells the new Met Bong she has a younger sister at this camp living with another family. Being a cook, she is able to sneak rice out of the kitchen and dry it in the sun. She brought us a feast the last time she came." I flinch with shame as Ma's voice trails off. I cannot listen anymore. I did not bring Ma and Geak anything. I am tormented by the knowledge of how much my family is willing to sacrifice for each other. If Chou gets caught sneaking food she will be severely punished, but she risks it. Kim stole corn for us and was brutally beaten. Ma was assaulted trying to get Geak a bit of chicken meat. I have done nothing.

I look at Geak and choke back my sadness. She was so beautiful when we lived in Phnom Penh. She was everyone's favorite. Her big brown eyes were always so full of life. She had two of the world's rosiest, chubbiest cheeks, which no one could keep from touching. Now she has lost all her color; her face is sunken and hollow. There is always sadness and hunger in her eyes. I stole her food and now I'm letting her starve.

"A lot has happened since you left." Ma's voice brings me back. My eyes stay on Geak. She does not talk anymore. She is so thin it is as if

her body is eating itself up. Her skin is pale yellow, her teeth rotten or missing. Still she is beautiful because she is good and pure. Looking at her makes me want to die inside.

When the sun falls behind the hut it is time for me to leave. The camp is a few hours walk and I need to reach it before dark. Ma and Geak walk to the road to see me off. With Geak hanging on to her leg, Ma takes me into her arms. She smells of sour body odor and dirt. My hands hang awkwardly to my side as I lift my face from her breasts and push myself away.

"I'm not a baby," I mutter and try to smile.

Ma nods her head, her eyes red and brimming with tears. Bending down, I lay my hand on Geak's head. Her hair is fine and soft. Gently, I smooth out the strands that stick up in the air. Then I quickly turn and walk away. They are both crying. I walk away not knowing when I will see them again. Though I long to be with them, being with them brings back too many memories of my family, of Keav, of Pa.

the last gathering

The period of plentiful food did not last long. Once again our rations have been reduced and many people are becoming sick. My stomach and feet swell as my bones protrude everywhere else. In the morning I find myself short of breath just walking to the rice fields. I have lost so much weight it feels as if my joints are rubbing against each other, making my body ache. In the rice paddy, my head throbs and it's difficult to focus on the task at hand. By midday, during lunchtime, the effort of pulling the leeches out of my toes requires more energy than I have in me. So tired, I allow the leeches to feed on me and only remove them at the end of the day.

Each morning my face puffs out a little bit more, my cheeks rounder and my eyelids more swollen. Each day, I awake feeling weaker and weaker, my arms, fingers, stomach, feet, and toes feeling heavier, until I am no longer able to train or work.

"Met Bong," I wheeze out the words, "may I have a permission slip to go to the infirmary? My stomach hurts very much."

She sighs with impatience. "You are so weak. You must learn to be strong," she shouts at me and walks away, leaving me standing in the sun with my head down. I curse myself for being small and weak. As I turn

and walk back to the hut, she calls to me. "Where are you going, you stupid girl?" Met Bong puts a piece of paper in my hand. "Go to the infirmary and recover, then come back. I am taking you out of the dance troupe!" I let out a sigh of relief and thank her.

The infirmary is a few hours' walk from the camp. With permission slip in hand, I walk toward it. The sun climbs higher and higher above the trees, heating everything around me. I walk over to a shallow pond near the roadside and squat down. The mud oozes warm and soft between my toes, soothing my aching joints. I wade in deeper to where the water is clearer, but each time I move, my feet disturb the water, making it brown and hazy. Standing still until the residue settles to the bottom, I scoop up the water in my hand. It is warm and soothing to my throat but tastes of rotten weeds.

I move on until the water reaches my chest. Slowly, I put my face in the water, my arms floating on the surface. My upper body floats easily in the water, pulling my feet up from the bottom. The water amplifies my heartbeat so that the thumps are much louder. The rhythm sounds normal but my heart feels very hollow. Listening to my heartbeat, my mind wanders to Ma and Geak. April and New Year's are behind us, so now we are all one year older. Geak is six now. She is a year older than I was when the Khmer Rouge took over the country three years ago. It has been six months since I visited Ro Leap when Ma showed me her bruises. Nine months since I pulled my hand out of Chou's grasps. Twelve months since I said good-bye to Kim, seventeen months since the soldiers took Pa away, twenty-one months since Keav—I stop myself from counting more dates. It is no use remembering when I last saw them. It will not help bring them closer to me. Yet in my world where there are so many things I don't understand, counting dates is the only sane thing I know to do.

When I am cooled down, I raise my head and spot a small cotton field in the distance. I get out of the water and walk toward it. The cotton stands as tall as my chest, puffy, white, and soft like the clouds, but I can actually touch the cotton. I pick a ball and pull it open. In the middle of the puffy cloud, there is a cluster of black round seeds like pepper. I have heard that they are safe to eat, but I hesitate momentarily

before putting one in my mouth. I roll the seeds on my tongue—they are hard and have no taste. Tentatively, my teeth crack the shells and dig into the soft, oily meat. Slightly sweet, the seed quiets the noise in my stomach. I quickly pour the rest of the seeds onto my hand. Scanning the field to check for guards, I shove the seeds in my mouth as fast as I can. Then I collect a few more handfuls and put them in my pockets.

By midmorning I arrive at the infirmary, an abandoned concrete warehouse with moldy, crumbling walls and open spaces for rooms. There is no electricity so it is dark, except for the area that is illuminated by sunlight pouring in through the glassless windows. In the air hangs the unmistakable smell of rubbing alcohol and stale flesh. The two hundred or so patients are lined up on straw mats or cots on the floor, their cries echoing off the cold stone walls. The bodies lie motionless, some bloated, others skeletal, all on the verge of death. Some are so sick they cannot get up to relieve themselves. There are not enough nurses to help so they lie in their own messes.

Keav's face flashes before my eyes as I gasp for air, only to cough at the stench of death that floods into my nostrils. Keav slept in cots similar to these, drenched in urine and waste. Some people come to this hospital hoping to be cured of their sickness, but many are dumped here because they are too weak to work and therefore of no use to Pol Pot. Those who can no longer work come here to die. A cold draft hits me and pricks my skin with tiny stings as I imagine Keav staggering here alone to die among a thousand strangers. In a makeshift hospital, on these yellow-stained cots, many of these patients will die before the sun rises tomorrow.

Forcing myself to focus on something else, I try to shake off the feelings of pity I have for these patients. I look intensely at my hand in the yellowish light. It looks stubby and waxy like five pale fat worms attached to the palm. When I move my fingers, they wriggle and I momentarily envision them detaching and crawling away. My toes wriggle in the same way. I am jerked out of this vision by the moans of the sick. This must be how Keav died, lonely and afraid. Am I to die in a sea of sick people I do not know?

In my dreamlike state I hear Ma's voice calling to me. "Loung! Where are you going? Come to us!" I wake up, gulping air. Am I

hearing voices? Am I going crazy? "Ma?" I whisper. My heart dances with hope, but I suppress it. "Ma?" I cry in anguish. "Over here!" I hear the voices of Chou, Geak, and Kim! I force my eyes to open wider against the heavy pull of my swollen lids, searching among the people for their voices.

Far in the corner of the room, I see hands waving excitedly in the air. I stare at the faces of Ma, Geak, and Meng. Chou and Kim run toward me, smiling broadly. Everyone in our family but Khouy is here! I cannot believe my eyes. I look into their beaming faces: Chou is barely able to suppress a laugh, Geak looks at me in confusion, and Ma is crying.

"Silly girl," Ma hollers at me. "You almost walked past us."

"I'm so glad you are here! I was afraid to be here alone!"

"This is the only infirmary in the area!" Ma replies. She pats the ground next to her, gesturing for me to sit. My knees go weak and I fall into Ma's arms. My eyes wide open, I clutch her sleeves while the rest of my siblings look on awkwardly. "We're all together now. We're all together," her voice is muffled through my hair. Looking into the faces of my siblings, I no longer fear I will die alone.

As Ma releases me from her grasp, Geak crawls over and seats herself between us. Ma tells me that she and Geak came here five days ago with stomach pains. Like me, all the siblings traveled separately and were lucky to find each other here. Ma says that Chou was the second to arrive, followed by Kim and Meng, who just arrived yesterday. Everyone is here but Khouy!

We spend our days in the infirmary lazily talking to one another about many things but never about Keav or Pa. No one in the family has ever explicitly stated that we are not to bring them up in our conversations. Yet we all know not to speak about them. Each of us keeps our memories of them private and safely locked in the boxes of our own heart. Instead, we spend the time telling Ma about our lives. Chou tells us she enjoys being one of the only two cooks at her camp. She says the other girl is nice. Being in charge of the food supply, she is able to steal a little of everything to bring to Ma. When the girls make her mad, she takes revenge by spitting in the food. At his boys' camp, Kim works day and night in the fields planting and harvesting

rice. The setup of Kim's camp is identical to that of Chou's and mine, where all the children sleep together in a large hut. Every night he also has to attend the same propaganda meetings that Chou and I do. Meng tells us that before he fell sick, he and Khouy were still loading bags of rice onto trucks that are rumored to be delivered to China. He reports that he still lives with Khouy and Khouy's wife, Laine. Despite our curiosity, Chou and I never ask Meng about her. Three years living under the Khmer Rouge regime has taught us that some things are better left unsaid.

Though we do not have to work, we are given a ration of rice and salt and sometimes fish. The amount of food is comparable to what I was given while I worked. Though from our shiny faces and swollen bodies, we realize that we are all suffering from similar symptoms: stomachache, extreme exhaustion, diarrhea, and aching joints. After much discussion, we conclude that we are not so much sick as weak from starvation. First thing in the morning and after dinner, the nurses walk over and pour water into a smooth, polished coconut shell bowl, then they put a small cube of white granulated material on my palm, telling me to eat it. I put the cube on my tongue and feel it dissolve. A smile spreads across my face when I realize it is sugar! Sugar for medicine. I plan to stay in the infirmary for as long as I can.

Even with the daily ration of "medicine" I am always hungry. It is hard for me to walk, but I must scavenge for food. I search the bushes for frogs, crickets, grasshoppers, or anything else that can be eaten. But I am a clumsy predator, moving slowly in my sickness. On my way back to the infirmary one afternoon, I see a rice ball left unguarded beside an old woman. My hand quickly grabs it and puts it in my pocket. My heart pounds rapidly, and I walk away as fast I can before anyone notices.

Once alone outside the compound, I am wracked with guilt for what I have done. The fist-sized rice ball rests weightily in my pocket as the face of the old woman comes back to me. Her gray oily hair clings to her skull and her chest contracts and expands in shallow breaths beneath her black clothes. Her lids are half closed, exposing the whites of her eyes. Her helpers will return to find the rice missing and they will have nothing more to give to her. Knowing she will die anyway,

they may forget about her. By taking her food I have helped kill her. But I cannot return the rice. I lift it to my lips as salty tears drip into my throat. The hard rice scrapes down in a dry lump, thus I put a marker on the old woman's grave.

With heavy feet, I make my way back to my family. They are sitting quietly, happy to be together. Somberly, I sit next to Ma and scratch my head with both hands. My hair is in greasy knots and my head itches. Our clothes are tattered and have not been washed in weeks. The well water is reserved for the nurses' use and the stream where we bathe is far away.

"Come." Ma's hand reaches for my head and parts my hair. "We will fix that." She reaches into her bag and takes out her special lice comb. She sits across from me and spreads her red-and-white scarf on the ground. She gently pushes my head down so that I am looking at the scarf and drags the brown plastic comb with its micro teeth through my hair. My scalp hurts from the pull, but it is worth it as I see the six-legged bugs fall from my hair onto the scarf. They scurry all over the scarf, trying to escape but are met with our thumbnails crushing them to bits. Blood squirts from their bodies and they make small popping sounds. Chou and Geak laugh and join in the killing. One by one, Ma combs our hair and rids us of the lice. We spend our days this way, sitting around, talking, laughing, and loving each other again.

One night I dream about Keav. She is beautiful, young, and exuberant. My dream starts peacefully. I am somewhere alone with her. We are talking, walking. I reach out to her but stop because her appearance is changing. In front of my eyes as she continues to talk, she grows thinner and thinner. Her skin becomes yellowish, aged, and hangs loose from her bones. Then the skin on her face begins to melt, becoming transparent, exposing the outlines of her large eye sockets and the skeletal bones behind them. I want to run away but I also want to stay. Her lips are still moving and she says, "I'm all right, I am not as you see me." I love her and want so much to be with her, to find out where she is now so that I can meet her. I do not understand what she is saying and I scream myself awake. Determined to live, the next morning I force myself to walk the hospital grounds looking for food to steal to fill my stomach.

I stay in the infirmary for as long as I can, and with the sugar cubes and food and rest from work, my body gradually grows stronger. After one week, the infirmary becomes overcrowded and the nurses force us to leave. First they kick out Meng, then Kim, then me. I cry, whine, and lie, but in the end I am forced to leave. Walking away, I break my farewell rule and look back to see Ma, Chou, and Geak crying and standing in the doorway. It was a mistake to turn around, my body aches to run back to them, to hold on to them. Expanding my lungs with air, I straighten my shoulders and march away firmly, wondering when I will see them again.

the walls crumble

Another six months has passed since our family reunion at the infirmary. Back at the camp, my life continues as before and with another increase in food rations, I become still stronger. We no longer work in the fields but spend the hours learning to fight in combat as rumors spread that Youns have invaded our borders. During the day, we train with the few sickles, hoes, knives, stakes, and guns that are available in the camp. Most of the training is repetitive, but Met Bong insists that only when the movements become automatic will we be able to fight well. In the evening, after our meal, we gather brush and sticks to build a fence around our camp.

Early one morning, I wake up with dread and panic. My stomach knots and I am drenched with sweat. I tell myself it is nothing, just nerves; I convince myself that I get nervous easily. After washing my face, I join the other kids in training. Met Bong takes her old clothes and stuffs them with leaves and straw to make dummies. For the heads, she stuffs her red checkered scarf with straw. She calls them her Youn dummies and hangs them on trees in the field. After another long report about the evil of the Youns, she lines us up single file across from the dummies.

With a six-inch knife in my hand, I stand at attention in front of the line. Panting like an animal, with my legs shaking and my hand gripping the knife, I attack at Met Bong's cue, charging at my dummy, I yell, "Die! Die!" Though I focus on its head, I am only tall enough to thrust my knife into its stomach.

The next morning, I wake up in great agony. My head throbs, my stomach hurts, and my chest constricts as if someone is sitting on it. I wrap my arms around my stomach, wanting to scream to the world. Something hurts inside me. Rage erupts in my body, making me jump and run out of the hut. I don't understand the electricity in my body, this panic, this sadness, hatred, emotions that manifest into physical pains.

I have to see Ma. It is dangerous to travel without permission, but I do not care. I have to go to her. I know I cannot leave through the front gate; if the girls see me, they will tell on me. I walk around the hut and search for a part of the fence where I can make my escape. I see a loosely built part where the stakes are far apart and the bushes sparse. Making sure no one can see me, I drop to my knees. Quickly, I part the prickly brushes, get on all fours, and crawl through.

I walk in the hot sun without food or water. Though my throat begs for water and my feet crave to stop, I push on. My heart races as images of Ma and Geak flash before me. Their faces are long, their mouths turned down, their eyes glisten with tears. They sit at the hut in Ro Leap, calling out to me, as if they are trying to tell me something. I know why they are calling out to me. But I cannot accept it. I know.

My thought turns to Pa, and I remember how he told me I had extrasensory perception. Even as young as I am, I have always felt as if I live 80 percent of my life in déjà vu. In Phnom Penh, many times I knew who was on the other line even before Pa picked up the phone. Walking in the streets with Pa or eating noodles with Ma at the shops, I would sense that we'd run into a certain person and we would. In Ro Leap, I had a dream that a certain house would catch on fire, and it did. Pa said it is a power and though I did not fear it then, I fear it now.

The minutes turn into hours until I reach Ro Leap. It is midmorning. The village is quiet. When I enter the village, I run to Ma's

hut. "Ma," I call out frantically. "Ma! Geak!" No one replies. "Ma!" I run as fast as I can into the garden. Ma and Geak are not there. Tears blur my vision as I run back to her hut. Everything is still there. Their wooden rice bowls and spoons. The small pile of clothes. "Ma!" I scream, my voice hoarse.

"They are not here," a voice answers. A young woman stands in the doorway of the next hut. She is new; I do not recognize her. "They left yesterday. My baby is sick so I did not go to work. I saw them leave."

"Where did they go?"

"I don't know. They went with soldiers," the woman says quietly and looks away. She stares into the distance, refusing to look back at me.

We both know what it means when the soldiers come to the village and take someone with them. Part of me cannot believe what the woman says, but the other knows it is true. Yesterday I could not explain the mental anxiety and physical pains I woke up with. Now I know it was Ma and Geak telling me about the soldiers.

"Ma, where are you? Ma, you can't do this to me!" I scream into the empty hut. They cannot have survived three years of starvation and the loss of Keav and Pa only to be taken now! The last time I saw her she was doing okay without Pa. I believed she was going to make it. She fought so hard to live! She cannot be gone. Poor little Geak, she never got anything good out of life.

At the sound of her baby's cries, the woman goes into her hut. Inside, the woman hums her baby back to sleep. A memory of Ma singing me to sleep in Phnom Penh flashes before me. I cannot be strong anymore. My wall crumbles and collapses on top of me. Tears run uncontrollably down my face. My chest compresses, my insides gnaw at me, eating away at my sanity. I have to run away, I have to leave. Somehow my legs take over and carry me away from the village. "Ma! Geak!" I whisper to them. Their faces flood my consciousness. My mind races, remembering the time I stole rice from the container, out of their mouths. She never knew how it felt not to be hungry. My mind will not leave me alone. My body goes weak when I wonder which one the soldiers killed first. My mind projects pictures of the two of them together.

I see them marched slowly in a long line of twenty people collected from other villages in the province. A group of five or six Khmer Rouge soldiers walk

on either side of the villagers. The soldiers' rifles point at the prisoners. The rain three days before has left the field wet and slippery with mud, making it difficult for the villagers to keep their balance. Besides the grunts, moans, and whimpers of the villagers, all is quiet. Both the soldiers and the villagers have on black pajama clothes and red-and-white checkered scarves with mud stains on their bottoms and knees. The men walk with their fingers locked behind their head. Sweat drips from their forehead and stings their eyes. But they dare not unlock their hands to wipe them. The women, children, and old villagers are allowed to use their arms to balance while they work their way on the uneven ground. Whatever their history, whatever their past, they are marching now because the Angkar branded them traitors to the government.

Trailing along at the end of the line, Ma carries Geak on her back. Ma cries softly, her body tense with fear and her hands holding on to Geak. She feels Geak bounce slightly on her back as she catches her balance and prevents herself from a fall in the mud. Biting her lips, she thinks of Pa and wonders if he was this afraid when they took him away. She shakes her head, not allowing herself to think of him as being dead. Parts of her will always believe he is alive somewhere. It has been almost two years and still she misses him every minute of the waking hour. In her dreams, he is so real that she wakes up hurting more than the day before. Sometimes, while she pulled weeds from the vegetable gardens, her mind wandered to their first meeting by the river, when she first caught his eye. She thought he was so handsome but knew her parents would not approve of him. She loved him and despite her parents' objections, she ran away and they eloped. She just wanted to be with him. Maybe she would be with him again soon.

The soldiers lead them past the rice paddies, past the swaying palm trees, to a field at the edge of the village. There, away from all eyes, they make Ma kneel with the other villagers. Sinking in the cool mud, Ma and Geak cling to each other. She hugs Geak tight to her chest, as if trying to push her baby back into her belly to spare her from the pain. She slides one hand up the back of Geak's head to make sure her face is turned away from the massacre about to happen. In her arms, Geak's body shudders and her teeth clatter near Ma's ears. She feels Geak's small hand gripping her neck yet she is quiet.

The soldiers stand before them, their rifles aiming at the group, their fingers poised on the triggers. The dark clouds move over them, casting black shadows on the soldiers. The wind blows warm air around them, but Ma is shivering. She

knows there is no fighting her fate. She knows no amount of begging will allow her to escape. She wraps her arms even tighter around Geak and squeezes her eyes shut, praying while the others beg for mercy. She brings Pa's face to mind and waits. That second feels like an eternity. She fights the impulse to scream, to provoke the soldiers to just get it over with. She does not know how much longer she can be brave. The wait makes her heart begin to believe in hope. Could the soldiers have changed their minds and let them all go? She finds herself breathing faster at this thought. "No, I must be strong for Geak. She must not leave this world in terror."

Then Ma hears the slush of mud as a soldier moves his position. Her heart pounds as if it will rip through her chest. One soldier slings his rifle across his back and walks toward the group. Ma feels the ground beneath her become warm and wet. Glancing to her side, she sees that the man next to her has wet his pants. A soldier approachs the group. He walks straight toward her. Ma's eyes widen with hope. Her heart palpitates with fear. The soldier reaches down and grabs Geak's shoulders. The two of them scream a loud shrill scream that echoes through the air. But the soldiers do not stop and pull Geak out of her grasp as they cling to one another, yelling to each other not to let go. The soldier tears them apart until only the tips of their fingers hold them together, then that chain too is broken. All the villagers cry and beg and start to get up off their knees. Suddenly the rattling sounds of the rifles go off and bullets pierce through their bodies, silencing their screams.

Geak runs over to Ma's slumped-over body with her face in the mud. Geak is only six years old, too young to understand what has just happened. She calls Ma and shakes her shoulders. She touches Ma's cheeks and ears, and grabs her hair to try to lift her face out of the mud, but she is not strong enough. While rubbing her eyes, she wipes Ma's blood all over her own face. She pounds her fists on Ma's back, trying to wake her up, but Ma is gone. Holding on to Ma's head, Geak screams and screams, not stopping to take in any air. One soldier's face darkens and he raises his rifle. Seconds later, Geak too is silenced.

Walking away from Ro Leap, I am deafened by the ringing in my ears. All the stories I have heard of how the Khmer Rouge kill their victims come back to me. Tales of them tying their victims in potato sacks and throwing them in the river and stories of their torture chambers frequently circulate among the villagers. It is said the soldiers often

kill children in front of their parents to elicit confessions and names of traitors. The ringing in my ears becomes louder, making me disoriented. Ma's face appears before me. I choke as I think of the pain she feels as she watches the soldiers hurt Geak. My mind obsesses over the pictures my mind makes up of their deaths, which refuse to let go of me. Then my head feels full and heavy.

Tears pour from me as I drag my body away from the village. Someone once told me that if you hit your head hard enough you lose all your memories. I want to hit my head hard. I want to lose my memory. The pain in my heart hurts so much it becomes physical and attacks my shoulders, back, arms, and neck like hot pins pricking at me. Only death will relieve me of it. Then something takes over me. It is as if I am drifting away into another place, into the deepest recesses of my mind to hide from the pain. Suddenly, the world becomes hazy and blurry. It is black all around me, soothing and empty. My pain and sadness no longer feel real or personal—no longer mine—when the blackness swallows my surroundings and me with it.

When I regain some level of conscious thought, I am back at my camp, standing before Met Bong. My hand massages my stinging cheek; I taste blood in my mouth. Met Bong has slapped me awake. "Where have you been?" she demands, as the world comes back in focus. The girls stand around us, watching me.

"I don't know," I manage to say. "I went to see—"

"And you stayed for three days? Don't you know the Youns are everywhere?"

My eyes widen in disbelief. "No, I don't know where I was," I tell her honestly. Her hand lands hard across my face again. The pain makes me dizzy, I almost lose my balance.

"You won't tell me? You won't have any food tonight and I will reduce your food ration until you do!" She screams into my face and walks away. After she is gone, I walk to the well and pull up a pail of water. Drinking some, I pour the rest over my feet. Rubbing one foot against the other, I remove the layers of red mud to expose my small, wrinkled toes. "Ma is dead," I repeat to myself with little emotion. "Ma is dead." I have no memory of the three days after I left her village.

In our training the next day, I charge at the Youn dummies even before Met Bong's cue. My skin vibrates with hate and rage. I hate the gods for hurting me. I hate Pol Pot for murdering Pa, Ma, Keav, and Geak. I stab my wooden stake high into the dummy's chest, feeling it puncture the body and hit the tree. Hard and fast, I stab it, each time envisioning not the body of a Youn but that of Pol Pot. Now it is all real. Now I no longer have to pretend to be an orphan.

the youn invasion

Hugging the rifle to her chest, Met Bong paces back and forth nervously at our nightly session. "The Youns have invaded our country! They are taking over our towns! These monsters are raping Khmer women and killing Khmer men. They will kill you if they catch you. You must protect yourself in any way you can. Pol Pot is all-powerful and we can defeat the Youns!"

"Angkar! Angkar! Angkar!" we scream in unison even though her words make no sense. While I pretend to listen, I wonder why the Khmer Rouge fears the Youns if we can defeat them. If we can beat them then why are they able to take over our country?

"Instead of one, two girls will now guard the camp at night. You are to shoot the Youns dead when you see them."

That night none of us can sleep as we listen to explosions of mortars and rockets in the distance. Though we are afraid, Met Bong tells us the Khmer soldiers will keep them away from us. After a few hours of shelling, all is quiet again. Then without warning, a mortar explodes near our base, blazing the sky white like lightning. Fear runs up my spine and shoots into my heart. I scream and cover my ears with my hands just as another mortar whistles and hits our hut. The straw walls and roof burst

into flame. Screaming and wailing, the girls try to escape before fire consumes the hut. The girls run and crawl to the door, their faces black from smoke and their eyes white with terror. Many are dripping blood from their arms and legs where shrapnel sliced through their skin.

I jump up and head for the doorway as fire spreads everywhere. "Don't leave me! I'm hit! Help me!" a voice screams out shrilly. She is lying in a pool of blood. Propping herself up on her elbow, she begs us to help her. She is shaking and shivering. The other girls do not stop. Seeing me looking at her, she holds out a bloody hand to me. "Help me!" On her elbows, she tries to crawl to the door but pants in frustration after a few yards. Her tears fall into her mouth. Fire spreads through the camp quickly, debris falling everywhere. "The smoke! The fire—help me!" Her hand grabs her chest as she coughs out blood. I want to help her. I wish to help her, but I am much smaller than she. I scream and cover my ears as another mortar explodes nearby. Panicked, I turn my back on her and jump out of the hut. When the roof collapses, the girl continues to scream long anguished cries as flames engulf the hut.

All the girls head off in different directions in a desperate bid to escape the camp. In the dark, the straw walls and roofs combust into yellow and orange flames, illuminating the red faces of girls running away. On the road, I find myself crowded among thousands of people walking amid deserted towns and villages. I have to find Chou. I am alone without her. Automatically, my body takes control of my feet and veers me in the direction of her camp. There is no time to be afraid.

Her camp is dark and empty when I get there. "Chou! Chou! Chou!" I scream her name. I circle around the compound, but she is not there. I run back out into the traffic, not knowing what to do next. I don't know where to find my older brothers. All around me the people move like a herd of cows in a stampede, yelling and crying out family members' names. "Please, let them be alive," I whisper while people bump and push me out of their way. Not knowing what to do, I walk out of the traffic and climb onto a big rock on the side of the road. Hugging my knees to my chest, I cry as the traffic rushes on ahead of me, leaving me behind. It is like the mass of humanity leaving Phnom Penh all over again, but I am alone now. I do not have Keav's

arms around me, protecting me, or Pa, Ma, and Geak by my side, or Khouy and Meng leading the way.

I sit there hugging myself when I feel a hand grab my shoulder. It's Kim. He's alive! Chou is with him, holding on tight to his hand. "Chou!" I exclaim happily. I have never been so happy!

"Come, we have to leave quickly!" Kim yells and grabs my hand as we head back onto the road and into the traffic.

Though we do not know where we are supposed to go, our goal is to somehow try to find our brothers. Kim is once again in charge of the family. As we walk, Kim tells us that once he heard the explosions coming from our direction, he escaped from his camp and ran here to find Chou. They were on their way to look for me. Chou and I follow Kim's lead and do as he says. He seems so much in control that I forget he is not quite fourteen.

As other people carry their pots, pans, clothes, food, and other belongings on their backs or in their wagons, Kim carries a backpack with a few clothes in it, while Chou and I hold his hands and walk with only the clothes we are wearing. We walk through the night with the sea of people, following their route. Kim says it is safer if we keep with the crowd. Though my feet and body crave to rest, through half-open eyes, I lean on Kim and totter on. Soon the sun comes out. In crimson red, golden yellow, and fiery orange, it lights up the world around us. In the field, tall elephant grass glistens with morning dew while gray smoke floats into the sky from distant villages. The small red gravel roads are swarmed body to body with people in their black shirts and pants. The traffic does not stop and continues to move, everybody dragging their feet slower and slower. Those who cannot move any farther sit at the side of the road, some curl up in a fetal position and sleep. Others leave the traffic to scavenge for fruits and berries a few meters from the road, all the time keeping themselves close to the traffic. The snakelike traffic pushes on with the strong able-bodied men forming the head, and the old, young, weak, and hungry trailing behind as the tail. As soon as the first snake disappears from our view, another one comes winding along for those left behind to join.

As the sun climbs higher in the sky, my stomach begins to growl. Kim spots a small grassy footpath hidden behind some bushes and veers

us toward it as the traffic moves on. Walking in silence, Chou and I follow Kim's lead. After five minutes, Chou and I glance at each other nervously, afraid to be so far away from the traffic but we dare not question Kim. Another ten minutes pass. We have walked a kilometer away from the road before our path leads us to a deserted village. Alone in the village, all is quiet except for the muffled grunts of pigs and cackles of chicken. The villagers evacuated in such a hurry that they left clothes, sandals, and scarves strewn everywhere on the ground. In the communal kitchen, smoke still rises from the ashes. Chou enters a hut and comes out with a few metal pots, aluminum bowls, and the remaining few small bags of rice and salt. I grab three scarves, spare black pajama clothes, and three light blankets. Placing them in the middle of another blanket and tying its corners together, I make a big bundle to balance on my head.

In one house, a pig and two chickens scurry about. After a few minutes of chasing after the pig, we become tired and let it go. Even if we could catch it, we do not know how we would slaughter it since we do not have a knife. Kim catches the two chickens and locks their wings behind their backs. We look around for a sharp object to slit their throats. Not finding one, Kim grabs the bird and walks over to a well. Holding the chicken by its legs, he swings it like a bat and smashes its head against the stone wall. From ten feet away, I hear the bird's skull crack as blood sprays everywhere on the wall, splattering onto Kim's feet. The chicken's body struggles and twists, refusing to die, until Kim whacks it again, this time smashing its head. Then he does the same with the other chicken.

Chou fetches water from the well and pours some over Kim's feet, rinsing the blood off. She pours the rest of the water into our new pot while Kim rekindles the fire by adding dry leaves and branches. Chou puts the chickens in the pot, submerging them in water to boil them whole. After an hour, she takes the chickens out and we pluck the feathers off. Then she boils them for another hour or so. When they are cooked, she pours salt on them so they will not spoil. While she prepares the chickens, my stomach growls and my mouth waters. I have not had any kind of meat in such a long time.

Finally Chou announces they are done. Kim breaks off a leg, scoops up a bowl of rice, and hands it to me. He gives Chou the

other leg, takes the breasts himself, and saves the rest for our trip. With our plates in front of us, we eat in silence. Slowly, I peel off the skin, which tastes tough and rubbery. I eat the rest of the chicken with joy and sadness as I remember how Ma was beaten for trying to get some for Geak.

After the meal, we pick up our bundles and walk back out to join the mob of people. Not knowing where we are going, we follow the traffic. We walk all day and stop to rest for the night along with everyone else. While others build fires, cook food, and talk, we eat our food in silence. On every side of us, men talk vehemently about the Youn invasion and the defeat of Pol Pot's army. They spit out the evil Pol Pot's name and swear to each other they will hunt him and his officers down to avenge their suffering. Their voices grow to a feverish pitch as they recount the bodies they saw in the fields nearby their villages.

Their words make me think of Met Bong. For a year while I was at the camp, Met Bong told me everyday the Youns were attacking Cambodia and that the mighty Khmer Rouge army would defeat them. She was so afraid of the Youns taking over our country that she was paranoid the Youns would populate Cambodia and in a few years the country would become no more than a Youn colony. How fearful she must be now—if she is alive—that the Youns, our enemy, have invaded Kampuchea, and as a result, stopped the Khmer Rouge from killing more Cambodians. Every night she told us that a Khmer Rouge soldier could kill twenty Youn soldiers because our soldiers are better and braver fighters. I wonder what happened to the mighty Khmer Rouge soldiers. Maybe the Khmer Rouge's power is just another one of Pol Pot's many lies.

My legs hurt and my body aches from the walk, but physical pain does not matter anymore. My mind wanders to Pa, Ma, and Geak, and I become deaf to the conversations around me. Pa cared about politics. I am too young to understand Pol Pot's strategies for creating a classless pure agrarian society. I do not know why Pol Pot did what he did when he made us leave Phnom Penh, gave us very little food, or took Pa away from me. All I know is if the Youns invading Kampuchea could have saved Pa, Ma, Keav, and Geak, I wished they would have come sooner.

After we eat more of our chicken, Chou spreads one blanket on the grass and I roll up the scarves to use as pillows. We have settled in the middle of an open field that sits at the edge of a forest.

"The open field," one man says, "is safe from the Youns' crushing monster."

"Met Pou," I ask a comrade uncle curiously, "what is this crushing monster?"

"You don't know?" he asks, incredulous. I shake my head in reply. "No one has actually seen it, but they say it is like a wild monster and nothing can destroy it. It is part machine, part man, but very evil. It is bigger than a hut and can shoot out flames and bombs. It has many wheels for legs and rolls across the land like thunder, destroying everything in its path. It can smash trees, rocks, metal, everything. Nothing can destroy it!"

My eyes open wide as I learn of this evil machine, wondering if it is sitting in the woods waiting for us.

"So it is safer for us to be in the open so we can see it approaching and run out of its way?" I ask as my knees go weak and my imagination creates images of the crushing monster chasing after us.

"Chou, let's move into the middle of the crowd," I plead with her as I grab her hand. Kim frowns at us as we repack our bundles and get ready to move.

"It's not a monster. That man does not know what he is talking about. He is a farmer who's never left his village until now and probably has never even seen a car, so he wouldn't know what a tank looks like. It's a huge machine that a man drives like a car." He tries to reassure us but it does not work.

"Does it roll over trees, houses, and metal? Does it destroy everything in its path?" I question him.

"Yes, but—"

"Does it shoot out fire and bombs?"

"Yes, but. . . . all right, we'll move." Kim sighs and picks up his bags. Making our way into the maze of many thousands of people, we move to a spot in the middle of the crowd and set up for the night.

"Now we won't be the first one to get crushed by the monster," I say and Chou nods in agreement. Kim smiles and shakes his head, dropping his bags to the ground. Chou spreads out our blanket again and lies down.

With her in the middle, Kim and I huddle closely on either side of her. Kim hooks the backpack through his arms while I do the same to my bundle. We pull another blanket over us.

The ground is cold, but I am warmed by Chou's body heat. All around us people are sleeping, eating, or setting up their areas. I look over to the side and watch a family sitting together, eating their meal. It is a family of five, parents with three boys, from perhaps five to ten years old. The father scoops rice and hands it over to his youngest child first, then he does the same for the others. The mother reaches over and wipes the child's nose with her fingers, then quickly wipes her hand on her skirt. While they eat, the father's eyes watch over his family and their belongings.

I turn away and look at the sky as tears roll out the corners of my eyes. "Oh Pa, I miss you," I tell him in my head. The sky is dark and silvery; it fills with a few gray wispy clouds and countless twinkling stars. I stare at the clouds and envision Pa's facing looking down at me. "Where are the angels, Pa?" I ask him. All of a sudden, the clouds pull together, forming many tight balls. Quickly, these balls begin taking the shape of skulls. They hover over me, these cloud-skulls, glaring at me with their invisible eyes. My breath quickens and my chest tightens, and I force my eyes to look away. I focus on my arm, and my heart races when I see grass growing out of my flesh. Like the hair on my arm, the grass pokes easily out of my skin like needles through paper, growing taller and taller. Then my flesh melts, and my skin sinks into the ground. In slow motion, my skin decomposes until there is nothing left and it mixes with the dirt, becoming Khmer Rouge topsoil. Holding my breath, I squeeze my eyes shut and pinch my decomposed arm. Feeling the pain of the pinch, I open my eyes and all is normal again. Locking my arms together across my chest, I close my eyes and try to sleep.

We wake up the next morning and resume our journey once more. Since Kim and Chou have not mentioned anything about searching for Ma and Geak, I assume they know of their fate. I do not know how he and Chou found out about Ma and Geak. I dare not bring up the subject. Kim tells us we will try and make our way to Pursat City and wait for our brothers there. Kim does not tell us how long we will wait for Meng and

Khouy or how long we will be there once we reach Pursat City. I do not know why Kim assumes Khouy and Meng are still alive. Since we left Ma and went to our separate camps, we have had no way of receiving news from our older brothers. It has been more than a year now since we last saw them. As an implicit rule, we do not talk about our family. I fear that if I ask, I will make Chou and Kim sadder than they already are. Being only eight years old, this is the only way I know to protect them.

Everyday we walk with the crowd, occasionally stopping in deserted villages to rummage for food. It is many days before we see the first sign of a possible end destination. My heart pounds so loudly I am sure others can hear it as my feet come to a complete stop. Before us walk three men dressed in green clothes with funny round cone-shaped hats on their heads. Their legs move in long, casual strides and their rifles swing on their back. "Youns," the traffic hums and whispers. My breath becomes short and shallow; images of the Youns torturing and killing their victims flash before my eyes. I have never seen a Youn and yet these men look remarkably human. They are the same size as our Khmer men and are similarly built, not like the Barang, with light skin and a thin nose, like I saw in Phnom Penh. The Youns look more like Ma than many Khmers. They do not look like the devils Met Bong said they were.

The Youns walk toward us and raise their hands in greeting. I search the ground for weapons—a staff, sharp rocks, anything I can use to fight them. All eyes focus on them as they come nearer. People gasp when, in the next moment, one Youn smiles and says in broken Khmer, "Chump reap suor," which means "hello." "There is a refugee camp up ahead in Pursat City," he tells us and keeps walking. The crowd smiles gratefully. I cannot believe it. The Youns did not shoot us. They did not take the children and slice open their stomachs. They even told us where Pursat City is. At last, after three days on the road, we have a destination!

The camp looms like a small village before me, flickering and swaying in the haze like a mirage. From afar, the many green, black, and blue plastic tents jut into the sky like thousands of anthills with black-haired people frittering in every direction. While most people sleep out in the open spaces, others are putting up makeshift tents and building huts. Next to the huts and tents, women prepare food, blowing and stoking the fires, coughing as the smoke finds their faces. Hovering

above these women, men and children tie strings of wet clothes from trees to tents, creating giant spiderwebs. Beside each group of tents lie small hills of trash, rotting in the hot sun, with children playing around them, occasionally picking up a half-eaten mango, orange, or fish head and putting it in their mouths.

The Youns are all around, weaving through the labyrinth of homes and patrolling the area with rifles on their shoulders and grenades attached to their belts. There are many of them, smiling and talking to the kids, sometimes patting them on the head. My eyes follow a certain Youn in a green camouflage uniform as he openly approaches a young Khmer woman in black pajama clothes. He flirts with her and I think he is barbaric. He reaches into his pocket and pulls out a box. Placing it on his palm he extends his hand to her. Shyly, she smiles and starts to take it, only to have him grab a hold of her hand. Abruptly, she pulls her hand out of his grasp. After the brief stolen touch, he continues to talk to her. It fascinates me to see the Youns courting girls in public, for in the Khmer culture these things are done in secret.

In the midst of the crowd, I overhear the Khmer men discussing how the Youns are there to protect us. They say the Youns marched into Cambodia only three weeks ago, on January 25, and through their artillery power and army defeated the Khmer Rouge, sending Pol Pot and his men running into the jungles. During his entire regime, Pol Pot had been provoking the Youns' attack by sending his men to their borders and massacring Vietnamese villages. Pol Pot viewed the Youns as the archenemy of the Khmer people and feared the Youns would annex our land if we did not attack them first. But Pol Pot's small, ill-equipped army could not win against the well-trained, well-equipped Youn army. The men say that the Youns have liberated Cambodia and saved us all from the murderous Pol Pot.

Kim pulls at my arm and gestures for me to hurry as I begin to fall behind. We pass through the crowd, searching for an empty spot to make our home. I look longingly at the adults in the crowd. I want to have our own adult to take care of things, build houses, put up tents, and forage for food. I remember when we left Phnom Penh how Pa, Khouy, and Meng searched for food and took care of us. Though I was also hungry then, I was less afraid because I knew they would look after me. Gazing at the

adults in the camp, I pray silently, wishing someone will ask us to join their family. But we are invisible to them. The adults look through us. They have their own families and can't burden themselves with us.

Having no success finding a home in the midst of the crowd, and with no tent for shelter, we settle under a tree at the edge of camp with a few other orphans. With our small bag of rice dwindling, Kim is as good as Pa was at rationing our food. Every morning he goes out to a nearby river and fishes while Chou and I guard our things. Sometimes we see a jubilant Kim return with a smile on his face and know we will eat well that night. Other times, Kim returns with drooping shoulders and a scowl on his face. With the influx of refugees pouring into the camp, the river becomes polluted and the fish gone. It becomes increasingly hard for Kim to catch fish in the shallow water. Tonight, Chou and I cook mushrooms and wild vegetables that we found in the field and we make rice soup for dinner. But many other nights we have nothing to eat and go to bed hungry. After we eat, Chou spreads a small blanket over the grass and covers us with the other two.

Huddling close to Chou, I cry silent tears for my family, my loneliness, and my constant hunger. But most of all I cry for Kim. I cry knowing how he feels coming back each night and having to tell us there will be nothing to eat. After a week of living under the tree, the nights become cold and our stomachs too empty, so Kim asks a family camping nearby to let us live with them. With our bundles in our hands, we stand before them, our faces washed, our hair wet and smoothed over, and our manners polite and respectful.

"Sorry, we cannot," the father says to us. "We can barely care for our own family." My face turns red with embarrassment and hopelessness. I do not understand their unwillingness to help us. They are adults, and adults are supposed to be able to care for children. But they don't want us. They don't want me. Nobody wants me. With our eyes downcast and shoulders slumped we walk back to our spot under the tree and I vow to try harder to make people like me.

Though he cannot take us in, the man feels sorry for us and looks for a family to take us. He comes back with a few interested families, but no one wants to take in all three of us and we would rather brave the cold than be separated.

the first foster family

January 1979

"I have found a family for you!" the man tells us excitedly a week later. "They have some small children and an old grandmother. They need someone to help with the children and around the house and they are willing to take all three of you." That afternoon I wait with nervous anticipation to meet my new family. I wonder what they are like and what it would feel like to belong to a family again. A new family! A safe home, food to eat, someone to protect me.

When finally I see their figures in the distance, I cannot believe my eyes! I squint to make sure it really is them. Opening my eyes again I grab Chou's hand and whisper quietly to her, "It is them. It is the palm tree boy and his dad. The same people who came to my soldier training camp to collect palm sap." Chou nods and warns me to be quiet.

Though appearing calm on the outside, inside I am spinning faster and faster. "How can this be?" I think to myself. "That in this crowd of people I actually know them?" The palm tree boy and his father break into big smiles when they recognize me. They seem actually happy about it. "This must be fate, a good omen! Maybe things will be all right after all!" I am barely able to contain my happiness.

"This is no coincidence," the man exclaims. "I know this little girl." He laughs and musses my hair. My face beams with joy at the touch of his hand.

"I am Kim and she is Chou, and this is Loung." Kim introduces us.

"You want to come and live with us?" the palm boy's father asks.

We nod.

"All right, let's go home." I look up at him and he smiles.

"Here, give me your bundle," he says, taking it out of my hand. My eyes shine at him and my heart floats to the clouds. "Father!" My mind whispers happily. Chou and Kim thank our neighbors as we leave with our new family.

"I have a big family already," the father says. "I have three little girls who are one, three, and four. And my oldest, Paof, is fourteen. My wife needs help looking after the kids. My mother is old and also needs help. You girls will help care for them, cook, collect wood, and tend the garden while Kim will go out fishing and hunting with me." His voice is so matter-of-fact now when it was welcoming and happy a few minutes before. The realization of our work arrangement sends chills down my spine. He is not Pa. I have to stop dreaming about our family and settle for being a part of a family of convenience.

As we approach the house, the rest of the family comes out to greet us, not with smiles but with cold stares. "Small, but I guess strong enough to help us out around the house," the mother says to the father. My face flushes with anger, but I contain myself. She motions for us to follow her inside the hut. Their hut is bigger than many we have seen yet built like all the others. "My family lives on this side so you three sleep in that corner over there." She points to the far corner of the hut. "Drop your things there."

One afternoon, after a day in the forest gathering firewood, Chou and I come home to find Kim in the corner of the hut watching the mother go through our things. I climb the steps and sit by him, holding in my anger. "I cannot believe this!" the mother squeals, her fingers picking up Ma's shirt. It was Ma's favorite silk shirt. She wore it many times in Phnom Penh. When the soldiers burned our clothes, Ma was wearing this shirt underneath a plain black shirt and was able to hide it from them. She risked everything just to keep it. As if she knew of her

impending fate, Ma gave Kim the backpack with her jewelry sown in the straps, as well as her favorite shirt, on his last visit to her.

"It is so soft!" the mother exclaims happily and slips the shirt over her head. It falls smoothly over her body, the blue silk shining beautifully in the sun. Kim's jaw bulges as he grits his teeth and Chou looks elsewhere; our anger rises, but we say nothing. Finally sensing our glares, she takes the shirt off and throws it back in the bag. "I don't like it anyway. It's ugly now that I really look at it. How can anyone wear this color?" she says and walks away. Kim takes the shirt out and gently folds it neatly before putting it back in the bag.

The only bright spot in the family is Paof, the fourteen-year-old brother, who is very nice to me. He often takes me fishing and swimming with him and introduces me to people as his new sister. I like him; it is nice to be treated kindly. I know he likes me; he says as much. Yet at times there is something about him that gnaws at me. The odd ways I catch him looking at me—his eyes lingering too long over my face and body—makes my stomach queasy.

While picking firewood in the forest one day, someone comes up from behind me and grabs my waist. I swing around ready to attack but stop when I realize it is Paof. The clouds darken and follow above us. He walks toward me, his hand sliding on my flat chest around to my back, pulling me close to him in a tight grip. He breathes heavily, his wet lips on my cheek. In a surge of anger, I slap him across the face and push him away.

"Leave me alone! Get away from me!" I scream into his face.

"What's the problem, am I not nice to you? You like me, I know you do." He smirks and approaches me again. I want to rip his lips off his face. "Get away or I'll tell on you!"

"All right," he says, and his eyes glare at me. "Who will believe you? It's your fault anyway, always tagging along and going places with me." Spitting at his feet, I turn and run away. Paof is right: I cannot fight him. I cannot tell anyone—not even Kim and Chou. There is nothing I can do but keep away from him. I do not want to cause trouble with our new family. I do not want to live on the streets again.

I avoid Paof after that. Wherever he is, I am not. Whichever direction he goes, I go the opposite, and with each passing day my heart

blackens with hatred for him, but I keep it all inside. I keep it well hidden as Paof laughs and goes fishing with Kim.

The arrangement with the family works well for me since I am used to long hours of labor. But no matter how hard we work, they let us know we are never efficient enough. To make matters worse, the mother often wonders out loud in front of us whether we are worth our keep. We know very little about the family and dare not ask them questions. Though we all now live in the newly liberated zone, after almost four years of living with secrets, it is hard to change. We do not know whether they were supporters of the Khmer Rouge or if they were base people. Even if the family doesn't love us, they do feed us a sufficient amount of rice, fish that the boys catch in the river, and vegetables from the garden. The family has many fifty-pound sackcloth bags of rice hidden in their corner of the hut. I don't know how they got them.

Each morning we set off, always the three of us: Chou, our girlfriend Pithy, and I. Pithy is Chou's age and, like Chou, is rather meek and not much of a speaker. Soldiers took her father away too, so now she lives with her mom and older brother. We first met Pithy while gathering water by the stream. We watched her fold her scarf and place it on her head. She was our size, with pretty brown eyes and skin. She still wore the black Khmer Rouge pajama shirt and pants, but her hair was growing out of the blunt Khmer Rouge cut. She struggled to lift her clay water jug on her shoulders. Chou walked over to help her. From then on she was our friend. Though she lives on the other side of town, she often meets us to gather firewood.

I don't mind the task, but I hate having to roam around the woods barefoot. I am wary of snakes. The ground is covered with leaves and branches, so I cannot see what's slithering beneath them. Once, I stepped on something that at first looked like a small brown stick, but then the stick wriggled, squirmed, and slid away. The sole of my foot tickled, sending shivers all over my body.

At sunrise, Chou and I greet Pithy at our meeting place on the road. The haze is pink today. I rub my eyes, yawn, and adjust the ropes we brought to tie the wood, slinging them over my shoulders. Cradling

an axe in her arms, Chou glowers at me for forgetting the canteen. Side by side, we walk into the woods, far away from the displaced people's camp. As I collect fist-sized, dry tree branches, Chou bends and shaves the leaves with her ax. As the sun climbs higher in the cloudless sky, we take a break and rest under a tree. But it is February and the weather is hot and sticky, even in the tree's shade. It cools only at night.

"I need water. My throat is burning," I complain loudly to the girls.

"Me too," Pithy echoes in agreement, "but we can't leave now. We'll all be in trouble if we don't bring home enough firewood."

"Shhh . . ." I interrupt Pithy and listen to leaves rustling nearby. "Someone's coming."

Looking up, we are startled to see a Youn soldier walking in our direction. He is thin and tall, maybe two feet above us and dressed in the standard green uniform but without the rifle and grenades on him. The Youn raises his canteen to his mouth and drinks from it.

"Maybe he'll give us some water," I say to the girls. "Let's ask him."

The girls nod. When he is close, we approach him. He stops and smiles quizzically at us. "Water, thirsty, drink." I say the words loud and slow. He narrows his eyes and shakes his head. I point to his canteen, and with my hand I mime the drinking motion. Finally, he nods and smiles with understanding. He then unscrews the top of his canteen and holds it upside down but nothing comes out. He points to the canteen, points to me, and motions us to follow him.

"He wants us to follow him to get the water," I declare proudly to the girls. In unison, we step forward. The Youn turns suddenly around and puts up his palm to stop us. He points to me and waves for me to follow him. "Don't worry, I'll bring enough water back for all of us," I say, and I follow him into the woods leaving Chou and Pithy behind.

The soldier takes me far away from the direction of the base, where I assume we would go for water. As he leads me farther into the woods, my heart quickens. Looking back, I try to find Chou and Pithy but cannot see them in the thick brush. The Youn points to an area where the shrubs are high and dense, and waves for me to come to him. Standing where I am a few feet from him, I ask, "Where water?" By now my palms are sweating with fear. He points to the bushes and motions for me to follow. "No!" I say firmly, refusing. Breathing rapidly,

I turn to run but am stopped by his hands on my arms. He throws me hard on the ground. I fall, scraping my knees and hands on rocks and sticks. Stunned and shaken, I try to get up, but his hands are there again, pushing me down by the shoulders. I land hard on my bottom as pain shoots through my body. My eyes widen in alarm.

"Nam soong! Nam soong!" He orders me to lie down in Viet-namese. I cannot understand what he says and stare up at him. In our culture, the bride finds out all there is to know between a man and woman on the night of her marriage. I do not know exactly what he wants to do, but I know that it is bad. I struggle to get up. Again he shoves me down. "Nam Soong! Nam Soong!" he screams at me, his white face dark and mean now, like the faces of the Khmer Rouge. I sit there, paralyzed and speechless. I am unable to get the scream out of my throat; my heart pounds; my eyes plead with him to let me go.

Time slows as he unbuttons his pants and they drop to his ankles. Breathing short, shallow breaths, I scurry back in terror. His bright red underwear stands in stark contrast against his white skin. They hug him tightly and hang below his potbelly. He hooks his thumb on the waist-band and pulls his underwear down. A scream claws its way to my throat, but it comes out in a whimper. He quickly squats down in front of me, one hand gripping the back of my neck, the other covering my mouth and most of my face. His nails dig into my cheeks. My eyes follow his stomach down to his penis. It is big and quivers like it's alive. My head is dizzy as I begin to hyperventilate. I shut my eyes. I have never seen a man's penis before. Babies, yes, but I never imagined it to be so different on a man. All its wrinkles and pouches. It disgusts and terrifies me.

He lowers my head to the ground, and while his hand still covers my mouth I can see my reflection in his eyes. "Shh, shh," he whispers. His body inches away from me. His hand lets go of my mouth and tugs at my pants, pulls them past my hips. A scream crawls its way from my throat and explodes loudly. Shocked, he stops. He quickly looks around. I pull my pants back on and twist my body to get up. His long fingers wrap firmly around my ankles, pulling me closer and closer, one hand now on my thigh. I slide on my bottom, unable to get away. Letting out a loud shrill cry, I squirm out of his grasp and kick to get away.

"Help! Monster! Somebody help me! Monster!" I yell as tears stream down my face and snot drips from my nose to my mouth. Dark, thunderous, powerful hatred rises in me as I scream and call him names. With a surge of anger, I twist and snap my left leg out of his grip. "I hate you!" I yell into his bewildered face as my leg crashes into his chest. His face winces in pain. He gasps for breath and lets go of my other leg. "Die! Die!" Screaming at the top of my lungs, I kick him in the groin with all of my hatred. He doubles over and falls to the ground, hollering like an injured animal. My legs push me up and I run as fast as I can without stopping.

I flee to where I left Chou and Pithy, and see their figures running toward me, axes over their shoulders, faces full of worry and fear.

"Loung! Are you all right? I heard you scream!" Chou questions me shrilly.

I nod shakily.

"We were so scared for you! We thought it was strange when he took you to the woods, away from the base. We kept our eyes on you, then you disappeared!" Chou is crying now. She drops her axe on the ground.

"I'm never going to be that stupid again. I want to report him to the authorities," I tell her.

"No, let's get out of here and go to a place where there are lots of people," Pithy pleads, and drags me away by the arm.

Reluctantly, I allow myself to be dragged away. Pithy helps Chou wrap the rope three times around the pile of wood. Then they sit facing each other with the pile in the middle. Both put their feet on the wood and push, each pulling one end of the rope. When the rope is taut, Chou ties it in a double knot. She lays the axe in with the pile of wood and strings her scarf through the rope to make a handle. Once she finishes, she helps Pithy with the other two piles. Grabbing the scarves, we pick up the wood, now the size of our bodies, and carry it horizontally on our backs. When we get close to the base, I look closely at all the soldiers, hoping to catch the monster. I want to report him, but I do not know who to report him to. With their funny round hats and uniforms, most of the soldiers look the same to me. I am not sure which one to tell my story to. I thought they were here to save us from the

abuses of Pol Pot and not to hurt us. "Come on, we have to go," Pithy again pleads after a few minutes.

Then from the corner of my eye, far in the distance, I think I see him. My mind swirls with rage of revenge. My heart jumps to my throat, and I take off after him. "Monster!" I yell, running. Chou and Pithy call for me to stop and return, but I ignore them. I am so full of hate I pay no attention to where I am going. Suddenly, something crunches under my foot and pain shoots through the sole. I break into a sweat but do not stop. I focus on him and leap on my toes in his direction. My foot throbs painfully as blood leaves a trail over the ground. Briefly, I look to see a piece of broken glass sticking out of my foot. I look down and yank the glass out, causing more blood to spurt. When I look up again, he is gone.

"He's gone!" I scream when Chou and Pithy catch up to me. The pain is so great now that I have to sit down. Saying nothing, Chou takes her scarf and wraps it around my foot to stop the bleeding.

"Come, we have to go," she says sympathetically.

"He's gone—"

"Leave him behind. We have to go."

I stand up and limp around for a few more minutes looking for the Youn, but he is nowhere to be seen.

They walk ahead of me as I hobble slowly behind them. Along the way we do not talk about it, and they do not ask me about the man's penis. I wonder if Chou will tell Kim, or if Pithy will tell her family. For me, the humiliation is too much, the terror too real to relive by bringing it up. I am determined to keep my secret until the day I die.

Once we reach our meeting place, Pithy leaves and goes her separate way. Chou and I continue on in silence.

"You were gone all morning and these small piles are all you brought?" the mother hollers at us when we get home. Chou and I nod. "And what happened to you?" she asks, noticing my foot.

"I stepped on a piece of broken glass," I tell her.

"Careless, lazy girl! You are so stupid you will amount to nothing."

"No, you're wrong. I am going to be somebody great," I mutter to her.

"What? Are you talking back to me?" She walks up to me and pushes my forehead with her index finger, spits at my feet.

"You will never be great. What makes you think you will be great? You are nothing. You are an orphan. You'll only be somebody if you become a hooker!" Her words ring in my ears as hate pulsates through my body.

"I will not become a hooker," I reply indignantly, turning my back to her and hobbling away. Later, crouching near a bush, hugging my knees to my chest, the mother's words echo in my mind and despair creeps into my heart. She is right. I am an orphan with no future. What will happen to me? Then, as I sit in the woods in a corner of the world, hiding from a war I know little about, I hear Pa's voice.

"No one knows how precious you are. You are a diamond in the rough and with a little polishing, you will shine," Pa whispers softly. His gentle words bring a small smile to my lips. The mother may not give me the love I crave, but I know what it feels like to be loved. Pa loved me and believed in me. With that little reminder from him, I know the foster mother is wrong about me. I do possess the one thing I need to make something of myself one day: I have everything my Pa gave me.

flying bullets

I have lived with the family for a month now, and the longer I am with them, the more my hatred grows. However, I know that no matter how I feel about them, their home is safer than living by ourselves. Even though Pursat City is protected by the Youns, people still live in fear. Among the villagers there have been many discussions about the Khmer Rouge closing in on us. The village men say the Khmer Rouge soldiers are all around us, some even hiding in the village or in nearby woods. It is hard to tell the soldiers from the civilians when they are all the same people, speak one language, and wear the same black clothes. Hiding their guns, the soldiers can easily infiltrate the refugee camp and spy on our activities. Every once in a while, a group of Khmer Rouge soldiers attacks a random village, raids the houses, kills a few people, and then ducks back into the woods. They attack without warning, and since no one knows when or where they will appear, we must have eyes in the back of our heads all the time. The refugee village is so large that in these surprise raids, the Youns are not able to arrive in time to protect us until people have been killed.

One afternoon, while the grandmother and I are outside the hut, squatting near the well scrubbing pots and pans, I hear the unmistakable

whizzing of bullets around me. "Flying bullets!" I scream, dropping flat and pressing my chest against the wet ground. I lay in the wet scum of dishwater as it soaks through my shirt and pants. My heart pounding in my ears, I stare at a small ant spinning in a circle in a puddle next to my face. I clasp my hands over my ears as more bullets ring in the air. They explode like Chinese firecrackers, one after another in a feverish succession. A few seconds later the bullets stop. My cheek presses to the ground. I watch the same ant flailing its four legs in the half inch of water. The more it struggles, the more it spins. A few seconds pass and still no more bullets. Raising my head, I quickly get up from the dirt and crawl on my hands and knees behind a tree.

Suddenly, the grandmother screams a loud, shrill cry. Up above, the sun hides behind the clouds. My body still protected by the tree, I peer out to look at her. She is on the ground, lying in a fetal position on her side, both hands clutching her leg as thin, red blood pours out from a wound above her ankle, staining her skirt. The blood forms a pool around her feet, mixing with dishwater as it seeps into the earth. She screams and cries for help, but I crouch in my hiding place. In the hut, the children scream and cry as the mother hushes them. Seconds later, the father jumps frantically out from the hut and picks her up off the ground. Then he carries her off to the camp's hospital with his son trailing behind him.

I do not come out of my hiding place, afraid that if they see me they'll blame me for not helping the grandmother. Long after they have gone, and after the mother has calmed down the little kids, I am still behind the tree. I sit there, scratching the dry mud out from between my toes and then looking up at the sky, wondering when more bullets will rain down on us. Though my heart is beating wildly I feel nothing. My mind still makes pictures and creates thoughts, but I do not have any attachment to them. I am sorry she got shot, but she is mean and often slaps my face and pinches my arms and ears. Now I will not have to see her wrinkled face or hear her poisonous mouth for a while. I stay behind the tree, deep in my own world, until Chou and Kim return from gathering wood.

Three days later, the mother sends me to bring food to the grandmother in the hospital. I take the packet wrapped in banana leaves and head toward the hospital. It takes me an hour to walk the two miles.

The small, well-traveled, red dirt footpath cuts through the town and is usually quite safe. On this day, all is quiet and yet I nervously put one foot in front of the other, my eyes scanning the trees and bushes around me for signs of the Khmer Rouge. Neglecting to look down, I kick something and hear it roll away from me. It is rusty-green and shaped like an egg with little square boxes on the surface. I freeze and suck in my breath. My knees are weak and my feet sting as if I have been electrocuted. It is a grenade. "Stupid girl! You have to be more careful," I curse under my breath.

It is noon when I see the hospital. Taking short steps, I proceed slowly toward it, dreading going in. The abandoned makeshift hospital looks sicker than its patients. The one-level warehouse is gray with age, crumbling from the destruction of war. Dark green mold eats through the cracks in the wall as wild trees and vines threaten to overtake the building. Stepping out of the sunlight into the dark building temporarily blinds me. Inside, the temperature is uncomfortably hot and the air hangs heavy, unmoving. The shrill cries of babies, the repetitive moans, and the echoes of shallow, labored breathing bombard the large space. The stench of human waste, urine, rotting wounds, and strong rubbing alcohol surrounds me, permeating my clothes, skin, and hair. My throat tightens and I swallow hard to suppress a gag. I want to run out of the building. My eyes twitch, wanting to shut so I do not have to look at the bodies lying on the floor. During the Khmer Rouge rule I saw many dead bodies. Having lost all hope of escaping the Khmer Rouge, many went to the infirmary to die. They did not have families to hold their hands and swat away the flies when they became too weak. Like Keav, they wasted away and laid in their own feces and urine, completely alone. In a Khmer Rouge hospital, people moaned and whimpered in pain but did not scream. Here at the hospital in the newly liberated zone, people scream in pain because they're fighting to live.

Taking small, cautious steps I walk past rows of people lying on cots and mats on the ground. Out of the corner of my eye, something scurries away. I jump, then relax. It is only a mouse. Walking on, I look at each patient, searching for the grandmother. I hate having to bring food for some old lady I don't care for. If she were Ma, it would be different.

My heart sinks at the thought and sadness spreads throughout my body. If she were Ma, taking care of her would redeem all the wrongs I've committed.

Ahead of me, two nurses kneel beside a young boy. An old woman sits cross-legged next to them, her face long and sad. The nurses are busy preparing silver trays of tools, bandages, and alcohol bottles. I hover over them, looking at the boy who lies motionless on a straw mat. He looks five or six years old, but I really cannot tell. His eyes are slightly open; his lips are gray and bloodless. My body vibrates with pain when I see that his upper body is badly burned. The skin looks as if it will peel off in one crisp layer. One of his legs is missing from the thigh down and the other is wrapped in bandages. The old woman cries softly, her hand clutching his small one, her thumb massaging the top of his hand in a circle. Her other hand fans his body, chasing away the black-green flies that wait to lick his scorched flesh.

"Bong Srei, what happened to him?" I ask the nurse as she prepares to clean him.

"He was walking here to visit—" The boy screams then, making the old woman sob louder. My toes and feet tingle when I hear the nurse say the boy either kicked a grenade or walked over a landmine. I quickly walk away and leave them with the boy screaming until he passes out.

When I find the grandmother, she is in the process of having her bandages changed by a nurse. The nurse is young and pretty, and wears a graying white uniform. She kneels by the grandma and reaches out for her arm. The grandmother swats her hand away and screams in protest. Hearing the screams, another nurse walks briskly over to assist the first nurse. She holds the grandmother by the shoulders and pushes her down on the cot. Under her weight, the grandma is forced onto her back.

"Are you with her?" the nurse asks, noticing me standing behind her.

"Yes."

"Well, you better help us then. She is a tough one. Grab on to her other leg so she won't kick me. I have to change the bandages." I quickly obey her.

With one nurse pushing her down by the shoulders and my arms wrapped around her leg, the nurse unravels layers of bloody bandages as the grandmother squirms and shakes to be free of us. The bandages coil on the floor like red-dotted albino snakes, exposing the grandmother's ankle. It is red, raw, and covered by a thin cake of dried blood. Just above her ankle is a tiny black circle the size of a cigarette burn. "It's lucky the bullet went straight through the flesh. Any lower and it would have shattered the ankle." The grandmother screams in response. "It looks good, but we still have to clean it." The nurse takes the silver tray of tools and pours alcohol into a white plastic bowl. With a pair of thongs, she dips a piece of white cloth into the alcohol bowl, allowing it to soak through. "Okay, it's time to really hold her down now." I grip her leg tight, my nails digging into her flesh as the nurse swabs the alcohol-soaked cloth on the wound. The grandmother screams and curses us, but the nurse continues to jab the cloth at the wound, wiping away the caked brown blood. When she is satisfied it is clean, the nurse wraps the ankle up again with clean white bandages.

"Please," the grandmother pleads, her bony fingers dragging the snot from her nose onto her cheeks, "please give me some medicine. It hurts very much." For that brief moment, the grandmother looks vulnerable, desperate, human. My heart goes out to her. The nurse looks at her and slowly shakes her head. "I'm sorry, Grandmother. If we had some I would gladly give it to you, but we do not have any medicine." The grandmother cries, both hands massaging near her ankle. She looks so frail and sad that even I pity her.

When the nurse leaves, the grandmother's face darkens and she turns her attention to me. "What are you doing? Give me my food!" she barks at me and unwraps the banana leaves to find rice and salted pork. "Stupid girl! I know you ate some on the way. I am old and I need this more than you." I say nothing and continue to stand there. "You are a little thief—I know you are. You are not even grateful we took you in. Stupid little thief!" Hearing her hateful words, I cannot find it in my heart to feel sorry for her anymore, and I leave her with her cries and moans and the stench of impending death.

The next day, the father brings the grandma home from the hospital. In the hut, she laughs and plays with the grandchildren, ignoring

Chou and me standing outside the hut. A few hours later, while Chou and I feed the children their lunch of rice and fish, we watch the father walk up to Kim as he waters the garden. Standing in front of him, the father says something that makes Kim's lips purse. Putting down his pail, Kim walks over to us.

"We have to leave in a few hours; the family can't afford to keep us. He says there's a family that will take us, and he'll return soon to take us there." Kim's voice is strong and firm, but his shoulders sag. Kim and Chou are surprised by the father's abrupt announcement. I, on the other hand, expected it to come sooner, and I wonder how much I am to blame for his decision. We have lived with them for almost two months and we have grown used to being there. I am thankful he has found a family who will take in all three of us. I am relieved that we will not have to go back to living alone on our own.

Chou and I continue feeding the children while Kim returns to the garden. After their meals, I wipe and clean the children's hands and faces of dirt and dribbles. In the hut, Chou folds our spare set of black pajama shirts and pants, now faded and tattered, and puts them in Kim's backpack.

By the afternoon, the father returns and asks Kim if we are ready. Kim nods. Grabbing the backpack, he carries all we have on his shoulder while Chou and I follow him, our hands clasped tightly together. Our eyes looking ahead of us, we leave without saying good-bye to the mother or the children. The father walks us to a house a mile away and introduces us to the new family. He tells them we are good workers. Kim thanks the former father for his kind words and for finding us a new family. Taking Kim's cue, Chou and I bow to him and thank him. Abruptly he turns and, without a word of comfort or bidding us good luck, walks away.

This new family consists of a mother, father, and their three little children who are between ages one and five. They live in a larger hut than the first family, but still we are relegated to the corner of the room. Behind the hut grows a big, luscious vegetable garden. In the front stands a tall mango tree heavy with fruit. Chou and I are to help look after the children, the garden, and various other chores while Kim

fishes and collects wood with the father. Dropping our bags, the mother hands me the baby, instructs me to look after her kids, and leads Chou to the garden. Outside the hut, with the baby balanced on my hips, I watch the mother squat next to the rows of vegetables and proceed to pull the weeds. Obediently, Chou does the same. Her faded black Khmer Rouge pajama clothes hang loosely on her thin body as her back bends over the garden. Chou is eleven and only three years older than me, but at times I feel much older than she is. It still amazes me how she can survive by being accepting and not fighting back.

Though we live with the family as their helpers, they treat us kindly. Many times the family will have special treats such as coconut cake or sweet rice balls for dessert. No matter how we crave them, it is not proper for Kim, Chou, and I to take a piece for ourselves. The mother and children can reach for whatever they want, but we have to wait until it is given to us. Even with his children screaming for extra pieces, the father always puts a piece on each of our plates. They occasionally raise their voices but never swear or raise their hands at us. Despite the Khmer Rouge ban on religion, they are able to continue to practice Buddhism in secret. A major Buddhist mantra preaches kindness to others or reincarnate in the next life as a slug for all to step on. Being from the country, the family is very superstitious—especially the mother. Whenever anything happens that she cannot explain or under-stand she blames it on supernatural powers. Every day she prays to the earth goddess for plentiful vegetables, the river god for plentiful fish, the wind god to bring rain, and the sun god to bring life.

One of my daily chores is to wash the family's laundry. Many vil-lagers are wearing colorful clothes now, including our new family. I look wistfully at the mother's dark orange sarong and marvel at her sky blue blouse. I remember the red dresses Ma made for Chou, Geak, and me. Our first red dresses.

One New Year's morning, I remember Keav, with big pink, yellow, blue, and green prickly plastic rollers in her hair held in by a hundred small black bobby pins sticking up everywhere like porcupine quills, as she combed my hair and tied it in ponytails. Next to her on our bed, Chou worked on getting Geak dressed. After Keav finished with my hair, she put red rouge on Geak's lips and cheeks as Chou and I

slipped on our new dresses and stood in awe of each other's beauty. On our bed, we bounced with glee as our mattress squeaked, prompting Keav to yell at us. On the other side of the hallway, Ma picked out gold necklaces and bracelets from her collection for us to wear. She set aside a pair of red ruby earrings for Keav because she was the only one of us girls with pierced ears. In the kitchen, our helpers cut brown roasted ducks and arranged white moon-shaped cakes on a large blue plate. In the living room, Pa, Khouy, Meng, and Kim, dressed in their best clothes, lit orange incense sticks. After bowing three times before the red altar decorated with gold and silver Chinese symbols of peace and happiness, they inserted the incense into a yellow clay bowl filled with rice.

The baby in my arms pulls my hair and brings me out of my reverie. Looking at the mother, I assume she feels happy and joyful wearing her colored clothes. Glancing at my own, I wonder when I will also get out of the Khmer Rouge uniform and into some colorful clothes. I dream of one day owning a red dress to replace the one the soldier burned.

The mother interrupts my reverie when she takes the baby and asks me to do the laundry. After too many green mangoes, the three kids have had diarrhea all over their sheets. I roll the dirty clothes and sheets into a wicker basket and walk down to the river. With the basket balanced on my hip, I wade into the river until the water reaches my knees. I take out the sheets and spread them open on the surface of the water, allowing them to sink slowly while the diarrhea floats to the top. While doing this, little fish swim over and eat the mess. Some nip at my legs. With no detergent or soap, I must beat the bedsheets against rocks to try and clean them. This chore disgusts me, but I do it without complaining, afraid that if I don't, the new family will send me away.

Sometimes the mother sends me to the forest to gather firewood. I meet Pithy along the way and we set off, making sure to stay clear of the Youn base. One day while walking, a stench attacks my nose and I begin to cough. It resembles rotting chicken livers left out in the sun for too long. Coming around the path into a clearing, I know what the smell is before I even spot the body. The corpse lies decomposing in the sun. I hold my breath and walk toward it.

"Come on, let's go back," Pithy urges, looking pale. I wave my hand at her and proceed forward while she stays back. Pinching my nose, I approach it. The face looks as if it has melted, exposing the cheekbones, the tip of the nose cartilage, and teeth in a lipless mouth. Beneath decomposing lids, the eyes are sunken deep into the skull. The eyelids and mouth are covered with small white eggs, some already hatching to become maggots, which crawl and disappear into the skin. More maggots wriggle around on the lids and out of the open mouth. Long black hair sinks into the grass, becoming one with the dirt. The chest cavity is caved in beneath the black clothes, home to hundreds of the black-green flies feasting on the body. I cover my mouth and push down vomit, not daring to look anymore. Quickly, I turn and walk away, but the smell of death still clings to my clothes.

"He was a Khmer Rouge soldier. He deserved to die. Too bad they are not all dead," I say vehemently to Pithy. She says nothing. I do not in fact know if the body is a civilian or a soldier. Thinking of the body as a civilian makes me think of Pa too much. It is easier to feel no pity for the dead if I think of them as all Khmer Rouge. I hate them all.

Holding on to my hate for the Khmer Rouge also allows me to go on living the mundane details of life. Another one of my fixed duties is to go down to the river and gather water for the family. Each morning, balancing two water pails on a long flat piece of wood over my shoulders, I set off to fetch the water. The walk to the river is only ten minutes, but in the February sun it always feels much longer. Squinting at a reflection in the water, I make out a figure of girl standing on the bank. She is not much bigger than I am and with one hand on her hip, she peers at the riverbank in frustration. She removes the pails from her plank and hits at something on the grassy bank.

"What are you doing?" I ask her.

"I'm trying to loosen the body so it will flow downstream," she says between halting breaths. A few feet from where we are standing, a body floats past, dressed in a black pajama shirt and pants. He is an adult man, bigger than most men in the village, and much fatter. He bobs up and down in the water, his hands and feet shiny and swollen as if made of white rubber. His upper body sways with the currents, but his pant leg

is caught on some branches from the bank. His head bobs in the water each time the girl pokes him with her wood.

"I want to loosen him up so he'll go downstream. He'll dirty the water, maybe his juices will flow into my pails." Her logic makes complete sense to me. I remove my pails, and with my stick help to push the body away. With the two of us beating on it, it bobs and sways even more. Finally we loosen the leg and the body floats a few feet down before getting stuck again near the bank. This time he is inches away from us.

"The water is too shallow. On the count of three, you push the body and I'll push the head," I direct. After a concerted effort, the body finally floats down the river, his long hair spreading around. The picture tugs at my heart and knots up my stomach. For a few brief seconds I think of Geak and hope the soldiers did not put her in a bag and throw her into the river. I nearly cry at the thought of someone poking at her body, but I push the tears down. "Another damn Khmer Rouge," I mutter under my breath. "I hate them. I hope they all die." We wait a few minutes until we believe the body fluids have all floated past us before fetching our water.

At the hut, the clay water container stands as tall as my chest. It takes me many trips and most of the morning to fill it up and still the water runs low by the end of the day. In the evening Chou, Kim, and I repeat our water chores before we go to sleep. We keep the pot full so we can have easy access to the water for we fear we will fall in if we have to reach to the bottom.

Kim, Chou, and I have had red eye disease for two weeks now. I fear I might have given the disease to them because I dare to look at the dead bodies. Somehow, the disease must have flown from the bodies and into my eyes, making them red as the blood I poke at with my stick. Every morning I wake up unable to open my eyes because both of my lids are glued together. Painfully, I pick, pinch, and pull the crud off of my lashes, but it is so thick that I have little success.

"Kim, are you there?" I call out to him. In the dark I sense a hand searching for me, finally finding my arm.

"It's me," Chou whispers. "Are you ready? I've got Kim's hand."

"Yes."

Grabbing Chou's hand, Kim slides on his behind until he reaches the edge of the hut. Then jumps to the ground and helps Chou and me. Linked together by our hands we feel our way to the water pot. Kim retrieves a bowl full of water and puts it on the ground. Squatting around it, we scoop water with our hands and wet our lashes.

By this time the mother has awakened and is looking at us suspiciously. "You must have been looking at dogs when they mate," she tells us. "It's a sin to look at dirty things. The gods have punished you to make you blind."

khmer rouge attack

The sky is pitch black and the air is still. All is quiet except for the rhythmical chirping of crickets calling out to each other. Suddenly a loud explosion awakens us. I sit bolt upright, my ears still ringing from the blast. My heart and stomach vibrate from the shock. Then we hear a shrilling whine before another rocket ruptures nearby. The straw walls and roof of the hut rustle and shake. The children scream at the top of their lungs, clambering around the mother. The father jumps out of the hut and runs to look outside. Chou, Kim, and I follow him. Outside, the earth shakes violently as crackling yellow, orange, and red flames devour a neighbor's hut. Gray smoke floats to the sky and white ashes fall on us like powder.

"Chou! Kim!" I yell.

"Follow me, stay together," the father hollers to his family. He picks up two of the children and jumps out of the hut. The mother holds the baby tightly in her arms and follows. Kim leaps into the hut and grabs his backpack while Chou and I wait. All around us people cry and scream for help as more rockets rain on the village. The dark night is bright as many houses are engulfed by fire and villagers rush to evacuate.

With our legs shaking in fear, we follow the father, ducking when he ducks, keeping low when he keeps low. We come to the river and, holding hands, wade across it. The river splashes in waves as thousands of people jump in it at once trying to get to the other side. With small bundles on their heads or draped on their shoulders and small children hanging on their backs, the villagers wade across the chest-deep stream, desperately reaching for safety. Once on the other side, we find shelter in an old abandoned warehouse with a low concrete roof, propped up by three remaining walls.

"We stay here tonight," the father tells us. "It is guarded by the Youns and it is safe." The shelter is filling up fast as more and more people arrive. Among them I see Pithy running through the door.

"Pithy! Over here!" I scream over the wails and moans of others. She waves and runs toward us with her mom and brother, settling in the space next to us.

We spend the night in the dark, afraid that any light might signal our whereabouts to the Khmer Rouge soldiers. Everyone is quiet, breathing softly, some even trying to sleep. My heart beats loudly, jumping at every sound as I crouch in between Pithy and Chou, praying to Pa to protect us. Chou sits beside me, holding Kim's hand tight. I grit my teeth hard together to stay calm. Outside in the distance, the mortars and rockets continue to explode through the night.

The hours pass slowly. I tap my feet as if to the beat of some fast song, hoping to make time go by faster. Chou now sits cross-legged, her hands clasping together and then unclasping. Next to her, Kim lies on the ground, using his backpack as a pillow. The father and mother stretch their legs beside us, with the children sleeping on both their laps. All around us, families are lying down on the ground with no mats or blankets separating them from the dirt. Their knees pull up close to their chest, and their arms prop up their heads like pillows.

By early morning it is quiet again. I can almost feel the shelter expand with air as everyone lets out a sigh of relief. Then, without warning, the whistle of a rocket flies near us and hits our shelter! The blast almost knocks the air out from my lungs. I reach for Pithy's arm, then jerk my hand back as my palm touches something wet and sticky on her. My stomach churns. I turn to see Pithy lying facedown on the

ground, quiet and motionless. The top of her skull is caved in. A pool of blood slowly seeps into the dirt around her head. Her hair is wet and matted with small bits of a tofulike substance on her black head. Her blood and pieces of brain are still on my hand. Pithy's mom screams for her, then gathers Pithy into her arms. I wipe her blood and brains on my pant legs. In a panic, I get up and run after Kim and Chou out of the shelter, away from Pithy. Away from her screaming mother. Away from the sorrow that threatens to take residence in my heart.

Outside, people are scattered everywhere, screaming and crying as they run in every direction, bumping and pushing each other. Kim and Chou hold hands and run ahead of me, yelling for me to keep up. We don't know where to run to, we just run. Kim stops running and looks back at the shelter.

"I left behind the backpack," he yells.

"Keep running. . . I'll get it and catch up!" I scream to him, and before he can answer, I am gone. I know he has to take care of Chou. Entering the destroyed warehouse, the thick smell of burnt flesh quickens my pulse. Black smoke obstructs my vision, stings my eyes. Stepping over slabs of concrete and parts of the wall that has fallen, I make my way to our spot. My heart drops at the sight of Pithy's mom holding her corpse to her chest, weeping. Pithy is limp in her arms, her blood soaking into her mom's blouse. So much blood everywhere. Then I see that Pithy's mom is also injured. She is bleeding from her stomach and arms. Pithy's brother squats beside them, urging his mom to leave. His voice quivering, he tells her the Khmer Rouge soldiers are crossing the river and will be upon them any minute.

I grab the backpack, ignoring the pleas and cries for help. Looking straight ahead I jump over the dead and run to meet my brother and sister. I see them waiting for me and scream for them to run ahead. The rockets have stopped, but the Khmer Rouge soldiers are getting closer. I hear their bullets whiz past me. I dare not turn and look. I know they are there. I run for my life. In front of me, a man falls from a bullet. His body stops midstride, his chest jerking forward before he falls to the ground. Many people get hit and drop one by one to the ground all around me. Some lie still while others crawl on their elbows trying to reach safety.

After I catch up with Chou and Kim, we all run and do not look back. We see an old remnant of a cement wall. It sticks out of the ground three feet tall by four feet wide. We crouch behind it. Chou covers her ears with her hands and squeezes her eyes shut. Kim is white, leaning against the wall for support. We stay there for what seems like hours until all is quiet again. No longer deafened by the bombs, I finally notice something circling and buzzing over my head. Then I feel like many tiny pins are pricking my skin.

"Hornets!" I scream. We get up to see that we have disturbed a hornet's nest. Big red welts cover our arms and legs. We were so scared we did not feel the pain when we got stung. When we believe it is safe, we leave to find our foster family. Finally, we spot them near the Youn camp.

"You all stay here with the women and children," the father tells us. "Stay here until we come back for you. The men must clean the village of its dead bodies," he says before he goes off to the village that afternoon. He tells us that the Youns have retaken our village from the Khmer Rouge a few hours ago.

"It is worse than anyone could have imagined," the father says to the mother after returning from his village. "One couple was hiding in their dug-out bomb shelter, which is only a hole in the ground. The soldiers threw a grenade in it, killing them both. We also found many of the victims' heads, hanging by the hair in front of their door or tossed about on the streets. The Khmer Rouge soldiers surely feel these people betrayed them by staying with the Youns."

Stories about victims of the Khmer Rouge attack spread like fire. There were stories about a baby thrown in the air and speared with a bayonet; the body of one mutilated man lying naked on top of another; a man's torso found in front of his house and the bottom half on someone else's front door. There are bodies of men found with their chests cut open and their livers missing. The Khmer Rouge soldiers believe that eating the livers of their enemy will give them strength and power. These images of the massacre play themselves over and over in my head as I take tentative steps back toward the village that evening. I do not doubt the truth of the stories. I know Pol Pot's men are capable of this. I walk behind the father and his family. Chou and Kim trudge ahead of me, their eyes focusing on the ground. There are smoldering

remains of bonfires giving off the stench of burnt human flesh all through the village. Trails and puddles of blood stain the steps and posts of the huts. My eyes are on the ground wherever I go, steering clear of anything that looks like a grenade. I'm also afraid of stepping on a land-mine, which the villagers say Khmer Rouge soldiers plant after an attack, maiming and killing people long after they have fled.

A few days after the attack, I happen to walk by Pithy's brother while gathering wood. He is about Kim's age, and like Kim, his eyes are very sad. His body is wiry and agile, allowing him to easily climb palm trees for their fruit. I stand there watching him, admiring his ability to get up and slide down the tree so fast. "Chum reap suor." I call out. He nods at me. "Where are you off to?" I do not ask him about Pithy.

"Everyday I go fishing and pick palm fruits for Ma. She is in the hospital. I bring food for her and stay with her through the night. She is getting better." I am surprised he is saying so much to me. He peels the fruit and hands me a slice.

"Aw koon," I say thank you to him, but he does not hear me. He is very far away now. He picks up his fruit and heads off to the hospital.

The next day, I see him again at the same place, peeling palm fruits. I walk over and ask, "How is your mom doing today?" He looks up and I see that his eyes are red and angry.

"Leave me alone. Don't bother me," he yells and comes after me with a large rusty silver cleaver. With my knees shaking I run from him. "Get away from me! I hate you all!" he screams as I crouch and hide in the bushes. Suddenly, he stops coming after me and stands transfixed, dropping his cleaver. With his shoulders slumped, he stoops and slowly sits on the ground. His elbows rest on his knees, his face buried in his hands. He cries long, hollow sobs and his shoulders shake uncontrol-lably. My heart leaps for him. I want to reach out to him, but instead I turn and walk away. He is alone now too.

It is April 1979. Our future looks bleaker every day. I dread the idea of going to live with another family, but I know it will happen soon. Kim is still hoping our brothers Khouy and Meng are alive somewhere and that soon they will come for us. We don't know how to go about searching for either them or our uncles in Bat Deng.

After completing his chores each evening, Kim sets off to the Youn camp. There is an area there where the newly arriving displaced people stay, and where people congregate to try and find each other. Every time someone new arrives at the base, Kim asks if they know or have ever heard of our brothers. Always, they give him the same sad answer. Each night, he drags himself back to give us the news, but my heart always sinks before he has had a chance to say anything. My world darkens when the thought that they might be dead enters my mind. I force it to go away. Khouy and Meng have to be alive somewhere out there.

I am feeding the baby when one of the kids runs over and tells me Kim is coming with some man. I cannot dare to hope. Chou and I look at each other, our eyes full of fear, praying the man is our brother. I see Kim's figure as he approaches us. Meng walks beside Kim. I do not know whether to cry or run to him. I am filled with so much happiness. He is alive. We are a family. I find myself feeling shy, and I stand stiff and awkward. Meng smiles and musses my hair. My heart soars quickly at the touch of his hand. He is real—not a figment of my imagination!

"You're coming with us," Meng says and goes to talk to the father. When Meng comes back out, Chou, Kim, and I leave with him. While Kim and Meng talk, Chou and I are quiet. Looking at my oldest brother, my heart is heavy with the memories of Ma. He has her almond-shaped eyes, long face, high cheekbones, and thin lips. In Phnom Penh, he wore blue bell-bottom pants, jean jackets, and thin sideburns that were trendy at the time. He was nice to everyone. Girls thought him handsome. Now he is twenty-two and already an old man. Yet even in his tattered black pajama shirt and pants, with his weathered face and sad eyes, I still see the brother I knew in Phnom Penh.

Meng takes us to the area where all the new arrivals live. Their dark green tents are set up in the middle of a group of trees. Around the front, there are two black cloth hammocks between tree trunks tied low to the ground. The tents and the hammocks look soiled, but they feel more like a home to me than the biggest hut here. He tells us he and Khouy are living with three women friends in two tents. He says Khouy's wife somehow escaped the labor camp when the Youns invaded. He believes she returned to her family's village to search for

surviving family members. The women whom they are living with are friends. It is dangerous for women to be on their own so they asked if they could live with my brothers.

Shortly after we arrive at their tents, Khouy returns too. I watch as he saunters slowly toward us. He moves gracefully, his steps firm and steady. He always reminds me of a tiger—strong, fast, agile, and mean when he bares his teeth. The sleeves of his fading black shirt and pants are rolled up, showing us muscular calves and forearms. His eyes are dark, his face is bony, his jaws are squared, and his ears stand straight. At only twenty years old, already everything about Khouy gives you the impression of hardness. When he sees us, his face softens and he smiles broadly. Walking over, he greets Kim, Chou, and me. While talking to Meng, he leaves his hand resting on my head—the way Pa used to do.

Our family sits near the fire that night listening to Meng tell their story. Khouy and he were together in a labor camp when the Youn invaded Kampuchea at the end of December. One night, rockets landed near their camp, and in the confusion, many people escaped and ran away, including Khouy's wife. But Meng and Khouy were unlucky and they found themselves confronted by Khmer Rouge soldiers just outside their hut. The soldiers did not kill them because they needed them as porters. As the Youns moved closer and closer, Khmer Rouge soldiers pushed them farther into the jungle. When the Khmer soldiers stopped each night to rest, Khouy cut firewood while Meng cooked meals for them all. One night, Khouy told Meng they had to make their escape. The soldiers were moving them up the mountain where they would be under total Khmer Rouge control, isolated from the world and cut off from all the escape routes. If they did not make their break now, the chance might never come again.

While the soldiers were sleeping, Khouy and Meng pretended to go relieve themselves. Each stole a twenty-pound bag of rice, and they met in the woods. At first they proceeded down the trail, but fearing the soldiers' ability to track them, they took off back into the woods. There they followed the sound of rushing water to a stream and, once there, tied a few logs together to make a raft. With the rice bags on the raft, they floated downstream. The water was cold and rough, threatening many times to tear the raft apart, but with teeth chattering and bodies

shivering, they managed to stay afloat all night. In the morning they arrived at the base camp of Pursat City, where we are now.

We are together again. Seeing my eyes slowly closing, Meng takes me to his cloth hammock. I climb in and suddenly feel very tired. Chou comes over and climbs in next to me. Our bodies press against each other as the hammock folds over us like a pod protecting its peas. Drifting off, I think of Pa and Ma; I miss them so much. By the fire, I hear Kim's voice quivering as he tells them about Pa, Ma, and Geak. They whisper to each other, as if trying to shield Chou and me from news we already knew. I shut my eyes, not wanting to see Meng and Khouy's faces as they receive the news. The remainder of our family is together again. With my brothers around me, I feel safe and relaxed. As I drift off to sleep, I hear Meng announce that our next step is to return to Bat Deng to search for our aunts and uncles. Bat Deng is Ma's hometown and where we left Uncle Leang and eldest Uncle Heang. We will go there and wait for other surviving family members to return. Since Bat Deng is many miles away, we have to stay here a while longer and gather supplies. Though risky because the Khmer Rouge may still control sections of the route, we will travel by foot again and hope to be reunited with our relatives.

the execution

A few days later, Meng arrives at the tent site all flushed and out of breath, telling us he has just returned from the Youn jail. He says somehow the Youns have captured a Khmer Rouge soldier and are holding him there. He reports that when the villagers heard about this, hundreds of them rushed to the jail and demanded that the Khmer Rouge soldier be released to them. Men, women, and children blocked the entrance to the jail, threatening to riot if their demands were not met. They carried steel bars, axes, knives, wooden stakes, and hammers— all the weapons used by the Khmer Rouge soldiers to kill their victims.

Meng says the villagers at the jail have only one thing in mind: blood for blood, life for life. They want a public execution of the prisoner. They screamed threats to the Youn soldiers and questioned why the prisoner should be protected. They are ready to break down the jail if they must to get to the prisoner. In the end, the Youns opened the door and handed the prisoner over to the people. The crowd raised their weapons in the air and cheered with satisfaction. Finally, they have the power to seek revenge for their suffering.

He describes how two Khmer men in their early thirties stepped forward and took the prisoner from the Youns as the crowd cheered

again. The men dragged the prisoner away while people were pushing and shoving around them. They took him to the middle of a field on the edge of town. Someone brought forth a chair and put it in the middle of the crowd. The two men thrust the prisoner into the chair, and tied his hands behind his back and his legs together.

Hearing this, my heart races with excitement. Finally, a chance to kill for Pa, Ma, Keav, and Geak. "Come, Chou! Let us go and watch!" I plead with her.

"No. Please don't go," Chou pleads with me.

"I have to go. We get to kill one of them for once."

"Meng and Khouy won't like it when they hear about this."

"Don't you tell them then. Don't you want to see the execution yourself?"

"No." When Chou makes up her mind, there is no changing it.

Failing to convince her, I head off on my own. To get to the field, I have to wade across the river, climb a tall hill, cross a broken bridge, and walk thirty minutes in the scorching sun. When I arrive hundreds of people are already there, standing around the prisoner. Their bodies block my view. I shift, trying to find an open space between them, but I cannot. Frustrated, I wedge my small body between theirs and push my way through, calling out loudly, "Sorry, I cannot see." The tall bodies snort and huff in annoyance but let me through anyway. I am in the middle of the crowd, totally surrounded by people. I cannot see anything. I look up to the faces of the adults who are all looking in the same direction. Breathing a sigh of relief, I follow their gaze. "Sorry, I cannot see." I repeat my pleas as I nudge and step on their toes trying to get to the front. Finally, I see a clearing between people's legs. I try to push my way through, but they are so engrossed in what's going on that they do not move. Determined, I get on my hands and knees, and crawl through the brown forest of legs up to the front.

There he is. I stand and find myself almost face-to-face with him, separated by only fifteen feet. Automatically, I raise my scarf to cover my head and face. My heart beats wildly. Fear seeps into my body. He is looking at me. He can see me. What if he escapes and kills me? I take a step back, leaning into the crowd for protection. The crowd vibrates with anticipation and energy, closing in around the prisoner, glaring at

him. I have never seen an execution before. Rage heats up my body, seeing only one of them killed is not enough!

His face reveals nothing. His lips do not beg for mercy. He sits propped up on a highback chair on a gravel hill that serves as a stage. He is dark and wears the black clothes of the Khmer Rouge—the black clothes I still wear. His matted hair is sweaty and he hangs his head to focus on his feet. The rough hemp rope that binds his feet together is so tightly tied that it draws blood. More rope straps him to the back of the chair, it coils around him from the chest down to the stomach.

"Murderer! You deserve to die a slow, painful death!" someone yells.

That is what we have planned for him. I hope he knows his life is about to end. I hope he knows we are here because we want his blood and will soon rip him apart for it. People talk loudly about the best way to kill him. They argue about how to make the execution as drawn out and painful as possible. They discuss which tools to use to crack his skull, to slice his throat. Someone says we should let him sit in the sun, shave his skin open little by little, and rub salt into the wounds. Someone else wants to strangle him bare-handed. The discussion continues for a long time, but the people cannot agree on what to do.

Finally, two middle-aged men step up in front. The crowd hushes. The prisoner glances up. He looks scared now. His eyes are squinting and his lips move as if to mutter something, but he decides against it and purses his lips shut. Sweat pours from his face, slides over his Adam's apple, and soaks his shirt. He bends his head, looks down at his feet again, knowing there is no way out. His government has created a vengeful, bloodthirsty people. Pol Pot has turned me into someone who wants to kill.

"Brothers, sisters, uncles, aunts," one of the two men yell. "We have decided that this Khmer Rouge will be executed for his crimes. His blood will avenge the innocent people he has slaughtered. We are asking for volunteers to be the executioners." The crowd roars. They look about, wondering who will be the first to volunteer. At first, no one raises his hand. For all the big talk, everyone stays silent. Then a few hands go up and the crowd comes to life again.

A woman, crying loudly, pushes her way to the front of the crowd. She is young, maybe in her midtwenties. Her straight black hair is tied

back, giving us a view of her angular, thin face. Like me, she wears the Khmer Rouge clothes. Though tears fall from her eyes, her face is dark and angry.

"I know this Khmer Rouge soldier!" she screams. In her left hand she holds a nine-inch knife. It is copper brown, rusty, and dull. "He was the Khmer Rouge soldier in my village. He killed my husband and baby! I will avenge them!"

Another woman then pushes her way out of the crowd. "I also know him. He killed my children and grandchildren. Now I am alone in this world." The second woman is older, perhaps sixty or seventy. She is thin and wears black clothes. In her hand she holds a hammer, its wooden handle worn and splintered. One man takes the women aside while the others continue to speak to the audience. I am no longer listening. I am fixated on the prisoner. He looked up briefly when the two women came forth, but now he is back in position, head down, eyes to the ground.

I watch without emotion as the old woman walks slowly up to him, her hammer in hand. Above us the black clouds move with her, shadowing where she goes. She stands in front of him, staring at the top of his head. I want to shield my eyes from what's about to happen, but I cannot. The old woman's hands shake as she raises the hammer high above her head and brings it crashing down into the prisoner's skull. He screams a loud, shrill cry, that pierces my heart like a stake, and I imagine that this, maybe, is how Pa died. The soldier's head hangs, bobbing up and down like a chicken's. Blood gushes out of his wound, flowing down his forehead, ears, and dripping from his chin. The woman raises her hammer again. I almost feel pity for him. But it is too late to let him go, it is too late to go back. It is too late for my parents and my country.

Blood splatters the woman's clothes, body, face. She screams and swings the hammer up above her head again. Blood droplets land on my pants and face. I wipe them off. Red smudges are still on my palms. Another scream comes from the old woman, this time her hammer smashes his leg. His leg jerks but is held down by the rope. The hammer lands over and over again, on his arms, shoulders, and knees, before the younger woman moves toward him. Taking her knife, she pushes it into

the prisoner's stomach. More blood pours out, spilling over his chair. She stabs him again, this time in the chest. The Khmer Rouge body convulses and trembles, as if electricity is traveling to the legs, arms, and fingers. Gradually, he stops moving, slumping over in the chair.

Finally the women stand still. Their weapons drip with blood as they walk away. When they turn around, I see that they look like death themselves. Their hair trickles blood and sweat, their clothes drip, their faces red and rigid. Only their eyes look alive as they seethe with more rage and hate. The women are quiet as the crowd parts for them to pass through. During the execution, the crowd did not cheer but watched, silent and devoid of emotion, as if it were the slaughter of an animal for food. After the women are gone, the crowd begins to buzz.

"Did you see how rich and dark the blood was? It was the color of the Devil's blood!"

"It is rich because he has been feasting on the food we grew while my family died from starvation!"

"His blood is dark because he isn't human. Humans do not have black blood!"

"Why didn't they make him die more slowly?"

One by one, people return to their homes, leaving me standing there alone, staring at the corpse. My mind plays back images of my parents' and sister's murders. Again my heart tears open as I stand there and wonder how they died. Quickly, I push the sadness away. The slumped over corpse reminds me of Pithy in her mother's arms. Pithy's head bled in much the same way. His death will not bring any of them back.

The crowd is gone, except for ten of us kids waiting to see what the adults will do with the body. Three men eventually approach the body and cut loose his legs and hands. As they loosen the rope around the chest, the corpse tumbles off the chair and lands in the dirt. One man tightly wraps the rope three times around the corpse's chest. Holding the end of the rope, the three men drag the body away, leaving behind a trail of blood in the dusty road. I follow along with the other children. The men haul the body to a well and stop in front of it. Four feet in diameter, the round concrete wall sticks two feet out of the ground. The once white concrete is gray with mold, the short grass around it brown and shriveled.

Turning to us they yell, "What are you kids following us for? Go home! Get away from here. There is nothing to see!"

I am not convinced and stand firm with the other children. Turning their backs to us, they bend and lift the dusty corpse off the ground and drop it into the well. I hear a big splash and a thud when it lands. Each man then wipes his bloody hands on the grass, picks up a handful of dirt, and rubs his palms together to clean off the blood. Finally, they leave together. The other children and I look at each other.

The smell coming from the well is horrible. Pinching my nose and covering my mouth, I walk up to it and peer in. The smell is so putrid it makes my eyes water. It takes a few seconds for my eyes to adjust to the darkness of the well, then slowly, thirty feet below, I make out the shape of human figures floating on top of the water. What my eyes cannot see, my mind makes up for, and I picture dark dead faces staring up at me. The hair stands up on my arms and legs as I run away.

"Don't fall in—the smell will never wash away!" I yell to the other kids.

back to bat deng

While staying at the displaced people's camp, Meng, Khouy, and Kim leave to go fishing every morning. My job is to search for wild vegetables and mushrooms in nearby woods while Chou guards our tents. Usually, we eat half of what the boys bring back each day. The rest we salt, grill, or dry to save. These days we go to bed on a full stomach every night. We have fish, wild vegetables, and the rice Meng and Khouy stole from the Khmer Rouge. We are the lucky ones. Most of the old and very young lie sick on the outskirts of the sites where the displaced people gather or die in the camp from disease and hunger.

At the end of April, Khouy and Meng decide we are ready to leave Pursat City. They believe we have gathered enough supplies to last the long trip to Bat Deng. Abandoning our tents, we pack our few pots, pans, clothes, and all our food. We leave with two of Khouy and Meng's women friends but the third stays behind to search for any surviving family members. Khouy and Meng each carry a fifteen-pound bag of rice on their shoulders and the rest of us help with bundles of clothes, blankets, and other food.

Balancing the rice pot on my head, I turn around and look one last time at Pursat City. My eyes linger on the mountains, thinking of Pa,

Ma, Keav, and Geak. The mountain peaks majestically jut into the sky as large clouds cast dark shadows on them. It all looks so calm and normal, as if the hell we have lived through for the past four years has never happened. Four years ago, on April 17, 1975, the Khmer Rouge took over Phnom Penh, a course that eventually brought us here to Pursat. Up there somewhere in the mountains, Pa, Ma, Keav, and Geak are still trapped and unable to go home with us. "Pa, Ma, Keav, Geak," I call out to them, "I am taking you all home now. I will not say good-bye. I will never say good-bye."

Day after day, we walk onward, stopping only to rest at night. In the dry April sun, our black clothes absorb the rays and the heat weighs heavy on our skin. Our bones grow tired, our backs ache, our feet blister, yet still we march. Almost exactly four years ago, we evacuated Phnom Penh. I remember how I cried and whined about the hot sun and how the touch of Pa's hand on my head soothed me. I was not used to the heat, the sun, and the hard ground then because Pa provided us with a sheltered, middle-class life. Now my body is accustomed to the extreme environment and weather, but my heart has never come to terms with the absence of those we have lost. Now we are leaving them behind. I hope wherever they are, their spirit will follow us back to Bat Deng.

One night, we find shelter in an abandoned hut. We are in the middle of nowhere and are highly vulnerable to a Khmer Rouge attack. The makeshift refuge must house the seven of us and one other family who arrived there before us. The other family consists of a mother, father, and baby. He is sick, his face and feet are swollen, as are hers and their baby's. When I see the mother of the other family, I think she is Ma. The woman could be a double for Ma! I want to run to her, talk to her, and hold her, but then I see her husband lying next to her. He is about Pa's age, but the resemblance ends there. I know then she isn't Ma, because she would never be with anyone else other than Pa. I don't dare ask my siblings whether they see the resemblance too. Watching their eyes, I notice they do not linger on the sight of the mother the way I do. Do my brothers and Chou see the resemblance too?

While the family stays on the ground level of the hut, our group moves to the top floor. Before they fall asleep that night, my brothers

practice jumping out of the second floor to plan their escape route in case of a Khmer Rouge attack. They leap off in different ways and clear the area of anything that might hurt us when we land. Next they test the stability of the stairs under pressure, and rehearse running up and down them. Chou and I sit and worry about what will happen to us because we don't think we can jump without breaking our legs. Now that we are together again, I fear something will happen to break us up again. I'm afraid that if there is an attack I will be left behind. If all of us cannot live then at least hopefully some will. I know Pa would have wanted it that way. Still, the thought fills me with anxiety. After I am sure my brothers are asleep, I take off my scarf and go to sleep on the ground at the bottom of the stairs.

Before we leave the next morning, and when my brothers and sister aren't looking, I grab some of our cooked rice and wrap it up in banana leaves. Downstairs, the woman is awake and breast-feeding her baby. I do not have the courage to talk to her or look at her. Instead, I place the rice near her and leave before she can say anything. Looking back longingly at the hut, I wonder what will happen to them. It does not look like they will be able to leave today, with a sick husband and baby. They will probably spend another night alone.

Day after day, we push on until I lose count of how many days we have traveled. Every day we walk, only stopping at night to rest. All along the way, I travel with Pa, Ma, Keav, and Geak in my thoughts. In my mind, I talk to them. I complain to Pa about my blistering feet and aching joints. I describe to Ma all the pretty flowers I see on the road-side. I report to Keav the flirting that goes on between Khouy, Meng, and their women friends. And Geak—I have the hardest time finding words to say to her. To Geak, I keep silent.

"We're very close to Bat Deng," Meng says, breaking into my thoughts. "If our aunts and uncles are alive, we will be with them soon." We have been on the road for eighteen days now and our food ration is getting smaller with each passing day.

As we walk the last few hours back to Bat Deng, Meng and Khouy ask many people on bicycles or wagons if they share our destination. When they say yes, my brothers plead with them to bring word to our uncles that we have arrived. Within an hour, we see a familiar figure on

a bicycle riding toward us. It is Uncle Leang! Uncle Leang still resembles the stick figure I drew in Phnom Penh, only his back curves more now. My brothers rush up to him and soon they are hugging each other and crying. Uncle Leang reaches into his bag and pulls out some sweet rice cakes. My eyes widen and my mouth waters at the sight of the roasted sesame seeds sprinkled over sweet rice.

"Here's one for you, Chou, and one for Kim." Shyly, I step toward him and extend one arm. "Sorry, little girl. I have only enough for my family. I have none extra for you." My face burns with shame and embarrassment. My own uncle does not recognize me. He thinks I'm a street girl begging for food.

"Uncle," Meng says laughingly, "it's Loung."

"Oh, here's one for you then," surprised, Uncle Leang smiles.

Chou, Kim, and I sit pressed against one other on the back of the bike, holding onto Uncle Leang. We are returning to Ma's childhood home without her. At Bat Deng, everyone is happy to see us. Uncle Leang and his family still live in the same hut they did when we stayed with them. The first thing Uncle Leang's wife, Aunt Keang does is to take off our dirty black clothes and give us new ones. She puts me in a shirt and pants the color of a blue sky. The clothes shimmer as they touch my skin softly, making me feel nice and light—transformed! In the back of the hut, I watch Aunt Keang throw our dirty clothes into an aluminum bowl and soak them with water. She then sprinkles a handful of white powdered detergent in the water and begins to scrub my clothes. I watch in fascination as the clear water becomes gray and then black as the detergent does its work.

When Khouy and Meng arrive on foot two hours later, they tell our story and Aunt Keang cries when she hears what has happened to us. They want the two of them to tell them over and over again about all that has happened. At Krang Truop, Uncle Leang's family is considered to be a base family because they have lived in the same village since the prerevolutionary days. As my family talks about the war, I pretend to have no memory of it. They do not ask me about my experiences. In our culture, it is enough that the oldest child relates the family's story. Children are not asked for opinions, feelings, or what they individually endure. I do not volunteer information about my

indoctrination as a soldier, escape from being raped, or how I lost three days of my life when I found out about Ma. For a long time I needed to hold on to the memories because they made me angry. My rage made me strong and resilient. Now, however, enclosing the memories in my heart and mind is unendurable.

Often I walk away from their chatter, but sometimes I just sit quietly and listen. Through their conversations, I learn that Bat Deng, my uncles' village in the Kompong Speu province was liberated by the Youns weeks before Pursat province. Furthermore, the Khmer Rouge cadres were different in every province. In the eastern provinces, the Khmer Rouge cadres were more moderate and humane: the work hours were generally shorter, the food rations were larger, and the soldiers did not kill the villagers indiscriminately. In Bat Deng, Uncle Leang's and Uncle Heang's families were allowed to live together. Though many new people who resettled in their village were taken away and never heard from again, my family's status as base people protected them from the killings. In the Pursat province where we lived, the cadres were among the most brutally insane. "And your mother," Uncle Leang says, shaking his head, "two more months, just two more months, and she would have made it."

Hearing this, I get up quickly and leave them. I walk to the new town market that has sprung up since the Youns came. There is no monetary system in place, so rice is used as currency. To go shopping, people bring a bag of rice with them and use it to barter for the items they want. I have no rice with which to buy anything, but still I weave my way around, remembering Phnom Penh. Unlike in Phnom Penh, this market is a gathering in a field. There are no tents selling eight-track tape players, imported vinyl pants, or hair-coloring cream, nor are there elaborate stalls glistening with dangling gold or silver necklaces and bracelets. Here in Bat Deng's market, long homemade wooden tables display dried fish, slabs of pork, yellow naked chickens, green beans, white corn, red tomatoes, orange mangoes, ripe guava, papayas, and some precooked food. Those with the most "currency" can cross from the food section to the book section, where old Khmer, Chinese, French, or English dictionaries and novels can be bought with several kilograms of rice.

The market here thrives because most people did not have to leave their homes and are therefore already settled. Our family is poor and survives by farming a small plot of land. With a heavy heart, I walk through the market taking in the smell of all the delicious food. My feet stop at a stall that sells pork dumplings. Pork dumplings will always remind me of Ma. It was her favorite food. "Two more months and she would have made it!" my mind screams. "Why couldn't she hold on for two more months? Did Ma do something stupid and get caught? Did she complain about her work? Did Geak cry for Pa too loudly and too often? They must have let their weakness show. What did they do?" My eyes burn into the dumplings. Anger rises up in me because I resent and blame my mother for not holding on for two more months. Eight weeks, sixty days, 1,400 hours more, and she would have made it.

A few weeks later, my uncle arranges a marriage for Meng. His bride's name is Eang and she is in her early twenties. Eang was in school during the evacuation of Phnom Penh and was separated from her family. She does not know where they are, or even if they are alive. Aunt Keang says not only is Eang Chinese but she is very clever and smart as well, and truly believes she is the right wife for Meng. Aunt Keang tells Meng he is the head of our family now and needs a wife to help look after us while he works. A week after they meet, they are married. There is no big celebration, only a small ceremony. It all happens in one day. Then it is over and life resumes as before.

Each morning, Meng, Kim, and the male cousins work with Uncle Leang on the small farm in back of their hut. They grow potatoes, onions, leeks, beans, and tomatoes. But the land is dry, having been neglected during the Khmer Rouge rule, and produces hardly any fruit. Khouy occasionally works as a laborer, helping people carry and load heavy bags of cloth, fruit, and rice from their wagon to the new market for a small fee. Eang and the female cousins stay at home and make crêpes, sweet cakes, and cookies from corn and wheat, which we exchange for rice.

Chou, the younger cousins, and I sell what they make in the market. We have no stall, no chairs, no cart, and no tables. Balancing our wicker baskets on our hips, we walk barefoot around the new market in our blue outfits, yelling out our goods of the day. We sell mostly to

other vendors, collecting twelve ounces of rice for five sweet cakes or ten cookies. When I see a well-dressed woman entering the market, I rush to her. Smiling widely, I lift my basket to my chest, hoping to catch her eye. I stare at the red ruby earrings draped from her ears and, for a moment, the wind is knocked out of me. "Ma," my mind whispers, and I walk nearer to her. The woman raises her hand and waves me out of her way. Ignoring me, she passes by. My eyelashes moisten; my smile fades.

For three months, we live our lives this way in Bat Deng. Then one day, a lady comes in to town looking for Eang. She is Chinese and in her thirties. She says she has come from Vietnam to search for Eang. When Eang sees the woman, her face wrinkles up and bursts into tears. It is one of her sisters! They rush into each other's arms and hug for a long time. They stand there, crying and saying very little to each other.

"Mother and father are alive and well in Vietnam," she tells Eang, "as is your oldest sister. Our brother is missing and believed to be dead. During the evacuation, we went over into Vietnam and have been living there ever since. We thought you were dead!" The next day, Eang and Meng leave for Vietnam. The economy in Cambodia is bad and Meng thinks maybe there will be work in Vietnam. With or without Eang, he says, he will return in a few days.

The days pass slowly as we wait for Meng's return. Our family continues to live as before, with the men working on the farm and the girls selling food in the market. At night, Chou and I sit outside the hut looking at the road until the sky darkens and our aunt orders us in to go to sleep. Each day that Meng is gone, my anxiety grows, and I wonder if he will ever come back. Sensing my fear, Kim tells me the route Meng took to Vietnam is very safe, and does not cross any Khmer Rouge zones. Still, I worry. But true to his word, he returns alone four days later. Sitting inside the hut with the family, Meng talks excitedly about Vietnam, Saigon, and Eang's family. Most of all, he talks about leaving Cambodia and going to America.

Meng tells our uncles that many Cambodians are leaving the country for Thailand in search of new life and to escape the war. Furthermore, they fear the Khmer Rouge might come to power again and kill more people until no one is left. Many Cambodians are trekking on

foot to the north, crossing dangerous mined fields and Khmer Rouge control zones, with little food and water, to go to Thailand. Many people step on landmines and die on the way or are captured by the Khmer Rouge.

He says the safer way to go to Thailand is via Vietnam. In Vietnam, Meng explains, the human smuggling operation, or leaving the country without papers, is illegal. If we are caught being part of the operation as either an abettor or a refugee, the Vietnamese government could take our gold and throw us in jail for five years.

"It will be very costly," he informs us. "We cannot all afford to go. It costs ten ounces of gold to buy a seat on a small boat that will take us from Vietnam to the Thai refugee camp. He says Eang's family knows the person running this human export operation. With money from the rest of the family and after selling Ma's remaining jewelry, we only have enough money for two to go."

Uncle Leang puts his hand on Meng's shoulder. "Your Pa is gone, Meng, so you are now the head of our family. Your life is not your own anymore. You have a family to take care of," he says quietly.

"Uncle, I *am* doing this for the family. I will take Loung with me. She is still young enough to go to school, get an education, and make something of herself." Though the younger children studied French in Phnom Penh, Pa made Meng and Khouy study English. As a result Meng is already fluent in English. Once in America, Meng's plan is to work hard and send money to the family. He will save and build a home, and in five years send for the rest of the family. Uncle Leang still has his doubts, but it is decided that Meng and I will leave at the end of the week.

At the rooster's cry, our family gathers outside the hut to say good-bye to us. While Meng says farewell to our relatives, I stand with Chou, holding on to her hand. One by one, our aunts and cousins come up to me and touch my hair, my arms, and my back. Meng ties our bags onto the backseat of his bicycle and lifts me up onto it. I straddle our bags, finally as tall as the adults, and look down at Chou. She stares up at me and cries, her lips quivering and her face crumpled. Our hands reach for one another and we hold on a few seconds more. I do not know how to say good-bye, so I say nothing. No matter what, I

am determined not to cry. Chou has this luxury; everyone expects her to. I am strong, so I cannot cry. I will never understand how Chou ever survived the war.

Meng gets on his bike and slowly begins to peddle, breaking Chou's hold on my hand. They are all in tears now as they wave good-bye to us. I do not turn around. I know they will not leave until we are out of their sight. I grit my teeth and fight back the tears. "Five years," I think as we ride away. "In five years I will see them again."

from cambodia to vietnam

I return to Phnom Penh on the back of Meng's bike, my heart beating wildly as I absorb the sights and sounds of the city. Nothing looks the way I remember it. The buildings are charred from fires and their walls riddled with bullet holes. The streets are covered with litter and filled with cavernous potholes. There are many bicycles and cyclos but few trucks. Gone are the tall, leafy, lustrous flowered trees that lined the wide boulevards. Instead, tall brown palms and coconut trees provide little shade for the dry, crumbling city. Though the palm trees are heavy with fruit, I see no people climbing to get it. People say the Khmer Rouge buried corpses next to them and now the palm milk is pink like thin blood and the fruit tastes like human flesh. Makeshift tents, no longer confined to the poor areas, sprout all over the city. There are people living everywhere, in alleys, in streets, in crumbling buildings and tents. Many are farmers and rural villagers. They moved to the city to look for work because their land is littered with landmines. They come to Phnom Penh to escape the Khmer Rouge, who still control parts of the countryside. They arrive and take up residence in the deserted homes. The memory of our life here comes flooding back to me.

"Eldest brother," I call out to Meng. In the Chinese culture, young children never call their elder siblings by name as it is considered improper and disrespectful. "Eldest brother, will you show me our old house?"

"It's not what it used to be. It is broken down with bullet holes everywhere, but we will go there," he answers and continues peddling. He tells me he went to see it when he came through the city with Eang and her sister on their way to Vietnam. He says someone is living in our apartment now. There are no documents kept on people's property from before the takeover in 1975. So whoever arrived first and set up residence in houses or apartments can claim them as theirs. He says it is no longer our home. Still, I want to see the place where I remember feeling joy and happiness. I want to ask him more about our former home, but Meng is quiet now, lost in his own thoughts. The stench of the city and its trash seeps into my nose making me want to pinch it, but I do not. Instead, I hold on tight to Meng as he steers the bike abruptly left and right to avoid the holes in the road.

We arrive at the water port late in the afternoon, but the sun is still hot and beats down on us. Meng holds the bike for me to jump off and tells me stay where I am as he disappears into a crowd of people with his bike. Vendors yell out their products to people passing by. In the sun, the fish scales on the seafood vendors' arms and faces sparkle and shimmer, reflecting the sunlight. On the rows of tables, big and small fish alike flap their tails on blocks of ice underneath them. It is October: the end of the rainy season and start of the dry season. Meng says that when it's hot, the water in the ocean goes down, so the fish move farther out to sea and are harder to catch; therefore, the fish displayed here are more expensive than usual.

Meng returns a few minutes later with a Youn fisherman, and they quickly usher me onto a small boat. Once in the boat, he hands the fisherman the small gold nuggets he received selling his bike and we take off. The boat looks no more than fifteen feet in length and perhaps five feet wide. Its wooden body is worn and old as the small engine chugs slowly along the Mekong River. As far as my eyes can see, there is water covering much of the land. The bright sun transforms the otherwise green lush scenery into a magical land of silvery lakes. In it, long black canoes slither like alligators, navigating themselves gracefully on

the water. On the other side of the Mekong River, I see orange and gold pointed temple roofs and towers erected on muddy red topsoil. The fisherman sits beside a small pile of fish, steering the boat. I sit in the middle with my hair whipping about my face in all directions, the wind cooling my skin. My eyes drift toward the port and all its cacophony. I am leaving Cambodia on a Youn boat, with a Youn fisherman, going to Vietnam. Meng forgot to show me our old home. Then suddenly, a picture of Met Bong lunging at the fisherman's throat with her sickle flashes before my eyes. I quickly shake my head free of the image. I'm leaving all this behind.

Many hours later as we approach Vietnam, the fisherman, in broken Khmer, tells us to lie on the floor and keep our heads down. He unrolls a sheet of blue plastic and covers us with it, leaving a small opening for our heads to stick through, and then piles fish on top of the plastic sheet and motions again for us to keep low. Underneath the plastic sheet, covered with fish, I enter Vietnam. I fight to breathe without choking on the stench of the fish. Once near the port of Chou Doc, the fisherman peels back the sheet and allows us to breathe in fresh sea air. Once we dock, Meng finds a bus station and buys our fares with the Vietnamese money he has saved from his last trip. We are on our way to Saigon!

From the windows of the bus, Saigon is a prosperous and bustling city. The streets are crowded with men and women in straw cone-shaped hats. The women are wearing red lipstick and colorful snug-fitting long dresses that split at the side over loose, flowing pants. In the streets, they talk openly to one another and laugh without covering their mouths. They do not avert their eyes nor do they glance from one side to another. Their shoulders are not slumped and their arms not held close to their sides. Taking long, casual strides, they walk without fear as we did in Cambodia before the Khmer Rouge. On every block, there are stores displaying wristwatches with flowered bands, black radios blasting Vietnamese songs, televisions projecting hand puppets talking to happy young children, and red traditional dresses on headless mannequins. The streets are crowded with many more bicycles, motor-cycles, and compact cars than in Phnom Penh. The food stalls and carts look bigger, cleaner, and are painted in brighter colors than what we had in Cambodia. As in Phnom Penh, people sit in alleys and side

streets slurping noodle soups, biting into crispy fried spring rolls and
egg rolls wrapped in lettuce. I only wish that someday Phnom Penh
will be as happy and rich as Saigon.

We live in Saigon for two months with Eang's mother and father in
their small one-bedroom apartment. Meng, Eang, and I sleep in the
attic. Eang's sisters live in their own place in the city. With no job, Meng
and I live off of the generosity of Eang's family. Eang and her parents
speak fluent Vietnamese because they lived in a Vietnamese community
in Phnom Penh. They are now able to meet people, go shopping, and
not be so isolated. Eang's family is very nice to us. Unlike Meng and
me, they are raucous and laugh loudly when they eat, and especially
when they drink alcohol. Meng and I do not speak Vietnamese, so
spend our days watching people, and trying to learn the language.

A week after we get there, Eang tells me we are going to the salon
to get our hair permed. It has been many months since Aunt Keang in
Krang Truop cut my hair. Sharing a cyclo with her, we weave around
the city as the driver maneuvers us through the traffic. I laugh and
point out to Eang the neon signs and billboards of movies, and giggle
in anticipation of having my first professional haircut in many years.

Finally the cyclo stops in front of a salon. While Eang pays the
driver, I stare at the poster-sized pictures of beautiful women and men
with curly brown hair, straight jet-black hair, short wavy hair, and hair
piled high in a braided bun on top of their heads. Inside, the walls are
covered with mirrors and more pictures of beautiful people. Vietnamese
music plays continuously on the radio as women snip and clip at their
customers' hair. One woman seats me in a chair and proceeds to put my
hair in small rollers. Then she pours acidic-smelling lotion onto my
hair. After twenty minutes, she removes the rollers and leaves me with a
head full of small ringlets instead of my old straight hair. Staring at
myself in the mirror, I laugh and pull at the curls, thinking they are
beautiful. That night I sleep on my stomach, afraid to crush the curls,
and I dream about Keav.

In the evening, I sit on Meng's lap as he reads and translates to me
stories about America from an English book he bought in a nearby store.
He describes how snow falls in flakes covering the land in a white, soft
blanket. I cannot envision snow because the only two kinds of ice I have

ever seen are either the blocks we use to cool our meat or the crushed ice we use for snow cones. He says it is more like the ice for snow cones but softer. I see myself making snow cones and getting rich selling them to American children. Then I can help send money home too. Meng tells me I should call the Youns by their proper name, Vietnamese. He says Youn is a derogatory name and since we are living in Vietnam, we should not use it. In Saigon, Meng's face grows fuller each day from the spring rolls and soups that Eang makes. My body is also filling out my clothes everywhere, though my stomach is still bigger than my hips.

· In December, Meng tells me we will relocate to Long Deang to live on a houseboat with one of Eang's sisters and her family in the lower end of the Mekong Delta. When we arrive at the port, Eang's sister picks us up in a small boat to take us to our new home. On the water, there appears to be a city of houseboats with many hundreds of them docked closely together. Some are forty feet long with two levels, sturdy wooden walls, brightly painted roofs, and strands of colorful beads hanging over the doors. Others look like makeshift cloth tents or small thatched-roof huts floating on the water. Out on the decks, women cook food in clay ovens and converse loudly with their neighbors. Little children sit on the decks with their feet dangling in the water as the boats rock gently back and forth. Laughing, one little girl splashes water into the faces of her siblings who bob up and down in the water beside their boat.

I stare at the girls with envy, and think about waiting another five years until I can see Chou again. The small boat slows as we approach our destination. Our two houseboats are twenty feet long and ten feet wide and are docked side by side. The wooden walls and roofs are aged and gray from the rain and sun but otherwise sound. Eang's sister and her five boys live in one boat. Meng, Eang, and I live in another with a Vietnamese man who is part of the operation. His job is to watch us and keep us safe. As our front man, he speaks for us whenever our neighbors ask about our background, why we are there, or what other part of the river have we lived at. He is in his early twenties and seems nice enough, but still I don't quite trust him.

Living on these boats allows us to blend in with other people since it is not unusual for the houseboats to change locations often. It will

not arouse suspicion if we disappear one night and head for Thailand. While sitting outside on the deck, we are not to speak Khmer or Chinese—only Vietnamese—and we cannot make friends or form bonds with anyone outside the family.

Day after day with nothing to do, I learn to fold origami and to speak Vietnamese. On the small deck, the boys and I make paper kites and fly them in the wind. When it gets hot, I dive off the houseboat into the murky water, taking care not to drink it. The water looks yellowish and often I swim away from the dead animals, garbage, and feces that float by.

For three months, we live slow, uneventful lives with our boats docked in the same spot. Then, in February 1980, another Vietnamese man joins us on our boat. One night the Vietnamese crew directs us to go inside, and in the dark we sit nervously as the boat moves slowly away. Suddenly, loud voices call out to us, asking us to stop. My heart lurches to my throat.

"We're only a fishing boat," our front man says.

"We want to see what kind of fish you have," the voice persists. After a few minutes of exchange, our man succeeds in bribing the intruder to go away with his gold watch, and all is quiet again. Our boat continues to move steadily, and I fall asleep. Hours must have passed, for when I wake up again, we are in the middle of the ocean. All around me I see nothing but miles and miles of water. Soon, many hands pick me up and lead me to a rope ladder hanging off the side of a larger boat floating alongside ours. Quickly I climb the rope onto the other boat. On the deck of the thirty-foot boat, seven crewmen are busy pulling people onto the boat and hustling them under the deck. All through the morning, many more small boats arrive to deliver their passengers and by late afternoon, ninety-eight people are onboard, each having paid for their escape in five or ten ounces of pure gold. They crouch underneath the deck, ready to make their way to freedom.

For three days and two nights we ride the ocean waves in the Gulf of Thailand, swaying and rocking as if in a wooden coffin. A crew member sits by the small doorway that leads to the deck, to make sure people stay below. "The boat must stay bottom-heavy," he says, "or it will tip over." Beneath the deck, the lucky ones sit leaning against the side

while the unlucky ones crouch in the middle, their heads between their knees. The air is stale and smells of sweat and vomit. Wedged between Meng and Eang, I hold my breath as people retch all around us. Soon it grows dark and through the deck opening I steal glances at the bright stars as they twinkle gaily at me. I crawl over to the opening and stand, basking in the glow of the moonlight.

"Sir, please, may I come up?" I whisper to the guard. His face peers down at me, then nods his head. Slowly I climb the steps and sit beside him. The breeze is cool as it fans my body. The guard smiles at me and points his finger at the sky. It is so beautiful: black, never ending, and brightened by billions of stars. It is so breathtaking I wish I could stop time and exist in this dreamland forever. Everywhere around us the sky meets the water, creating a clear separation of heaven and earth. Somewhere up there in heaven, I hope Pa, Ma, Keav, and Geak are watching over me.

I wake up in the morning to the loud voices of the crewmen. "Sharks!" they exclaim. "If they crash into our boat and put a hole in it, we are all dead!" Sliding to the edge, I catch a glimpse of the bodies of a group of silver-skinned sharks, as big as I am and swimming straight for our boat. They duck under at the last second. I quietly pray to Pa to chase them away. After a few minutes, the sharks become bored and stop following us. When the water is safe again, the crew allows a small group of people to come up to the deck for air. After a few minutes, they are sent back down until everyone has had a chance to go up on deck. Because the crewman likes me I am allowed to stay on deck all day.

The next day, the sky turns black with angry storm clouds. Bursts of rain and thunder crash into the ocean and create large waves that threaten to swallow our boat. The captain sends all but the crew below deck and shuts the lid tightly on us. The passengers huddle closely together and pray. Yet the sea becomes rougher and the boat rocks from side to side like a pendulum, and with each swing the waves violently slap against the side of the boat. People vomit and moan loudly, afraid of their imminent deaths. The cries echo and bounce into each other in the dark, deafening me. Leaning against the wall, I push my index fingers deeper into my ears to attempt to block out the sound. With my ears plugged, I hear only the soft whizzing of my breath going in and out.

After what feels like many hours, the boat gradually decreases the violent rocking and all is quiet again. After the storm, the crewman opens the lid and fresh air rushes back into the cabin. Stepping over sick bodies, I climb up onto the deck before anyone can stop me. The clouds part and out comes the sun from behind them, shining brightly on us. The deck is wet and soaks my pants as I sit down and inhale the fresh sea air. While the crewmen pass out our food ration—two balls of rice and six ounces of water—I sit and watch the sunset in the middle of the ocean. The clear blue sky is the perfect setting for the orange, red, and gold pallet of the gods. The colors shimmer majestically before disappearing with the sun into the water. I squeeze my eyes shut, not understanding why such beauty torments me with pain and sadness.

On the third day, the captain spots another ship in the distance. He has made many trips before and knows they are pirates. On previous trips, the pirates have stolen valuables, killed people, raped and abducted girls. They know well the route of the boat people and travel the sea looking to steal their valuables. We, on the other hand, know the pirates' intentions and have devised plans of our own. Eang's sister made candies and hid bits of gold in them. Some families sewed gold and jewelry into the linings of their bras, the waistline of pants, in sleeves, behind buttons, or in underwear. Others wear their gold as teeth and some swallow diamonds and other jewelry, knowing they can make themselves throw up or get diarrhea and retrieve the items later.

The captain speeds up our boat and tries to outrun the pirate ship but to no avail. It is much bigger and faster than ours and rapidly gains on us. Meanwhile, the women work frantically to ugly themselves up by smearing black charcoal paste on their faces and bodies. With ashen faces, some of the younger, prettier girls reach into the bags we have vomited into and scoop out handfuls of it to smear on their hair and clothes. Following Eang's lead, I grab the charcoal paste and cover my face and body with it. As the pirate ship comes nearer and nearer, the captain sends everyone but the crew under the deck.

Crouching between Meng and Eang, my stomach churns from fear and the putrid smell. I do not know what to expect and only know of them from the pictures in books I've seen. Flashes of ugly flags with skulls and bones, swords slashing at people's throats, and long knives

cutting out our hearts edge their way into my consciousness. Slowly our boat stops and my heart leaps as heavy footsteps jump aboard. Seconds later, the door to the deck flings open.

"Come on out. It's okay," the captain yells to us. "These are just friendly Thai fishermen." His voice does not sound to me as if his throat has been cut. The passengers refuse to come out and stay hidden beneath the deck. "They only want to help us. They have invited us all to their ship for food and to stretch for a few minutes." The captain assures us there is no harm in doing what they ask. Breathing a sigh of relief, I climb out with Meng and Eang. To my surprise, the pirates do not look scary at all. They have no swords, wear no eye patches, and hang no skull flags anywhere on their ship. They are dark-skinned and have facial features very much like us Cambodians.

The boat is maybe ten times the size of ours, with room enough for ninety-eight people to walk and stretch. True to their word, they give us rice with salted fish to eat and allow us to drink as much water as we want. Afterward, I walk and find a toilet. A real toilet with flushing water and seats like the ones we had in Phnom Penh. While on the boathouse, when we had to go we squatted in a hollowed-out weaving basket hovering over the water at the edge of the boat, and had to hold onto a pole so as not to fall in the sea. As soon as I begin to relax, the captain announces that we are to return to our ship. Before we can get back onboard, however, we have to file into a single line to "meet" our new friends.

From out of nowhere the pirates seem to pop up all around me, and they increase in number so that now there are many more of them. Eang quickly hands me a small matchbox. In it is a small jade Buddha pendant in a gold frame that was Pa's. I shake as a pirate walks up to me. He bends down so his eyes meet mine. My throat swells as he looks into my eyes. I have what he wants in my pocket.

"Do you have anything for me?" he asks, smiling, in broken Khmer. Looking down, I slowly shake my head, not daring to look at his face. My heart pounds so hard that I think it will burst through my clothes. He does not believe me and reaches into my pocket, pulling out the matchbox. I hear him shake the box and the Buddha moves around inside. He slides open the box and takes out the Buddha.

"Can I have this?" he asks.

Meekly, I nod my head.

"You can go back to your boat." He takes Pa's Buddha and puts it in his pocket.

Fighting back tears, I walk toward the boat.

While the pirates body-search everyone onboard, other pirates ransack our small boat, taking diamond rings, sapphire necklaces, gold nuggets hidden in sacks of clothes. On the deck, people hand over their valuables without protest. Our family does not have any gold for them to take. Meng had anticipated the Thai pirates and left all of Ma's jewelry with Khouy in Cambodia. Though they took the one thing that means the most to me, the captain tells us we should consider ourselves lucky. When we are all back on the boat, the pirates offer directions to the Thai refugee camp. Our captain thanks them politely, seemingly bearing no grudges or anger, and the pirates wish us luck and wave good-bye as we sail on.

"Land! Land!" someone yells many hours later. I am bolt upright in no time. After being on the ocean for three days, I am at last staring at the glorious sight. Real land with green trees and grass. We have heard that many boats get lost coming to Thailand and end up in the Philippines or Singapore with the refugees onboard starving to death before they are picked up the by the ocean police.

"Not just land but the Lam Sing Refugee Camp," the captain says confidently. A crowd of people are gathered at the port waiting to see if their relatives or friends are onboard. Everyone rushes up on the deck at once, causing the boat to sway and dip heavily to one side. The boat passengers wave wildly, laughing and yelling the names of friends and family. The captain screams for everyone to stay calm or the boat will tip over, but I do not pay attention to him.

"We made it!" I holler, my arms flapping up and down like wings.

lam sing refugee camp

Surrounded by a large crowd of refugees, we line up on the pier in single file waiting to be registered. Around me the newly arrived boat people talk excitedly to their friends and family, and deliver them news of relatives in Vietnam. They are happy to be reunited. "Five years," I say to myself.

It takes us many hours before we reach the registration table and give the workers all the necessary information. While Meng talks and answers questions, I become conscious of the charcoal on my face, the knots in my oily hair, and my flaky skin. The refugee workers have Meng fill out many papers before sending us off to the camp's church, where we are given clean clothes, bedsheets, and food. Newcomers without friends or family spend their first night in Thailand in the hollow, wooden church.

That night our family and Eang's sister with another friend remove the gold nuggets from their bras, waistlines, and the hems of their shirts and pants. They pool the gold together to buy a bamboo hut from another refugee who is leaving for America in the next week. With what little money we have left, we buy pots, pans, a few utensils, and bowls, and set ourselves up for a long stay. The refugee workers tell us it

can take a long time to find a sponsor. They say a sponsor can be a person, a group of people, an organization, or a church group who will take responsibility to help us settle in our new home in America. The sponsors will help us find a place to live and schools to teach us English, and they will help us adapt to life in America. Our sponsors will also show us how to buy food from grocery stores, visit doctors and dentists, buy clothes, go to the bank, learn to drive, and find a job. They caution us that while waiting for sponsors many refugees get married and have children, and each time that happens new paperwork must be drawn up, which prolongs their stay. We're told we can do nothing to bring us closer to America other than to wait. Meng says there are approximately three or four thousand refugees in Lam Sing, so our wait will not be too long. He tells me in some camps, there are more than a hundred thousand refugees living there, so the wait is much longer.

Every morning a row of trucks carrying bags of rice, fish, and tanks of fresh water comes blaring into Lam Sing. The refugee officials then divide and ration us salt, water, rice, fish, and sometimes chicken. All other supplies—including soap, shampoo, detergent, and clothes—we have to find for ourselves. When the food ration is reduced, we supplement it by buying food from the Thai market at the edge of the camp. Otherwise, routine life in the camp consists of standing in one line after another for our food and water rations.

One day I watch as a long line of people edge toward the ocean. The hot February sun beats down on them, causing beads of sweat to collect on their upper lips. From the shade of a tree, I laugh as one by one they walk into the water to face "the Father." I stare at the Father with fascination, and wonder at how he could stay so white under our hot sun. The Father's eyes are blue like the sky, his nose long, his hair brown and curly. He looms big and tall above the men and women standing before him. One hand slowly makes some crosses while the other gently guides the heads of his subject backward into the sea. My eyes open wide when I see Meng standing in a group at the side dripping wet.

"Eldest brother!" I call, running up to him. "Did you also get dunked in the water by the Father?"

"Yes, he has made me a Christian." Meng chuckles with his friends.

"Why? I thought we were Buddhists."

"We are, but being a Christian will help us get sponsors faster. Many refugees are sponsored by church groups. Christians like to help other Christians." I do not understand, but Meng has already turned his back on me.

Day after day, with nothing to do, the cousins and I walk to the beach. In my shorts and T-shirt, I run to the water for a cool swim. From the water, I catch sight of something red from the corner of my eye. I turn and gasp with horror, not believing my eyes. A young woman walks into the water wearing nothing but a small bright red bathing suit! The stretchy material clings tightly to her body, allowing everyone to see her voluptuous figure. The suit has no pant legs or skirt, leaving her white thighs uncovered. The V-neck top exposes her cleavage, which bounces as she runs into the water. I know she has to be one of "those" Vietnamese girls everyone always gossips about, because no Khmer or Chinese girl would wear such a thing. Khmer girls swim either with their long sarong wrapped tightly around their chest or are fully clothed.

A few weeks later, I am awakened by a loud scream in the middle of the night. There are a lot of angry noises coming from the hut of one of our neighbors. After an hour, all is quiet again and I fall back asleep. The next day the whole camp is talking about it. We are told that while we were sleeping, one of the Vietnamese girls woke to some guy sitting on her stomach. He held a knife up to her and told her not to scream, but she did anyway and he ran off. Waiting in lines for their ration of food, the women prattle about how the girl brought it upon herself. "After all," they say, "she is Vietnamese. These Vietnamese girls are always laughing loudly, talking, and flirting with men. They wear sexy clothes with long slits up their skirts and swimming suits. They bring bad attention to themselves." My face burns with rage; I run away from the gossips. Are they right? Those people who are always so quick to blame the girls.

Days turn into weeks, weeks into months. Soon it is May and still we have no sponsor. Many more people have arrived by the boatload to our camp while others leave for other countries. It has been eight months since we left Cambodia. We have no way of reaching Chou and our family to let them know we are well. For all they know, we could

be missing at sea or dead. My heart weighs heavily at the thought of our family worrying. Though many of the refugees are poor, we are by far among the poorest. Day by day, Meng and Eang have to borrow money from her sister and friends to supplement the low food ration we are given. While the other girls wear pretty dresses and eat delicious food from the Thai market, I eat rice gruel, and fish when we can afford it. As a result of continuing malnutrition, my stomach stays swollen while the rest of my body is small and thin.

Then on June 5, 1980, Meng returns from the camp officials' office with his face flushed with excitement. He announces that we have found a sponsor. "We're going to America!" Eang and I scream and cry with happiness.

"We still have to be here for another week but we're going!" Meng tells us.

"We're going to America! We don't have to save money anymore!" Eang stops her screaming and stares at me. "We must buy some cloth and make you a dress to wear in America!" She takes me to the Thai market the next day to shop for material. I walk around the store looking at the pretty rainbow colors of cloth laid out on top of each one of the tables. I wipe my fingers on my pants, making sure they are clean of dust and grime before lightly touching the cloth. The silk shimmers in my hand, soft and cool. It is so pretty, but I know we cannot afford it. "Come look at this," Eang calls out to me. In her hands, she holds up orange, red, and blue checkered cloth. "Isn't this pretty? I think it will look nice on you." I nod, my eyes fixed on the red squares.

The next day, in our happy mood, Meng, Eang, and I walk to an open field to watch the movie that the camp officials are showing that night. The film is supposed to give refugees going to America an idea of what our new home is like. The movie is projected outdoors on a large white sheet in the middle of the camp. At twilight, the refugees gather with their blankets, rice pots, plates of fish, thermoses of tea, and eat noisily as the movie begins. Lying on my stomach on our blanket next to Meng and Eang, I hold my breath as moving pictures of America flash on the makeshift screen. The buildings are made of green marble, white granite, or red bricks with tall glass windows. In the silver mirror-

like walls, people of different height weave through the streets in high heels and black leather boots. The people have all different color hair: black and frizzy, orange curls, red straight strands, blond waves, or black straight bobs. They get in and out of cars, whistle at friends, and glide along the sidewalk on shoes with heels as loud fast music blares from speakers.

"America," I whisper. Meng smiles and musses my hair.

"California," he tells me.

"Is that where we're going?"

"No, we're going to a state called Vermont," he says, and focuses his eyes back on the screen.

"Is it like California?" I ask.

Meng tells me he doesn't know. It seems not many people are going to Vermont and many have never heard of it. But he assures me it is in America and therefore, it must be a little bit like California.

At home, Eang and her friend measure me up and down to make the dress. For a week, they sew my dress furiously, pinning and unpinning the hem, the sleeves, the collar. They even make little ruffles for the neckline. The night before we leave the refugee camp, I pack my clothes slowly. Laying my finished dress and new sandals aside, I put a small writing book that Meng bought for me, two pencils, and a few sheets of looseleaf drawing paper in my shoulder bag. Then I lift and smooth my dress once again before laying it down carefully, making sure it will not be wrinkled tomorrow. I am sad thinking I have finally replaced the other red dress that the soldier burned. This is my first dress in five years, and tomorrow I will wear it and show off to everyone. Before the giggles can escape my lips, a feeling of sadness pushes them down. Staring at the dress I realize it will never be the dress Ma made for me. They are both gone.

That night the air is hot and humid, as it always is in June in Thailand. Lightning and thunderstorms accompany the moist air. I shiver hearing the storm clouds rumble in the distance. I hate electrical storms; they sound as if the sky is at war with itself. The explosions make me feel like death is chasing after me again. I squeeze my eyes shut, trying not to be afraid. Beside me, Meng and Eang sleep quietly, their backs to each other. I envy them their adult status and fearlessness

of dark stormy nights. After what feels like an eternity, the thunder finally moved on and rain came in its place. The soft pattering of raindrops against our straw hut makes my eyelids heavy. As I drift to sleep, I think of Pa. I know his spirit can travel over land to be with me but worry if he can cross the ocean to America. Then in my dream, Pa is sitting next to me, his fingers caress my cheeks and face. The light touch tickles and makes me smile.

"Pa, I miss you," I whisper.

Pa grins at me, his round face wrinkles around his mouth and eyes.

"Pa, I'm leaving for America tomorrow. Eldest brother said America is very far from Cambodia, very far from you . . ." The words linger in the air. So afraid of what his answer may be that even in my dream I cannot tell Pa my fear.

"Don't worry. Wherever you go, I will find you," he tells me as his fingers gently brush strands of hair out of my face. When I open my eyes in the morning, the rain has stopped and the sun is peaking out behind the clouds. The cool breeze blows my hair across my cheeks, tickling them.

A few hours later, Meng, Eang, and I hold hands as we enter Bangkok International Airport. Our plane, a giant silver bullet with wings awaits us at the gate. My heart thunders loudly in my ears, my palms cold and sweaty. Heartened by my dream of Pa, I walk onto the aircraft.

epilogue

I'm almost home. After a thirty-one-hour plane ride across the Pacific, I am in my last hour of the trip from Bangkok to Phnom Penh. Below me is Cambodia—my land, my history. With my forehead resting on the window, I see that it is the rainy season and most of Cambodia is submerged in silver, shimmering water. I think of Pa, Ma, Keav, and Geak. Swallowing tears that drip down my throat, I reflect on how I left my family behind.

When Meng and I came to America, I did everything I could to not think about them. In my new country, I immersed myself in American culture during the day, but at night the war haunted me with nightmares. On occasion, the war crossed over from my dreamworld to reality, as it did in 1984 when the drought in Ethiopia brought daily images of children dying from starvation. On the television screen, children with bellies too big for their bodies and skin hanging loosely on their protruding bones begged for food. Their faces were hollow, their lips dry, their eyes sunken and glazed over with hunger. In those eyes, I saw Geak, and I remembered how all she wanted was to eat.

As the Ethiopian crisis faded from the screens and Americans' consciousness, I was even more determined to make myself a normal American girl. I played soccer. I joined the cheerleading squad. I hung

out with my friends and ate a lot of pizza. I cut and curled my hair. I painted my eyes with dark makeup to make them look more round and Western. I'd hoped being Americanized could erase my memories of the war. In her letters to Meng, Chou always asked about what I was doing—I never wrote her back.

Khouy, Kim, and Chou continued to live in Ma's hometown of Bat Deng with our aunts and uncles. Soon after Meng and I left, our maternal grandmother, along with the wife of our youngest uncle and their two daughters, also made their ways to the village. Youngest aunt wrote that Khmer Rouge killed her husband. As for our grandmother, she is in her eighties, weak from old age, and speaks very little Khmer. When asked about what she saw, grandmother's wrinkled eyes well up and tears flow down her cheeks. Shaking her head, her small hand wipes her eyes and rubs her chest above her heart.

When she turned eighteen, Chou married a man in the village and later bore five children. Together they opened a small stand in front of their house selling bamboo containers and brown sugar. Khouy, with his salary as the village's police chief, supports his wife and six children. In Bat Deng, a community of almost a hundred Ungs grew out of the ashes of the war.

In 1988, hoping to join us in America, Kim made his way to a Thai refugee camp. There he stayed in hiding for a few weeks, surviving on the money that Meng sent him. On the other side of the world in Vermont, Meng hurriedly filled out the family reunification papers to bring Kim to the States. A few months later, we received news that the United States had reduced the number of refugees allowed into the country. As a result, the Thai camp officials rounded up the refugees and deported them back to Cambodia. In Vermont, Meng scrambled to raise the ten thousand dollars it would cost to get Kim out of Thailand. Meng arranged his escape through a black market ring that brought him as far as France. After many years and after filling out many immigration forms, Meng now anxiously awaits the arrival of Kim and his family in Vermont.

Meng and his wife, Eang, have lived in Vermont since we arrived there as refugees in 1980, and they now have two daughters. Because of

their hard work and determination, our family in Cambodia and in America thrives. Stranded in a foreign land, with little knowledge of the culture, society, food, or language, both work long hours at IBM to support the entire family. Though Meng has kept the family in Cambodia and here afloat for many years, he still harbors deep sadness that we did not succeed in bringing over our entire family. With current politics and immigration laws, the chance that our family will ever be reunited is very slim.

As for me, I lived for fifteen years isolated and sheltered from the continuing war in Cambodia. While Meng and Eang worked not only to make ends meet but to have enough left over to send to Cambodia, I learned to speak English, attended school, and looked after their two children. Eventually, I earned an undergraduate degree in political science and went to work for a domestic violence shelter in Maine. After three years, in 1997, I moved to Washington, D. C., and found work at the Campaign for a Landmine-Free World (CLFW).

Now, as the spokesperson for CLFW, I travel extensively across the United States and overseas, spreading the message about landmines and what is was like in Cambodia. As I tell people about genocide, I get the opportunity to redeem myself. I've had the chance to do something that's worth my being alive. It's empowering; it feels right. The more I tell people, the less the nightmares haunt me. The more people listen to me, the less I hate. After some time, I had talked so much I forgot to be afraid; that is, until I decided to return to Cambodia.

As the trip grew near and my anxiety increased, my terrible nightmares returned. In one dream, I'd board the plane in America as an adult woman only to step off in Cambodia as a child. The child was lost in a crowd of people, desperately looking for her family, calling the names of her siblings, calling out to her parents. I woke up each morning increasingly panicked about this homecoming.

The day of the trip, my anxiety transformed into excitement. As I boarded the plane in Los Angeles, I fantasized about how it would feel to return to where I belong. A place where everyone speaks my language, looks like me, and shares the same history. I envisioned myself getting off the plane and walking into the open arms of my family. I

daydreamed about the warmth of the many arms of my aunts, cousins, and Chou around me, encircling me, forming a protective cocoon, keeping me safe.

Finally, the plane's tires screeched against the tarmac of the short runway, and I braced myself for the first meeting with my family in a long time. My heart beat loudly inside my head, making my scalp sweat. The stewardess announced for all to remain in their seat until the plane came to a complete stop. It felt like hours later by the time I emerged from customs to make my way out of the airport.

I spotted my family right away. They were all there. Twenty or thirty of them stood elbow to elbow and pushed at each other to catch their first glimpse of me in many years, with Chou and Khouy in front. Though the temperature was a mild seventy-five degrees, my hands were sweaty and hot. I watched my aunts' and uncles' eyes frown as they continued to study me. My comfortable, practical, stain-resistant, loose-fitting black pants, brown T-shirt, and black Teva sandals drew quizzical looks from Chou and Khouy. Then I realized my mistake. I looked like the Khmer Rouge. All my fantasies of instant connection were crushed. My family and I reacted awkwardly to each other and they kept their many warm arms at their sides.

Standing by myself, I stared at Chou. My throat tightened. Though she had grown, I am still a few inches taller than she. Her hair long and black, her skin smooth, her lips and face made up with rouge, and she reminded me of Ma. She was beautiful. Once her glance reached my face and our eyes locked, I saw that they are the same: kind, gentle, and open. Instantly, she covered her mouth and burst into tears and ran over to me. The family was speechless. She took my hand, her tears cool in my palm. Our fingers clasped around each other naturally as if the chain was never broken, and I allowed Chou to lead me to the car while the cousins followed with my bags.

acknowledgments

I wish to acknowledge first and foremost Bobby Muller, my employer and mentor. Many thanks for his work in Cambodia and for opening the Kien Khleang Rehabilitation Center. When I was in America trying to erase the genocide from my memory, Bobby was in Cambodia giving a voice and aid to the survivors and victims of landmines and the continuing ravages of the Pol Pot regime. Without his support and encouragement, this book might not have been written. Bobby has shown me how one person can change the world. I also wish to thank Senator Patrick Leahy of Vermont, who has been an inspiration to me. He is a politician who transcends the stature of his office, and his dedication and work is invaluable in our efforts to abolish landmines.

My gratitude goes to my agent extraordinaire, George Greenfield, for believing in this book. Many thanks to my friend, reader, and incredible writing teacher, Rachel Snyder. I also owe a huge debt to the fabulously talented Trena Keating, my editor at HarperCollins, whose support and enthusiasm for this book never wavered. Without Trena's great editing, you'd all be reading a much longer book. Thanks also go to Bronson Elliott for her words of encouragement.

I would like to give special thanks to Mark Priemer, my best friend, who always encouraged me no matter what I did or where I went, and without whose love and support I would not be who I am today. To my girlfriends and new sisters in America: Ly Carboneau, Heidi Randall, Beth Poole, Kia Dorman, Britta Stromeyer, Joan Mones, Nicole Devarenne, and Jeannie Boone, thanks for reading many drafts.

To my second family in Vermont, Linda, George, and Kim Costello, thank you for bringing my family to America. To Ellis Severance, my ninth-grade English teacher at Essex Junction High School, thank you for my first A-plus on my essay. Every time I think to myself that I cannot write about this, I remember you. To all the great teachers at the Albert D. Lawton Junior High School and Essex Junction High School, and Saint Michael's College, thank you for preparing me for life in America. Also a special thank-you to the community in Essex Junction, Vermont, where kindness is abundant. There was no better place for me to heal.

Finally, to my American-born nieces, Maria and Victoria, I hope this book will allow you to get know the grandparents and aunts you never met.

resources

To learn more about the **Campaign for a Landmine Free World** contact:

Campaign for a Landmine Free World
2001 S Street, NW
Suite 740
Washington, DC 20009
Tel. 202–483–9222
Fax. 202–483–9312
Web. http://www. vvaf. org

To learn more about **Cambodia** contact:

The Cambodian Genocide Program
Yale Center for International and Area Studies
Yale University
P. O. Box 208206
New Haven, CT 06520–8206
Web. http://www. yale. edu/cgp/